EVENING RAGAS: *A Photographer in India*

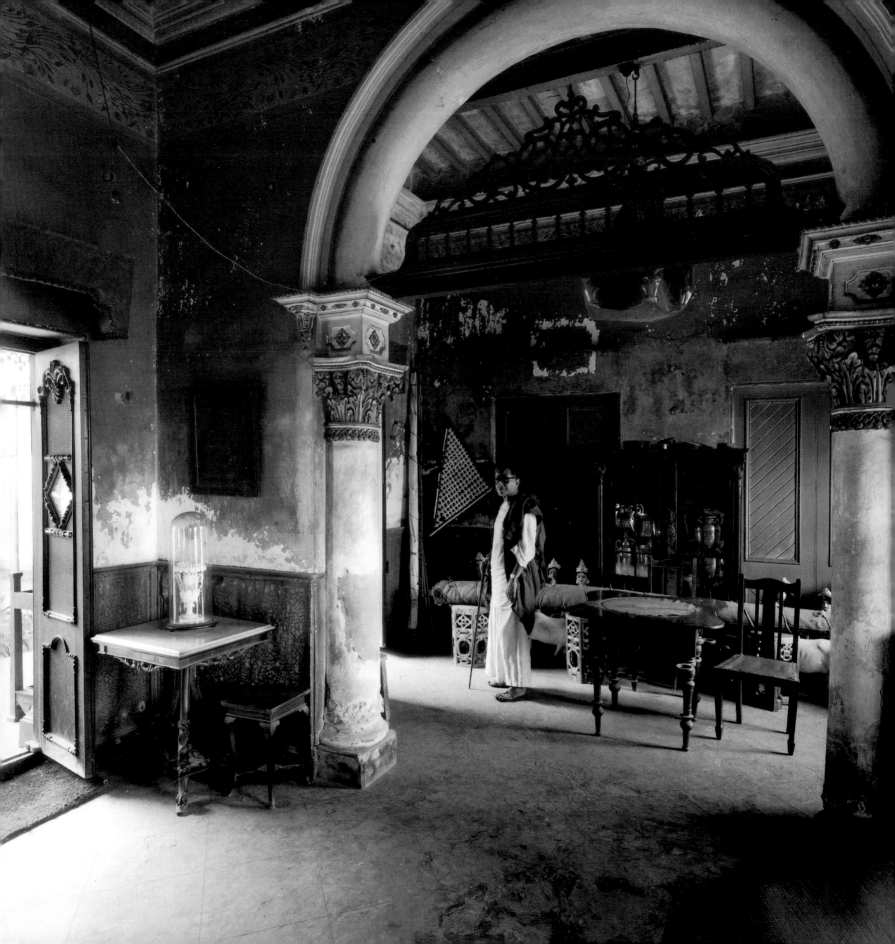

EVENING RAGAS

A Photographer in India

DERRY MOORE

John Murray / Albemarle Street / London

To Benjamin, Garrett and Marina

First published in 1997 by John Murray (Publishers) Ltd, 50 Albemarle Street, London W1X 4BD

The moral right of the author has been asserted

A catalogue record for this book is available from the British Library

ISBN 0-7195-5809 3

Typeset in Fournier

Printed and bound in Great Britain by Butler and Tanner, Frome

CONTENTS

PHILIP GLAZEBROOK: *Setting the Scene*

THERE IS a magnificent image amongst these photographs of a billiard-room in Hyderabad; swagged in silence and shadow, the ponderous table sheeted, it seems to be the room of a palace in which, upstairs, the last grandee of another era lies in state. It made me think of afternoons at Cambridge, in the Pitt Club billiard-room, dim winter afternoons spent playing against an Indian friend with a bottle of '27 port on a side table, game after game to while away time. Years later, when I was staying with this friend in India, he told me of two cousins of his in Hyderabad who passed most of their waking hours playing each other at billiards. 'Actually', my friend added a trifle wistfully, 'rather a nice idea, don't you think?' I thought it was a terrible idea, the two figures' absorption in their time-killing game like Satyajit Ray's Chess Players, facing one another with their backs to the light in some sombre room like the one in the photograph. Even at Cambridge in the late 1950s our afternoons spent at billiards had seemed to me a pastiche of Edwardian idleness,

7

enjoyable half in jest, like wearing spats; for him, I soon realized when we met again in India, Edwardian idleness and dissipation were a reality, the only reality he knew. He would not like what has since happened to the Pitt Club. Physically it still stands, but behind the imperial touch of its white-columned portico the premises have been leased to a Pizza House, whilst the Club itself has retreated to an upstairs room.

It was not amidst the ruins of the Pitt Club but in Italy, whilst seated on a fallen column within the amphitheatre at Pozzuoli, and reflecting on the post-imperial mood caught by these photographs, that I thought of Edward Gibbon listening in Rome's Campo Vaccino to the singing of barefoot friars as he considered the decline of empires. If there had been singing friars at Pozzuoli I would not have heard them: the noise of traffic and the siren scream of police and ambulance rushing to crimes or accidents filled the evening air. Pozzuoli has been dutifully excavated. Columns, architraves, statues, fragments of worked stone: much that has been retrieved from the dusty rubble has been heaped up against the walls of the amphitheatre – retrieved, heaped up, and forgotten. Apartment blocks overtop it, traffic mills round it. The whole vast edifice has the air of a forgotten irrelevance in the way of the all-important traffic. Pozzuolians sweep past. Rome built the thing, let Rome worry about its decay. Amphitheatres, temples, moles, villas – none of these stone progeny of Rome's wealth were of the least use to Pozzuolians, and to neglect them once the Romans had gone was an assertion of independence.

Conquerors acquire with their conquests a grand idea of themselves and of their destiny, which they express, hoping for permanence, in architecture. Everything imperial is constructed on a scale larger than life, stairways and arches and lakes of glimmering marble fit for the dwelling of a race of gods, fit for the heroes of battlefield and council chamber whose colossal images are deified in paint or marble wherever you turn. The architecture of successive conquerors bit deep in India. There are the ruins of six cities in the neighbourhood of Delhi, culminating in the Mogul palace (or what was left of it after the Mutiny) and in Lutyens' New Delhi, once a city of pleasant white-colonnaded bungalows in

8

large gardens now undergoing 'development' in concrete. The destruction of Lutyens' achievement, like that of Georgian Dublin, may soothe nationalist indignation, but in India the influence of Europe was so widespread, in the mighty buildings planted throughout the subcontinent in the last two centuries, that it is ineradicable. Indians who could afford to build at all built most commonly in imitation of one European style or another, matching each other and their conquerors in opulence and outlay. Size was the thing, sheer size.

The grandeur in which the British rulers of provinces liked to live was the result of individual ambition, not of government or Company policy. Government and Company were always trying to save money on building, their viceroys and governors always eager to spend. The magnificence of Wellesley at Calcutta and Barrackpore, or of Clive at Madras, was in each case extravagance by design of the man himself, and was in each case censured by government. Authority in England fought a losing battle: by 1800 or so there came about a general feeling amongst the British who visited India, as well as those who worked there, that they 'wished India to be ruled from a palace not a counting-house'. So palaces were built. Colonnaded mansions, and temples to the gods of Victory or Fame, everywhere arose amid a profusion of *chunum* pillars which evoked imperial Rome on the cheap as well as creating shaded walks and a welcome draught in a hot land. There were no notable architects employed in creating these extravagant palaces; a nameless overseer in the Public Works Department or a military engineer who happened to be at hand was responsible for them all – all except the ugliest, Viceregal Lodge at Simla, which had begun as a horrid chilly idea in Lord Dufferin's own head.

The first employment by the British government of a well-known architect to carry out its first grandiose scheme of building was the appointment of Lutyens to build New Delhi; and, as is probably a universal truth with official imperial building schemes, the Delhi project to confirm and celebrate Empire was commissioned just as imperial power began its ebb. A British viceroy inhabited Lutyens' palace in New Delhi for only ten years. By then the British rulers had begun to look inflexible, and

unsuitably dressed in their English clothes, and altogether a little lost.

More graceful, a better match for their surroundings, had been the earliest Residents at Delhi and elsewhere. These representatives of Britain in her vigour – men like David Ochterlony and William Fraser at the Mogul court at Delhi, or Major Kirkpatrick at the court of the Nizam of Hyderabad – fused their manners and morals and style of life with the attitudes and ideas of the Indian nobility, surrounding themselves with warriors and a harem, hunting lions and dacoits, living at ease among the ruins of the Mogul empire and steering the wealth of India into Company coffers. Kirkpatrick married a Persian princess and became the Nizam of Hyderabad's adopted son. There is a miniature of Ochterlony in Indian dress entertaining himself with a nautch-girl in his Residency. At first, when much of the power lay in Indian hands, it was the Resident who adapted himself to native ways, and lived in Indian quarters, and secured respect for himself and his remote Calcutta chief by Indian methods.

It was an idyllic time for the adventurous. There was a mutual understanding of objectives. It seemed that the British would be absorbed into India as other conquerors had been, and that life for the Indians would go on much as before. Lodged first in decaying Mogul palaces, when they began to build for themselves the British built, as the Fraser family did in Delhi, a Greek Revival façade which masked the Mogul pavilion in which they still lived.

So it might have gone on, the wary mingling of British and Indian life and custom, had it not become necessary (due to a shortage of British manpower in the army of occupation) for the conqueror to arm and trust the conquered race. Trust, in exchange for loyalty, was the way in which a British officer was used to rewarding British troops, and in India he trusted his sepoys' loyalty to himself. Neither trust nor loyalty (not, at least, loyalty bought with the invaders' wages) were at that date oriental concepts. The British learnt this lesson from the Mutiny. Nothing was ever the same again.

The Mutiny's separation of Briton from Indian, and the post-Mutiny arrival of a bureaucracy with its wives, ended the mingled style of life which had been developing before 1857. As power was taken

out of the native rulers' hands, there was no inclination among Residents and Governors to Indianize their households or their ideas. On the contrary, the native rulers began, as these photographs so graphically display, to imitate their conquerors. Enormous gimcrack palaces of calamitously eclectic European design, furnished like hotels and filled to the doors with a rabble of servants, were planted in jungle or desert. Indian taste in this area was always uncertain. I remember driving out of Cambridge one afternoon with my Indian friend – no doubt in search of a tea-garden, which he doted upon as a hot-weather alternative to billiards. We passed an enormous sprawl of buildings under tall chimneys spouting smoke and with grimy little windows issuing wisps of steam, a terrible mass of brick and slate. Slowing the car he said, 'I say, rather a nice country house, don't you think?' I looked in amazement. 'But it's a laundry,' I said. He was unsurprised, his opinion unaltered. A laundry would do.

When I saw the houses and palaces of my friend's family in India I understood why he might mistake that inglorious laundry for a country house. I remember coming upon the desert palace of one of his uncles, a sandstone pile rising from scrub and thorn, where we had been asked to lunch. We were invited not to the palace itself, however, but to a guest-house in the surrounding jungle, which reminded me not of a laundry but of a golf club – sitting-rooms crowded with chairs, sporting prints on the walls, pampas grass in brass vases, a gong, a gilt gasolier overhead. There the man in charge, the ex-ruler's brother-in-law, a plump figure in brogues and club tie, came forward almost on tiptoe, uneasily wringing his hands. There was an anxious atmosphere. In these guest-houses rather than within the palace itself Europeans were usually put up by the ruler; made welcome, made comfortable, but at the same time made just a shade apprehensive, against their will, by the presence of the palace close at hand. His brother-in-law's proximity evidently dismayed our guest-house host, whose polish at once vanished into more hand-twisting and nervous sideways glances when my friend enquired after his uncle's health. 'His Highness is very . . . very depressed you see,' he whispered in reply. The place was full of whispers. We were led to a table laid for two in a dining-room darkened by gloomy furniture which had an air of

recent resurrection from dust-sheets and desertion, and there, watched by our host who remained standing, we ate a meal of soup, fish and bananas. As we finished there was a stir without. Behind a gust of respectful salaaming there swept into the room the dark, wild-eyed Maharaja in a duffel coat pulled on over pyjamas. He took long strides round the table watched by all in frozen attitudes of piety, shooting out questions at his nephew: 'You've got a flag on your motor car? Fly it, man, fly the bally thing. I'll find you one in my palace. No trains. You haven't heard? Terrible things. No trains, nothing doing.' Here my friend broke into his uncle's recurring nightmare of the 1947 Partition atrocities, when his state had run with the blood of massacres, and tried to introduce me. Black pupils in very brilliant white eyes swept over my face. 'Who? How do you do? You will come and shoot? I am having a big shoot on the 18th. Yes, yes, I invite you. The Maharaja of Kashmir is coming. And Mysore I think. Of course you'll come. How long are you staying with me? I am leaving for Delhi immediately.' Out he rushed, his aides after him, leaving the dining-room to come to timid life, as servants dared to move, the way grass rights itself after a trampling.

Palaces may be turned into hotels, thus preserving their architecture. But the genius of the place, that building's distinction as a machine for living a certain kind of Indian life, will have vanished with the transformation. To stay in a 'palace hotel' conveys not a glimmer of the old palace life, a rough and tumble quite unfamiliar to Westerners, with its origins in the earliest Indian and Persian cultures. The emptiness left behind by the ebbing out from such buildings of the old life, is the emptiness which haunts so many of the images in this book.

Staying with my friend that year in his own father's state for His Highness's birthday celebrations I saw enough of the tumult of palace life to find it wonderfully disconcerting. You had to be on guard from morning till night, to keep your head above water in complicated currents stirred up by the Raja's fickle humours. Again, I had been put to sleep in a guest-house. Even in the hills, in Mashobra (a hill-station a few miles from Simla) we stayed not in His Highness's chief residence, 'Kenilworth', but in one

of his lesser properties, 'Honington'. It was March, and the cold of 'Honington' when we arrived at dusk, despite the servants sent up from the plains to prepare for us, was the most intense indoor cold I have ever felt. The icy stillness crept through two sweaters and a tweed coat and into the marrow of my bones. Orders were given for fires in every room, but even a bright blaze in my bedroom grate seemed not to have the power to convey heat through the crystal air, let alone to warm the damp of my sheets. Of course they were summer houses, the hill-station villas, their architecture all gables and porticoes and airy verandas, certainly not meant for a Himalayan winter. Within, life was the usual Indian mixture of basic discomfort ameliorated by luxurious trimmings. I remember waking to a thunderous knock on my door; as well as my bed-tea a string of servants carried in towels and a hip-bath and hot water in two copper jugs, which they placed before a rekindled fire. It was as if the 1970s had been spirited away in the night, and the 1930s brought back in their place. Outside, the sunlight of a cold and beautiful morning fell in shafts through the deodars on to a moss lawn pale from its snow-cover and sparkling with little blue flowers.

We visited the other family properties in Mashobra, and they too were all museums of a pre-war, pre-Independence era. Not so in my friend's eyes; no, here at last, in this wholly artificial construction of a British hill-station, after all the different environments in which I had seen him – English, European and Indian – here at last in this museum of a place I saw my friend at home. We visited 'Kenilworth', his father's chief hill residence, a large blue-grey wooden structure – his palace in his home city was also painted blue – and we took the open jeep through twisty suburban lanes to visit 'Sherwood', summer home of His Highness's mother. Here too were the brass ornaments and gate-legged tables of Camberley, and framed photographs of His Highness picnicking with Viceroys, and again the cold of the tomb. Glad to be outside, I was taken to the back yard of 'Cosy Nook', the family's fourth house in Mashobra, where the doors of a range of garages were rolled back for us. Old cars! A 1948 Rolls, a '51 Bentley, two Mark VII Jaguars, two '48 Packards, some cannibalized US jeeps, a row of motorbikes.

Not a 'collection' in the Western sense, not choice items deliberately assembled, this line of cars was the outcome of buying and never selling, for to sell a car would have hinted at indigence, with consequent lowering of prestige. So here they all sat, Dinky toys in a nursery cupboard. Cars, silver and gold ornaments melted down into bullion, Purdey guns and Hardy rods, a collection of valuable books in a 'Kenilworth' cabinet no one could open, these Mashobra houses themselves – all were treasure in diverse forms, the assurance of wealth. It had been one of the hardest tasks of the British Resident at a native court to persuade his Ruler to employ his income dynamically instead of heaping it up as treasure in a palace strongroom.

As the garages were being closed my friend took it into his head to try an old motorbike. One was started up and wheeled out to him. He swung into the saddle and rode off gingerly, feet trailing, across the yard of 'Cosy Nook'. Behind this uncertain figure ran a servant, hands spread wide to catch him if he fell. The wobbling bike and the running servant in that garage courtyard among the mountains make an abiding picture of Indian royalty in my mind.

As well as its Library and its Smoking-room and its Lounge, 'Kenilworth' boasted of course a Billiard-room. Into whatever fastnesses British ideas had penetrated, billiards soon followed. The young Henry Layard found a table in the fortress of a Montenegrin vladika with whom he stayed, and was playing a game against his host when his break was interrupted by the return of a war-party, who tipped out of a bloody sack on to the table their 'harvest of heads'. In the Residency at Lucknow, in an upper room holed by shot and shell, a broken-legged billiard-table survived everything the Mutiny could throw at it, to remain a gaunt symbol of the garrison's defiance. A billiard-room, like a porte-cochère to shade arriving guests and a colonnaded veranda screened from the sun by bamboo tatties, found its way on to the plans for any substantial house to be built to British or Indian orders. It stood for idleness and leisure, and for gentlemanly time-wasting in pleasant company. Not everyone approved: the sniffy Metcalfe, who succeeded Kirkpatrick as Resident at Hyderabad, wrote that 'As long as the billiards-table stands,

the Residency will be a tavern. I wish I could introduce a nest of white ants and cause it to disappear.'

The white ants have come and done their work, in the Pitt Club as well as in Hyderabad. My Indian friend would not care for it; but he has not survived the white ants either. I did not know, when I was in India in 1973, how short a future lay ahead for so much of what I saw and enjoyed and thought permanent. Derry Moore did. He focused his penetrating and discerning eye on what he believed was not going to last. The resulting photographs are in the spirit of pictures Pausanias might have chosen to illustrate his travels through what remained in his day of the buildings of the Greek empire. There is something melancholy, of course, in a record of what is doomed, and these are sombre pictures: they pierce through colour and movement (which are the apparent face of India) to the stillness and shadow of neglect and retreat. 'Photography', writes Susan Sontag, in words which might have been written to describe this book, 'is an elegiac art, a twilit zone . . . All photographs are *memento mori*.'

DERRY MOORE: *The Photographer in India*

THE PHOTOGRAPHS in this book were taken during a series of visits to India that started in early 1976. My initial idea had been to photograph some of the palaces whose days, I knew, were numbered. In the event what fascinated me was not simply the palaces themselves but also the hybrid quality of many of the lesser buildings that had been constructed since the first arrival of the British in India. A cultural osmosis was clearly discernible, that of British and European architecture on Indian buildings, and that of India and its climate, as well as its styles, on the British. In the latter instance a grandeur and a sense of space, such as are rarely seen in Britain, were frequently the outcome: rooms were higher, windows larger, corridors wider, detail more lavish; the porticoes of relatively humble houses might have been snatched from the front of the British Museum. The appearance of their inhabitants too surprised me. I had been expecting folkloric looks, whereas what I found was far more interesting – the look and atmosphere of another century.

Though I did not realize it at the time, a transformation was beginning to overtake India, a transformation effected not merely by political change, such as the revocation of the princes' rights and privileges, and thus the effective extinction of the princely states, but also by technological change. In 1976 the telephone still appeared to be in its infancy – to telephone from one part of Bombay to another could take the best part of a morning, and as for telephoning from, say, Gwalior to Lucknow, only an optimist would attempt it. Inconvenient as this might be, it had the effect of making the country even vaster. Life was more unpredictable and more surprising, and that feeling of adventure which is such a vital feature of Kipling's writings could still be sensed. Television was barely known, its homogenizing effects yet to come. Mass tourism, with its camp-follower banality, was also a virtual stranger. Anything imported was prohibitively expensive, and 'handmade' was the rule rather than the exception. The motor car – and by 1976 there were effectively only two models, both quite humble, to choose from – was a luxury rather than a necessity. Moreover, since Independence the ethos of Indian politics had been Socialism with a sympathetic tilt towards the Communism of the Soviet Union. This had created a veneer of progress beneath which a traditional way of life was carried on with no more than its customary inconveniences.

On my first visit I was extremely fortunate in the introductions I was given, in particular to Bombay and Hyderabad. It was the latter which evoked a feeling of entering another age. Hyderabad was a Muslim state, whose ruler, the Nizam, had in the early eighteenth century been the Mogul emperor's viceroy in the Deccan, until he established himself as an independent ruler. It was the largest princely state in India (an area the size of France) and before the Second World War it had had its own coinage. In 1947, after Indian Independence, the seventh (and last ruling) Nizam attempted to retain Hyderabad's own independence from the Indian government with disastrous consequences. By 1976 the state was a shadow of what it had once been. However, it was still just possible to find traces of its former glory, albeit in poignant circumstances. A friend of mine was married at the time to the present Nizam and I was her guest, although neither she nor her husband were in residence during my visit. I was driven

around in an enormous 1950s Cadillac accompanied by an ADC, a well-known nawab. One day I astonished him by announcing that I would like to go for a walk in the palace grounds; he evidently thought I was mad. Undeterred I set off past saluting sentries into the thorny and rocky wilderness that constituted the palace grounds. After a couple of minutes I heard a crunch on the gravel behind me; it was the Cadillac, sent to follow me in case I became tired. I abandoned the walk.

Lucknow, the capital of Oudh was, like Hyderabad, Urdu-speaking. Both places had been large enough to have a nobility that was not directly related to the ruler and both had a courtly tradition and had known a period of graceful and cultured life far removed from the twentieth century. Lucknow in particular had been renowned for its poetry, its music and its food. Nothing could have been further from the fanaticism and intolerance of Islamic fundamentalism. In Lucknow I visited a house cared for by an elderly and highly distinguished looking *chokidar* or watchman; he was, I discovered, a direct descendant of the last king of Oudh who had been deposed by the British when they annexed the kingdom just prior to the Mutiny in 1857. In 1976 both Lucknow and Hyderabad were relatively contained and there was a definite point at which each city ended and open country began – in the case of Hyderabad a landscape littered with rocks reminiscent of the island of the Gogottes.

I visited Calcutta a year after my first journey to India, apprehensive of finding a city of the dead and the dying such as had been described with relish and righteous indignation by many a journalist. What I had not realized was that Bengal (of which Calcutta was the capital) had the finest tradition of literature and learning in the subcontinent. Nirad Chaudhuri describes how, as a child brought up in a remote village in Bengal, he was familiar with all of Shakespeare and with much of Dickens. I was taken to a theatre in Calcutta where a performance of Turgenev's play, *A Poor Gentleman*, was being given in Bengali. Not speaking a word of that language, I was fortunate to be accompanied by someone who could translate for me. The play was transposed to Bengal in the 1960s and was the most remarkable performance of a Russian play that I have ever seen, the similarity between life in nineteenth-century Russia

and that in India prior to the 1970s being very marked. There were still landowners with dozens of servants and retainers, landowners who frequently had poor relations living with them. And there were an increasing number of Lopakins waiting to cut down the cherry orchards.

Another surprise in Calcutta was its architecture: apart from the buildings of British India, there was a host of houses that had been built in the last century by wealthy Bengalis, nearly all crammed into the narrow streets of North Calcutta. These buildings had gardens or large inner courtyards, or both, and generally boasted an assortment of columns and statuary. By 1977 all, except the Marble Palace, were in various states of advanced decay. In the absence of the rule of primogeniture they were shared by an ever-increasing number of descendants, none of whom were willing or able to accept financial responsibility for their upkeep and maintenance. In addition to this, the owners were frequently subjected to petty forms of persecution by government officials resentful of what they perceived to be relics of the bad old days. The Bengal climate, the enemy of plasterwork, paint and bricks, having been allowed to perform its work of destruction relatively unmolested, now seemed to pause and leave the buildings supported by their own decay.

While in Calcutta, a friend mentioned the city of Murshidabad on many occasions, until it assumed an almost mythical significance for me. In the eighteenth century, until the arrival of the British, Murshidabad had been the most important city in Bengal, the Nawab of Murshidabad enjoying the same status in the region as the Nizam of Hyderabad in the Deccan. The city is situated near Plassey where in 1757 the British under Clive defeated the French and the forces of the Nawab of Murshidabad, Mir Jafar, in a battle that established the supremacy of the British in India. The railway never reached Murshidabad – a deliberate omission, according to my Calcuttan friend, calculated to destroy the city's importance. The journey which I eventually made involved a day's bumpy drive at the end of which I reached a city which was a ghost of its former self. There I found an assortment of palaces all in varying states of neglect and with little sign of habitation apart from the occasional watchman. One palace

in particular caught my attention; it was not that of the Nawab – indeed it did not appear to have a name – but it had apparently been built by a Hindu grandee. Situated on the edge of a tank, or lake, and surrounded by palm trees, it was like a Renaissance palazzo uprooted and replanted in Bengal.

Madras, as a city, was a disappointment, for by 1976 it was already fast becoming an industrial centre. My visit was redeemed by an important introduction – to Subulaksmi, the most famous singer in India, and her husband T.S. Sadasivam, a distinguished and devout Brahmin, who had been very close to the grandees of the Congress Party before Independence. Subulaksmi was to give a concert a few days later and both she and her husband were very keen that I should be there. Much as I wanted to attend I was reluctant to spend four inactive days in Madras, and they therefore arranged for me to visit Madurai and Tanjore. Having recently come from the city of Hyderabad, where I had been amongst Muslims who were very much of the *ancien régime*, it was a shock to be plunged into an orthodox Hindu world.

The temple at Madurai, according to *Murray's Handbook* of 1937, is probably the most interesting Hindu shrine in India, giving one the most complete idea of Hindu ritual. Murray's recommendation that it should be visited at night as well as in the daytime, 'the dark corridors with a lamp gleaming here and there being peculiarly ghostly', still applies. The temple, practically a self-contained world, is built in the shape of a parallelogram and contains a series of huge corridors and courtyards, those nearer to the centre being progressively more holy. In the outer corridors are vendors and shops, areas that seem to be practically dormitories for pilgrims, a stable for the temple elephant, and quarters for the priests. To me, it felt like walking into a temple in the Old Testament.

Of the places I visited in Rajasthan, the most interesting was probably Bikaner. It did not have the obvious attractions of, say, Jaipur or Udaipur, which so appeal to the tourist, but for that very reason it had remained relatively unaffected by the modern world. There were two curiosities which particularly caught my attention: one, the camel farm, and the other, a temple where rats are treated with love and

respect – it is believed that the inhabitants of the city are reincarnated as rats – an interesting variation on the story of the Pied Piper.

It was in Bombay that I first heard that sound which evokes India more than any other, the cawing of the crows, 'the dustmen of India'. In the daytime it is never absent, whether in town or country. It was in Bombay too that I first saw the houses that intrigued and surprised me so much. Built mainly in the last century and in the early years of this, they were European in style, but European with a difference, their walls a riot of decorative detail that eschewed any bare surface. The effect was not dissimilar to that achieved on Indian temples and temple carts. They displayed too those architectural features necessary to buildings in the tropics, in particular the extravagant window surrounds designed to afford extra protection in the monsoon. In 1976, despite Bombay's move towards its incarnation as another Hong Kong, quite a number of these houses survived, and on Malabar Hill there were still a few of the great Parsee mansions standing.

The Parsee community more than any other has been responsible for Bombay's reputation as a city of tolerance, culture and humanity. Charity and good works are an intrinsic element of the Parsee religion and its fruits are manifest in Bombay in hospitals, in the university, in art schools, in museums, in fact in everything that goes to make a city not just a place of employment and business but one of true civilization as well. A glance at the section on Bombay in an old Murray guidebook will reveal to what extent this is true. Virtually every major institution in the city owes its existence to Parsee largesse.

With the immense increase in population that has taken place in Indian cities over the past fifty years, and with the huge influx of people from the countryside, the essence of the cities and that which gave them their individuality has been diluted, frequently to the point of invisibility. It was for this reason that I felt the urgency of recording what remained.

THE PHOTOGRAPHS

The photographs are presented full page without margins or captions and in no geographical
or logical order. They have been selected both for their visual impact and to capture
the spirit and atmosphere of the India that Derry Moore experienced.
The captions appear at the end of the book.

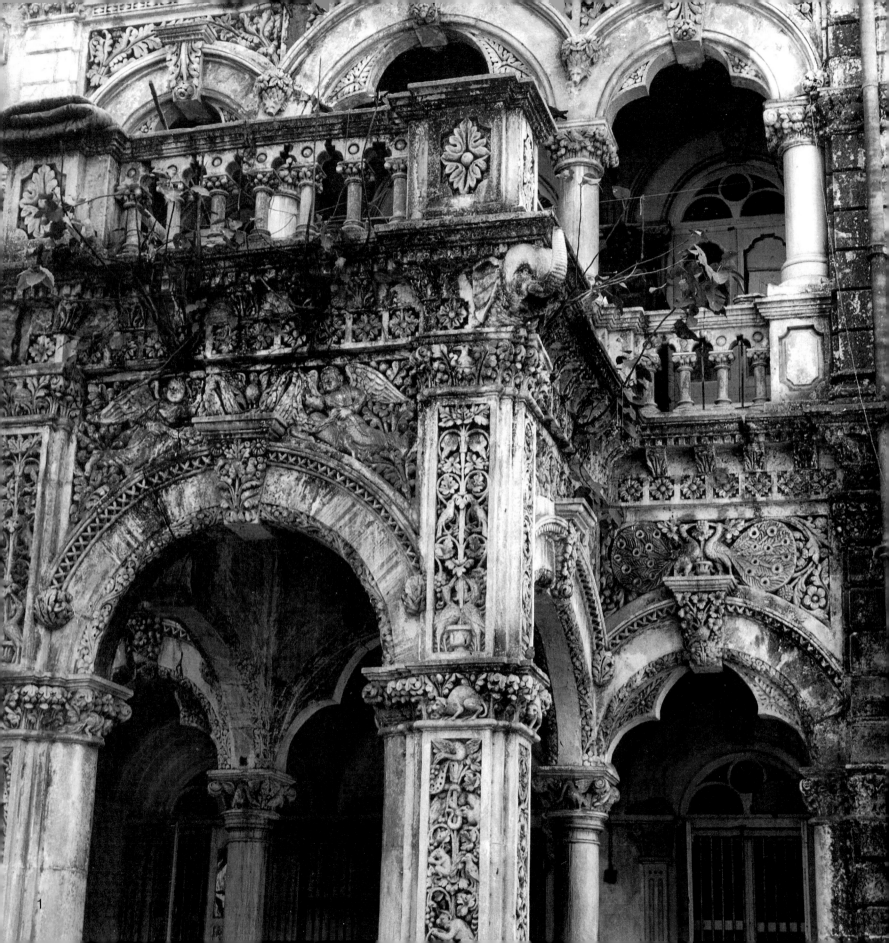

1

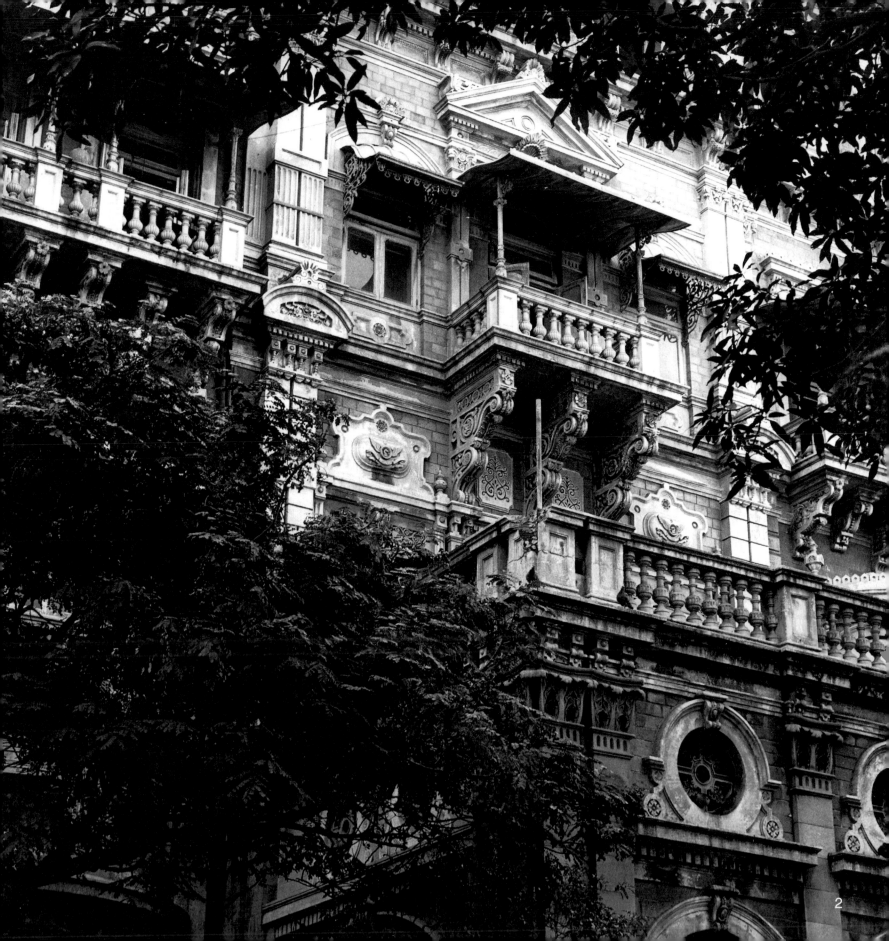

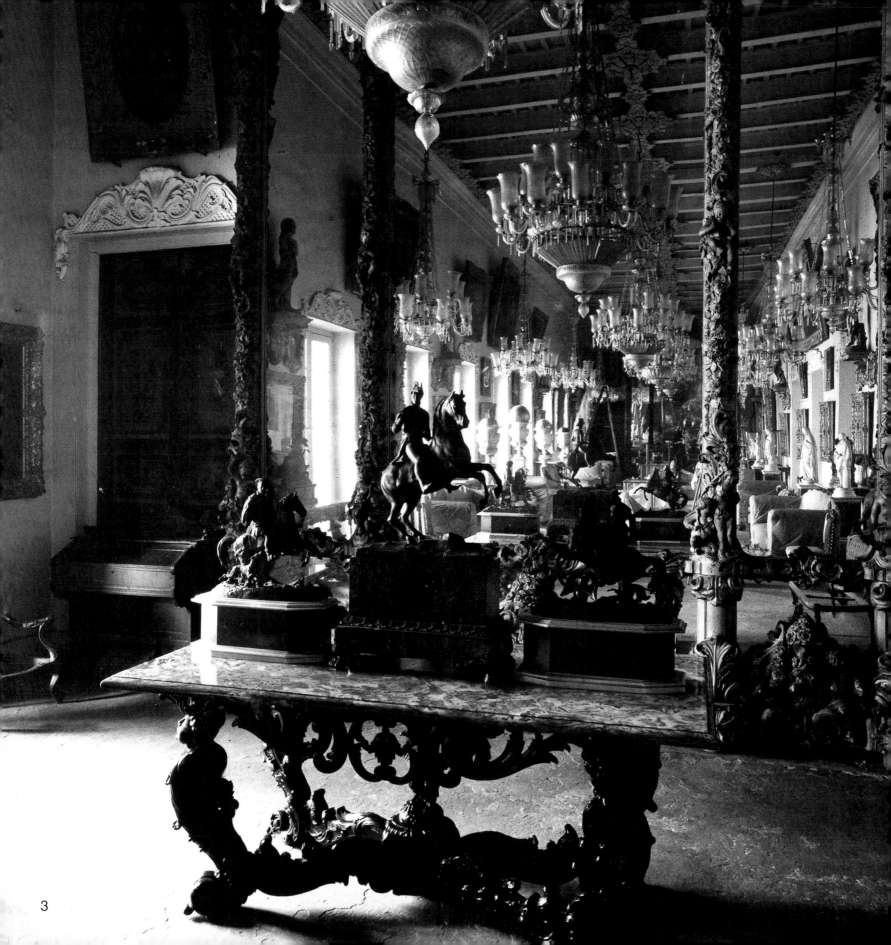

3

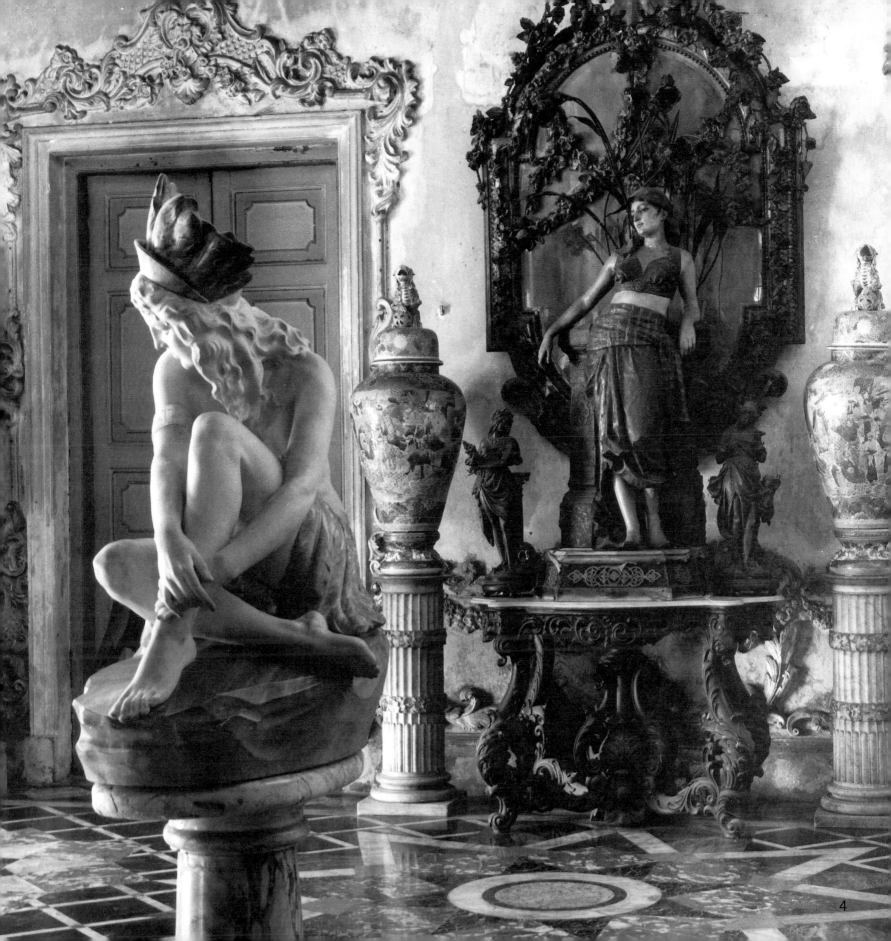

4

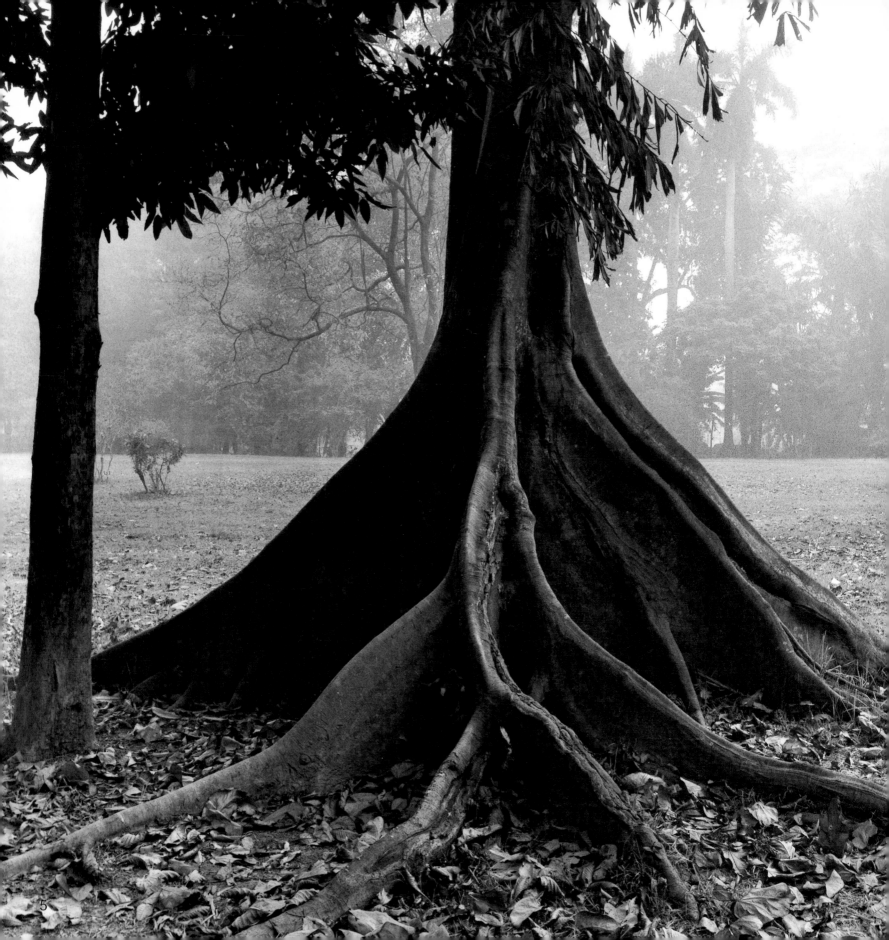

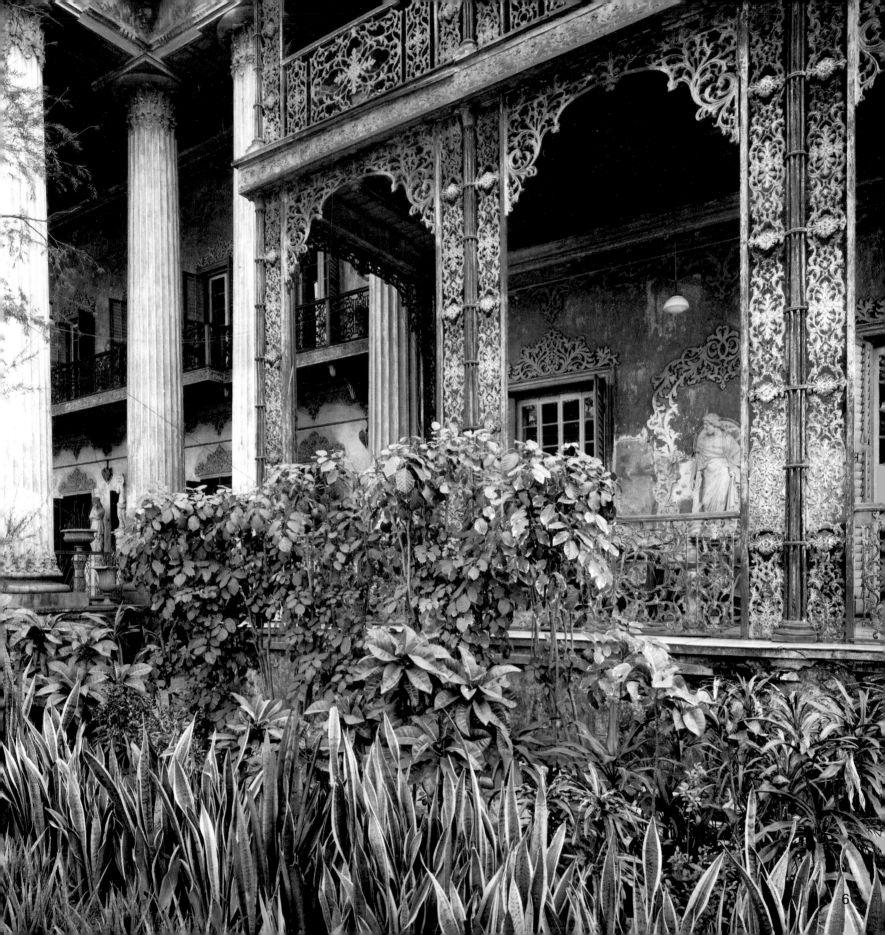

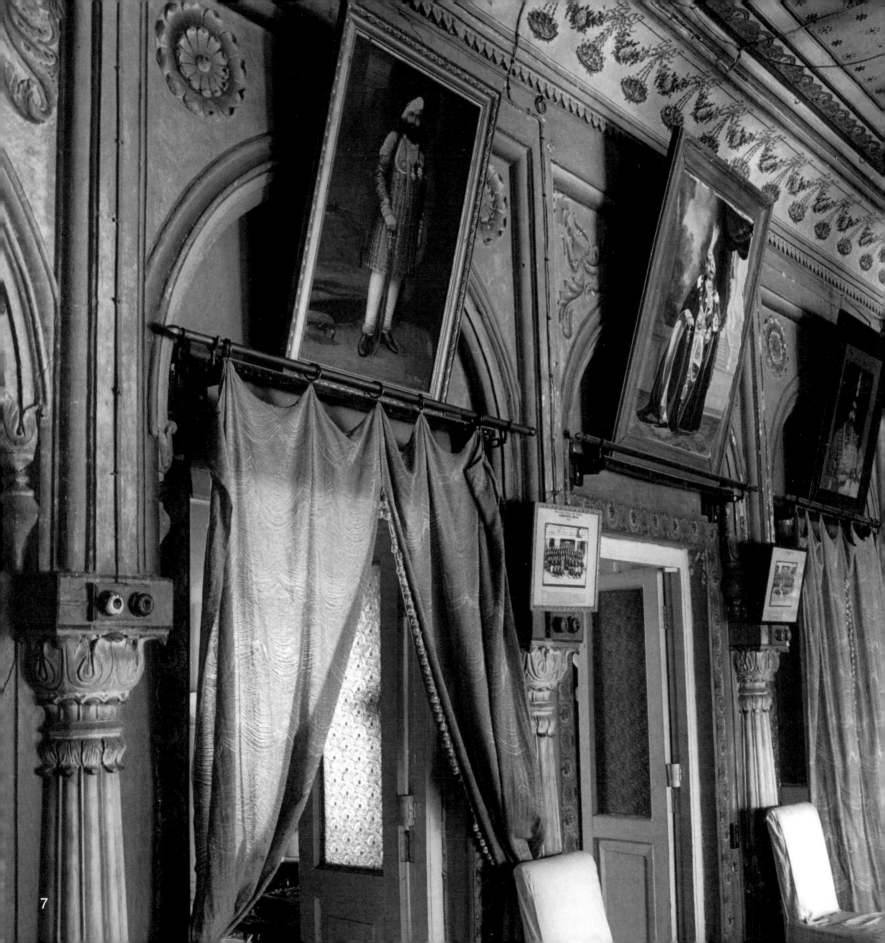

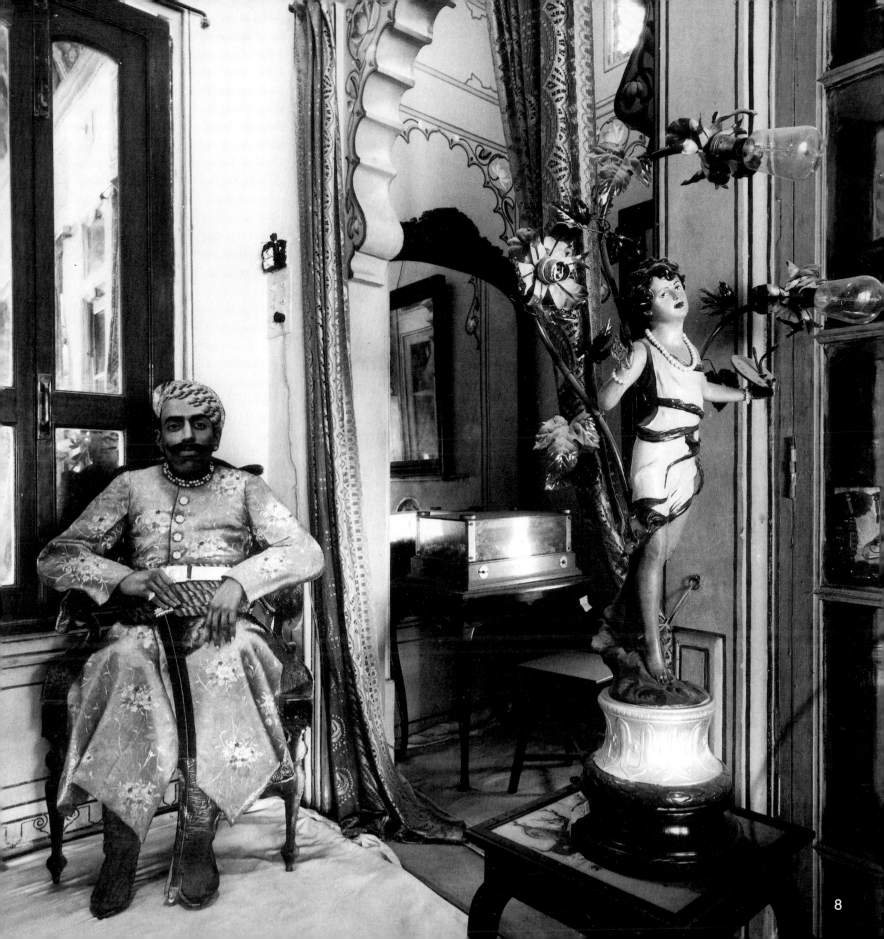

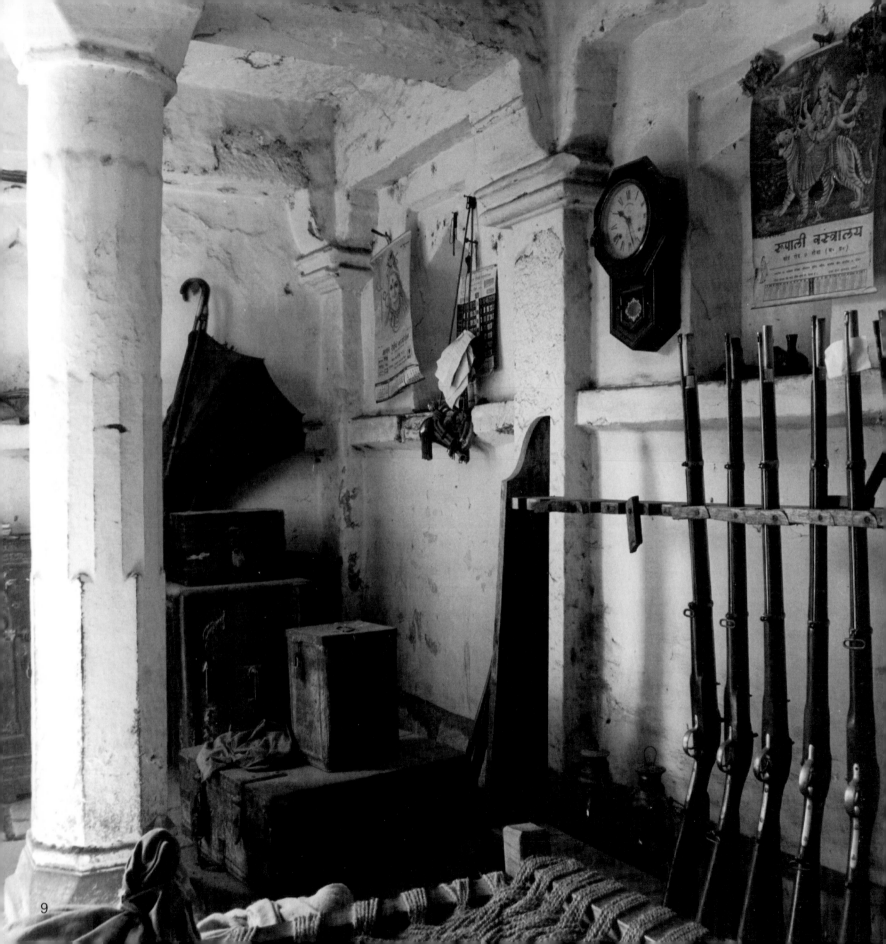

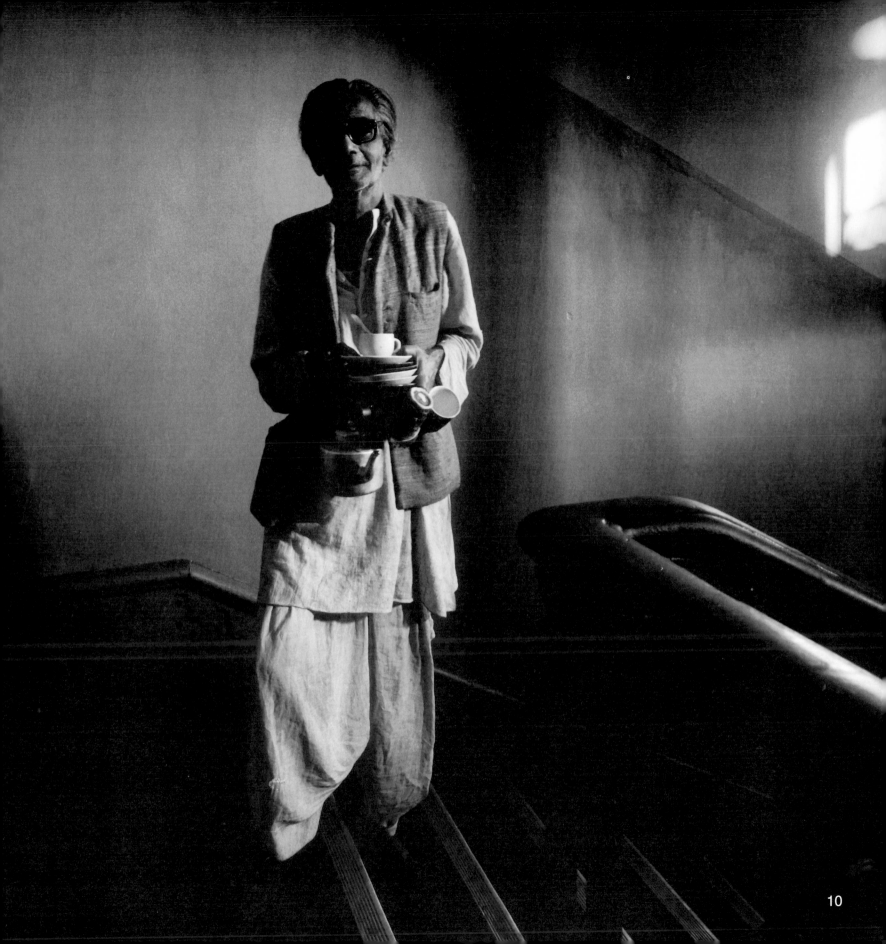

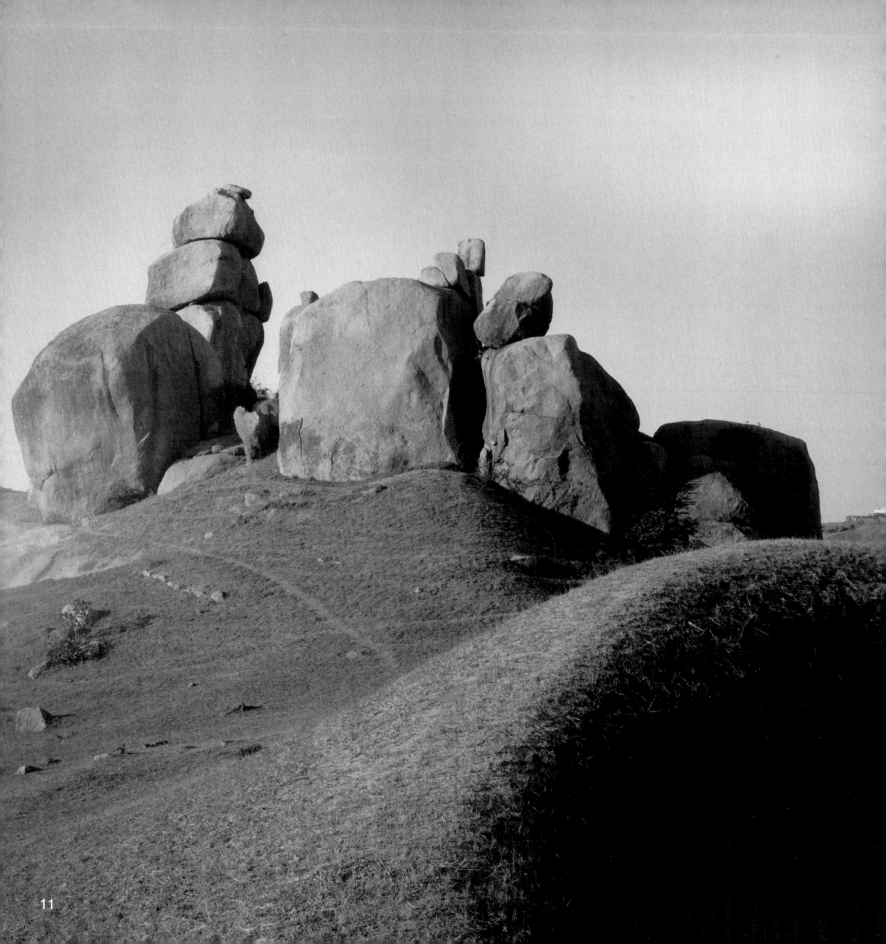

11

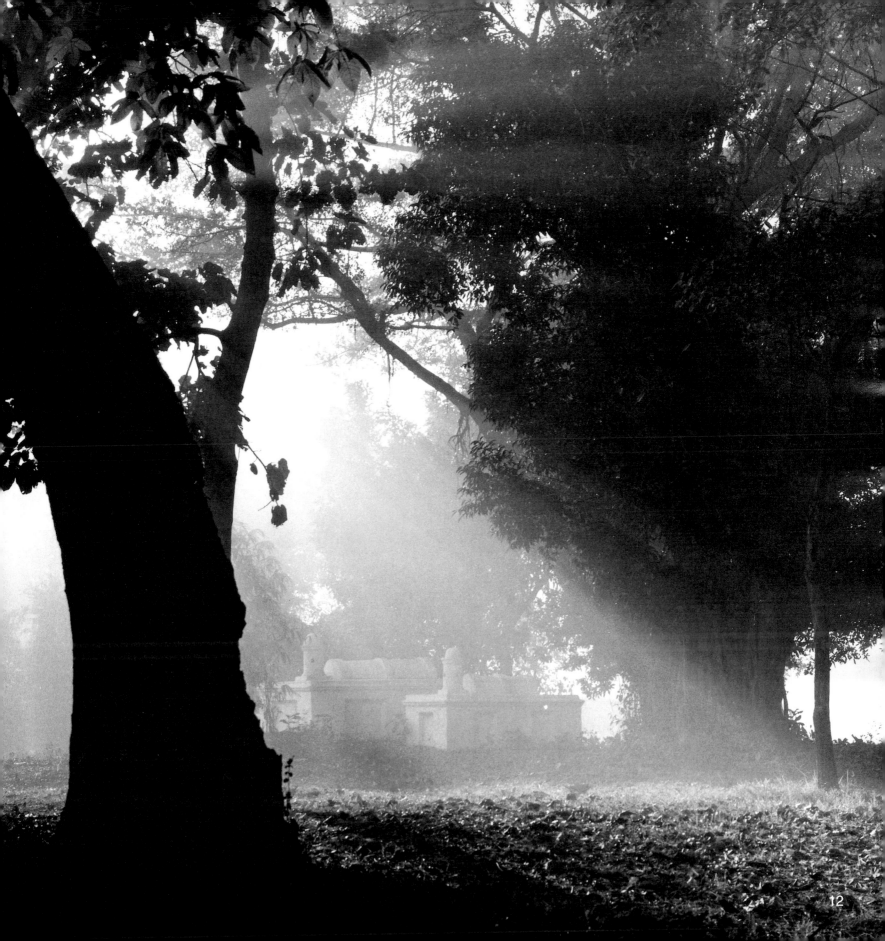

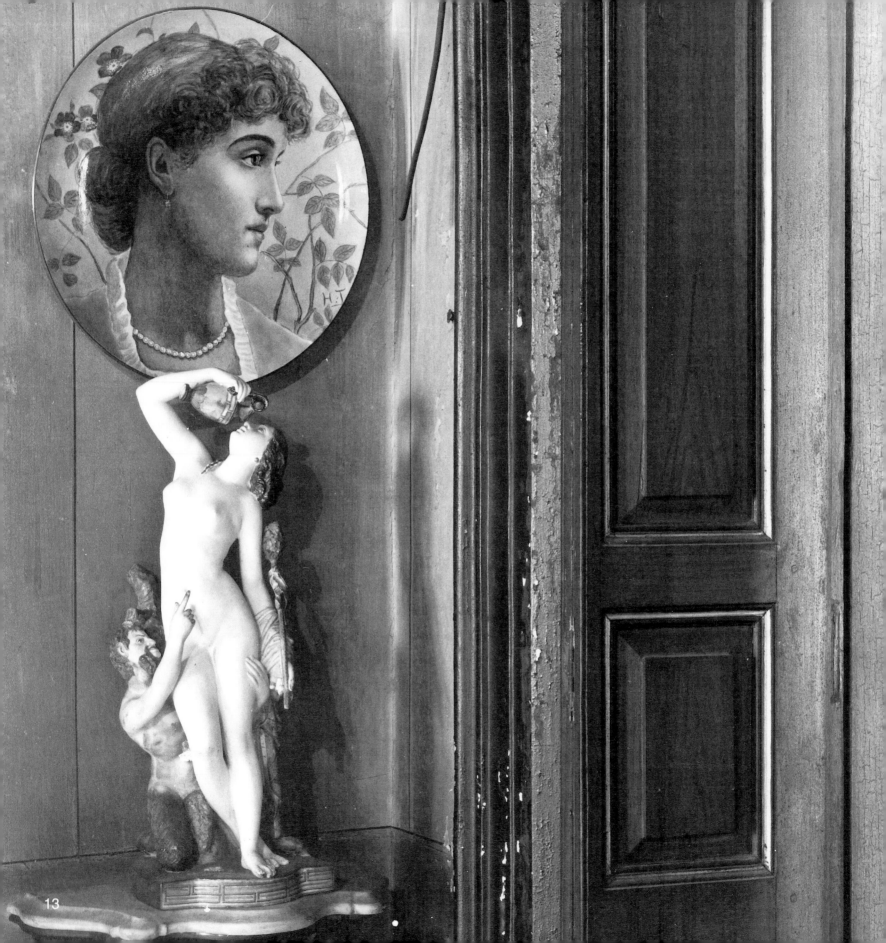

13

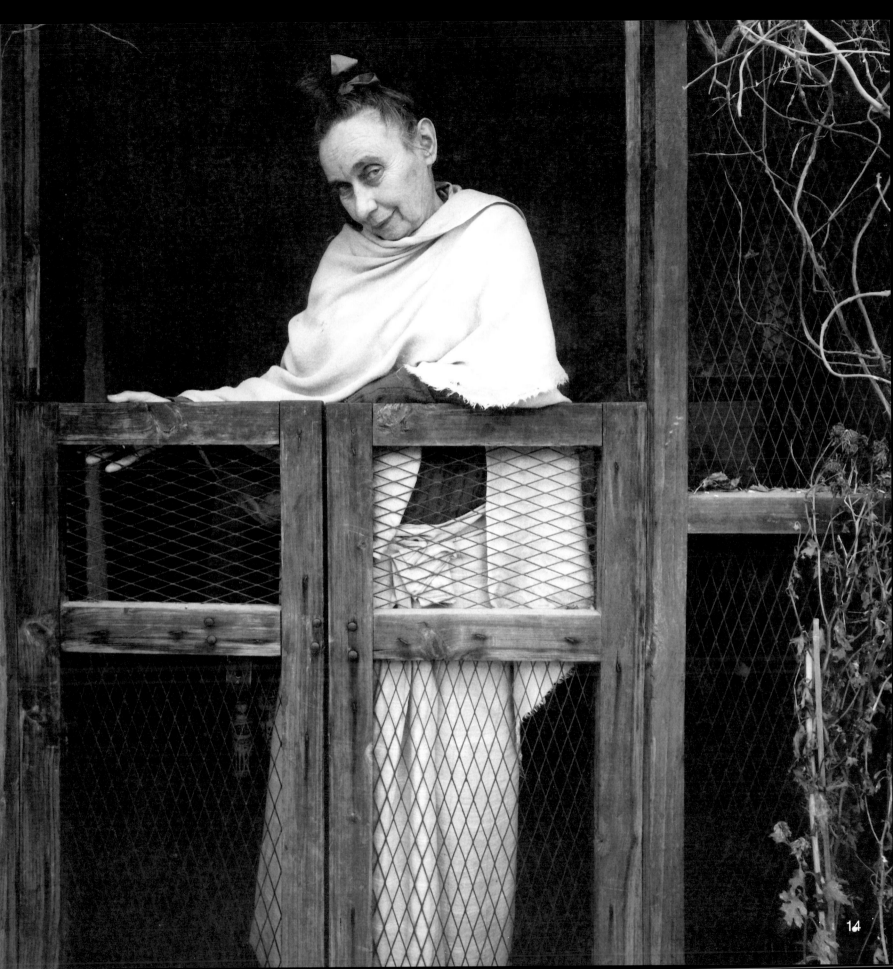

14

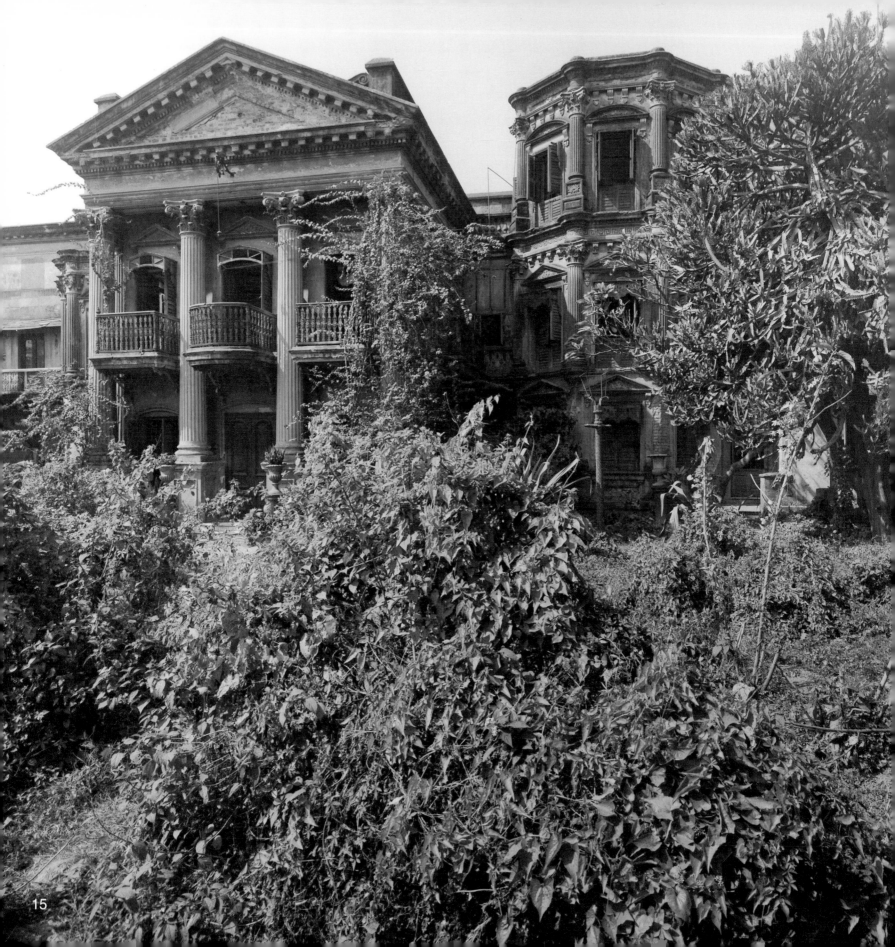

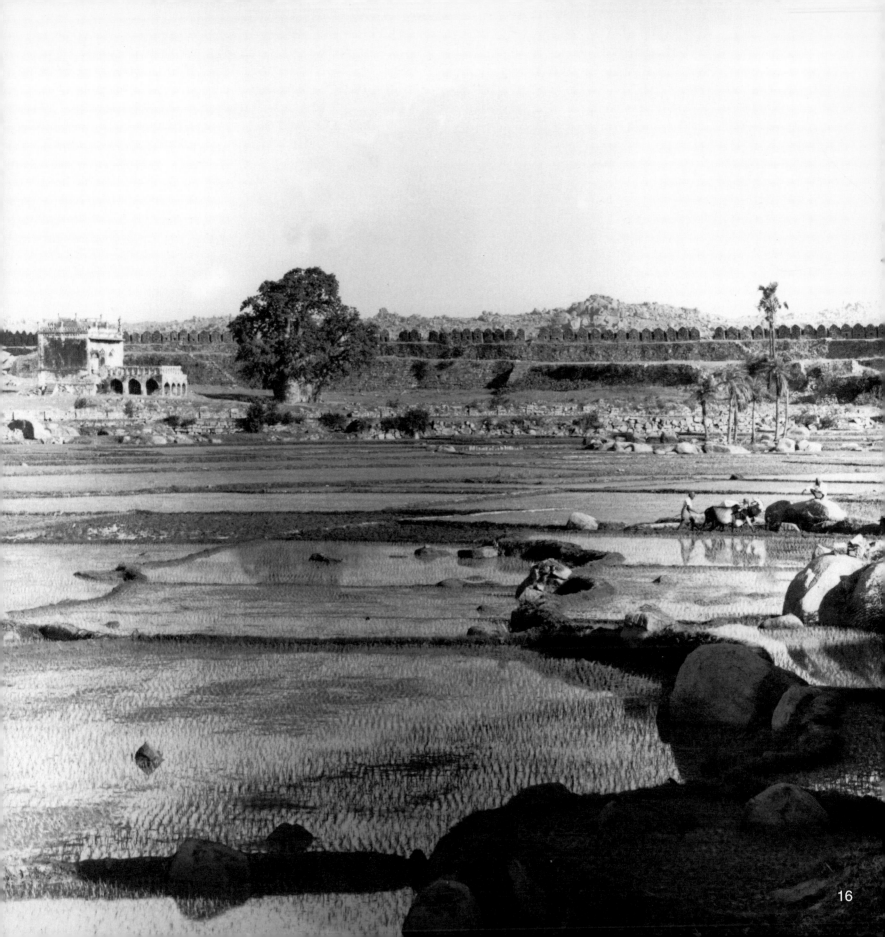

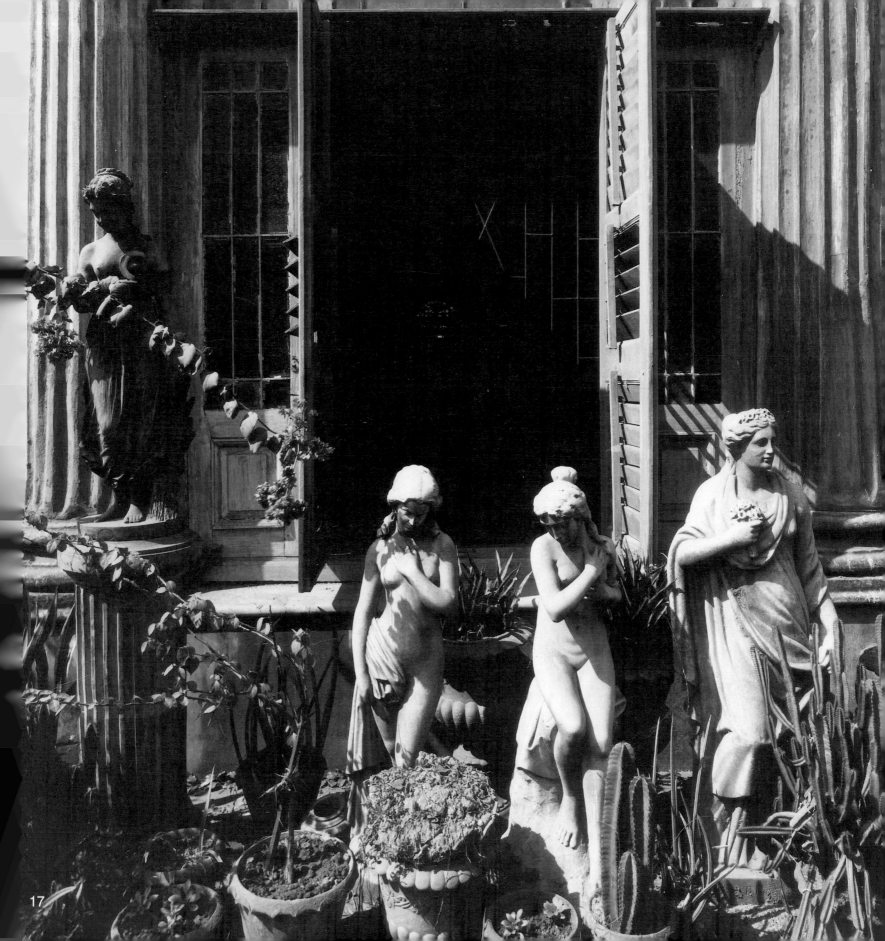

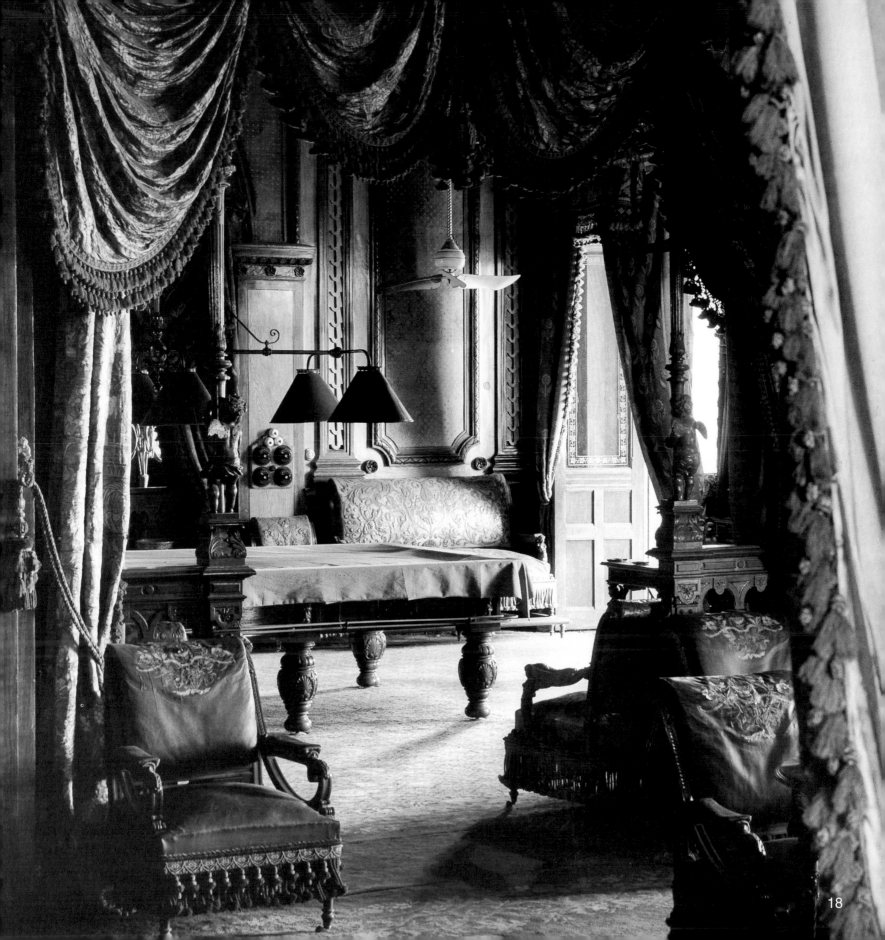

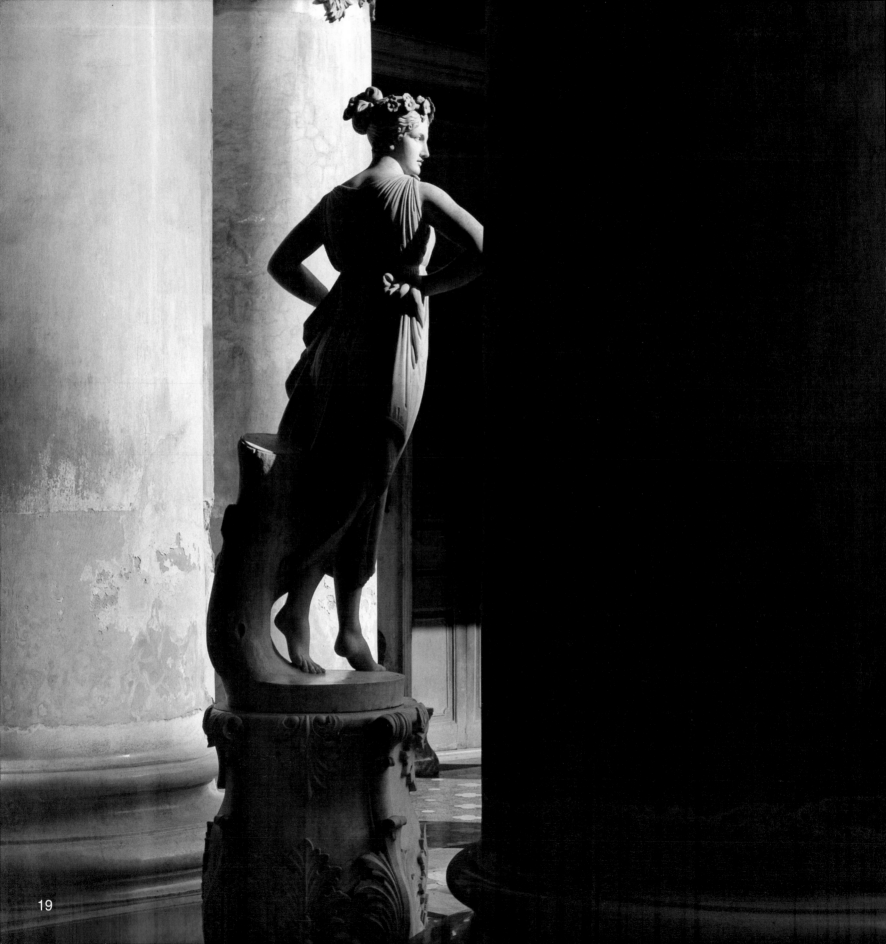

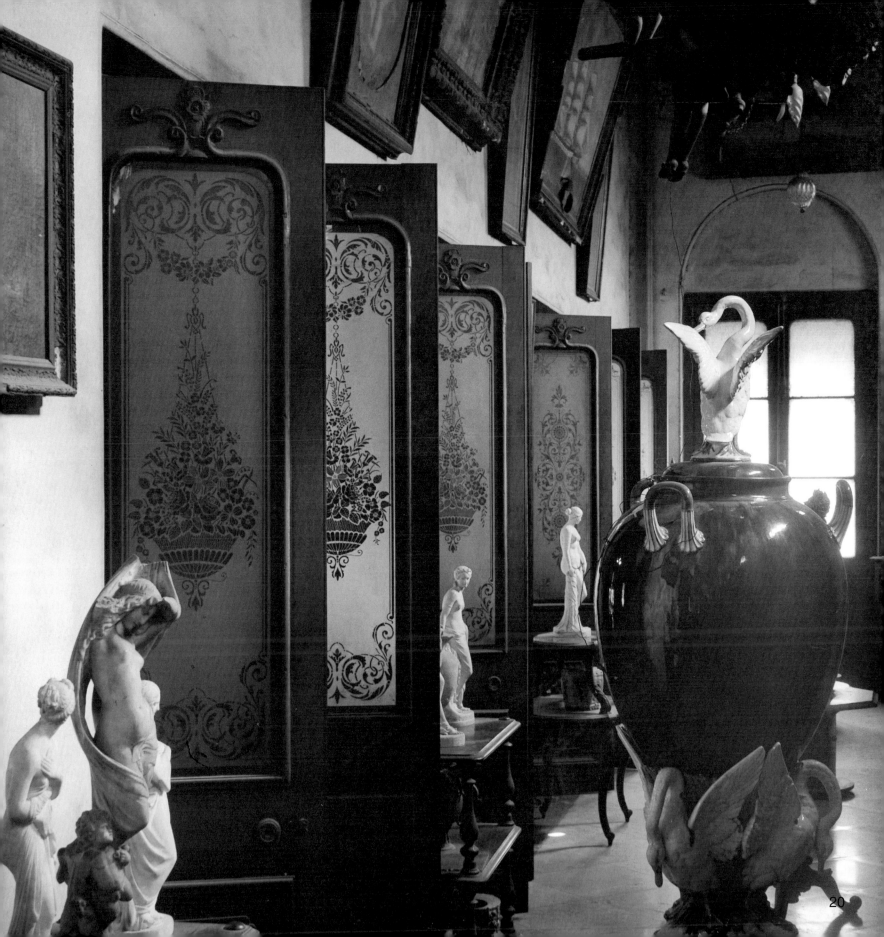

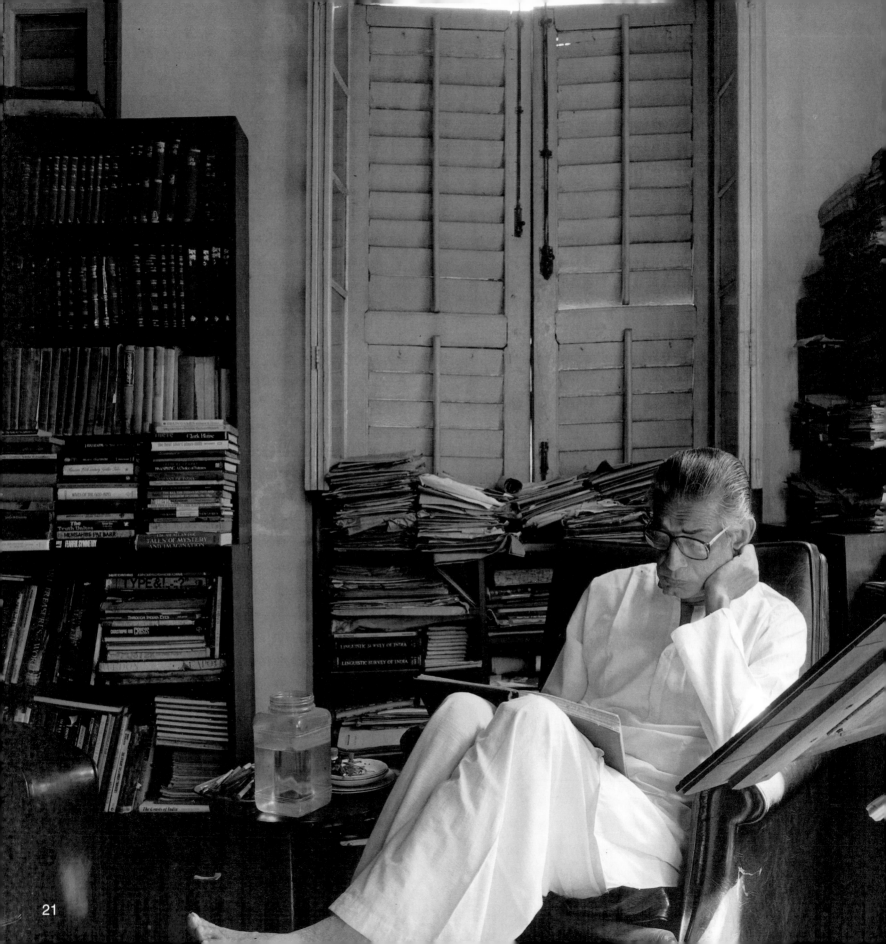

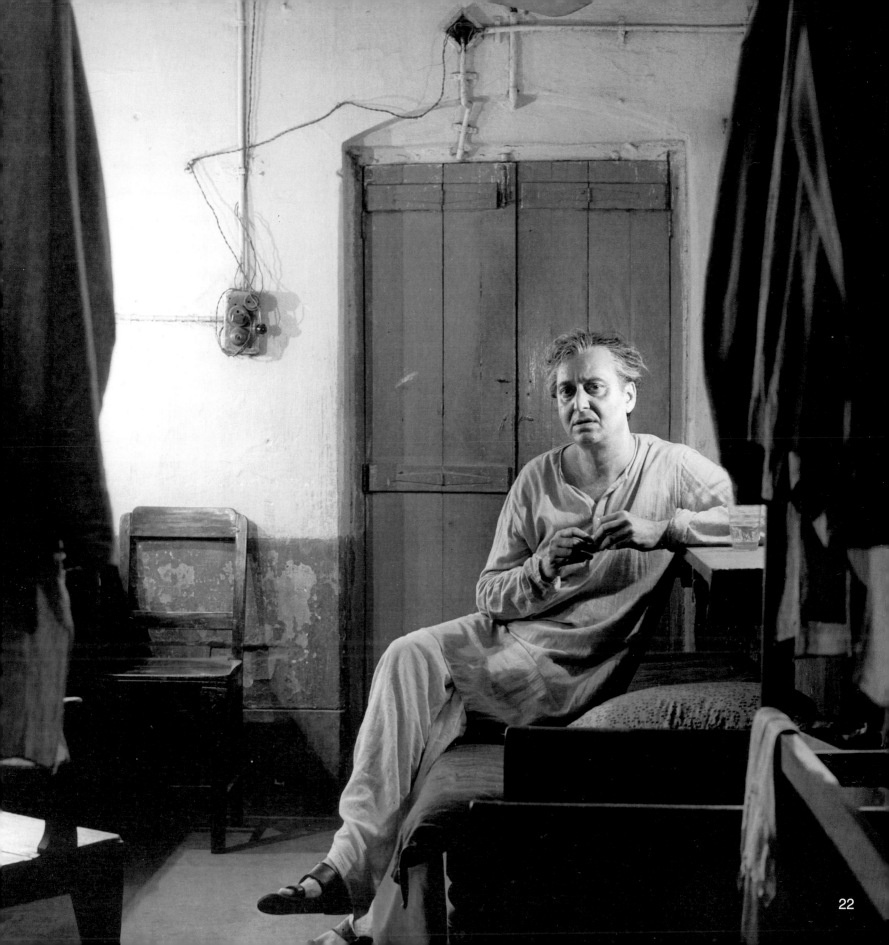

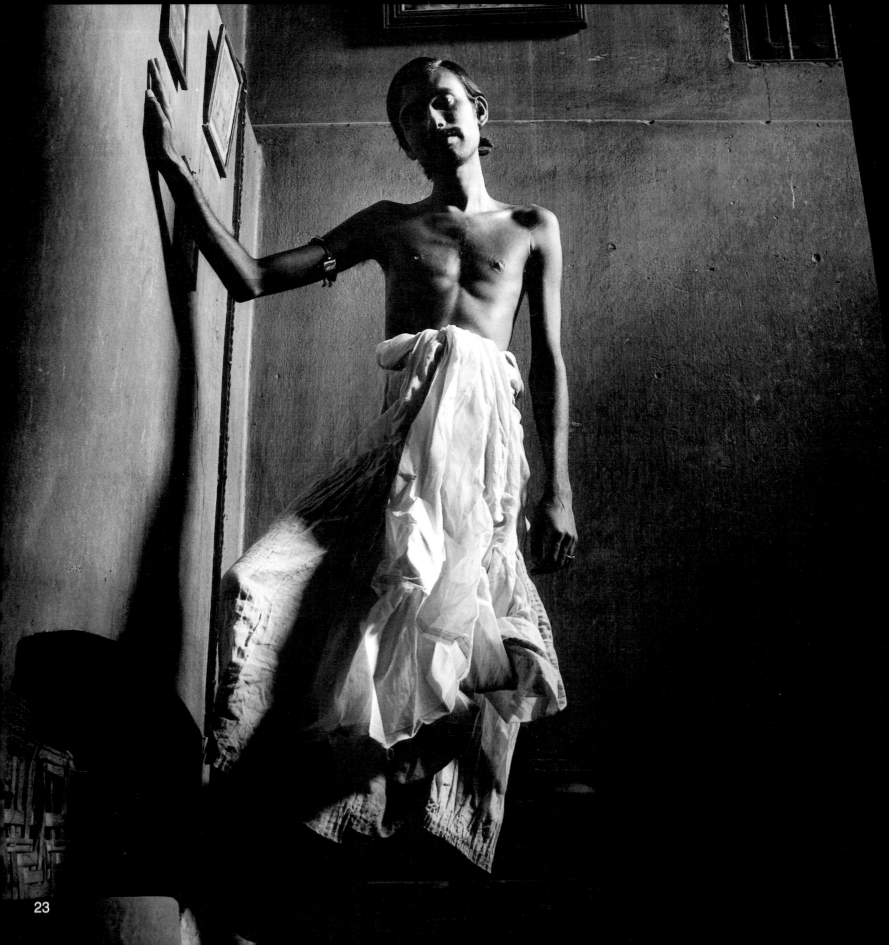

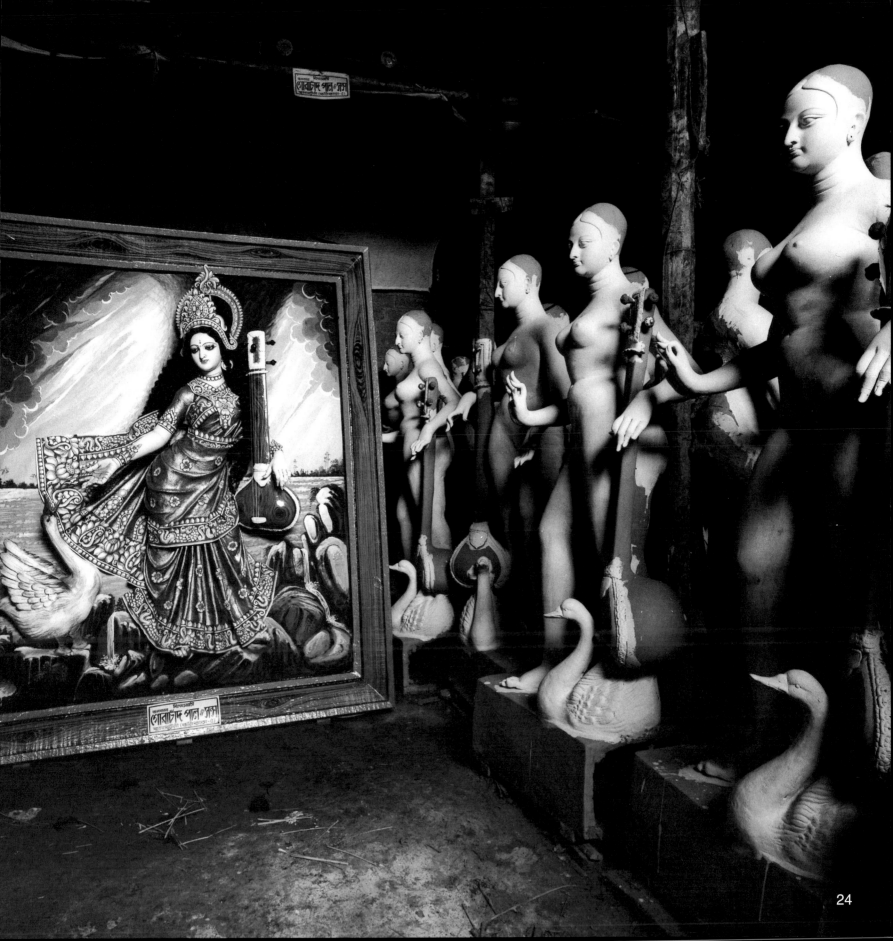

24

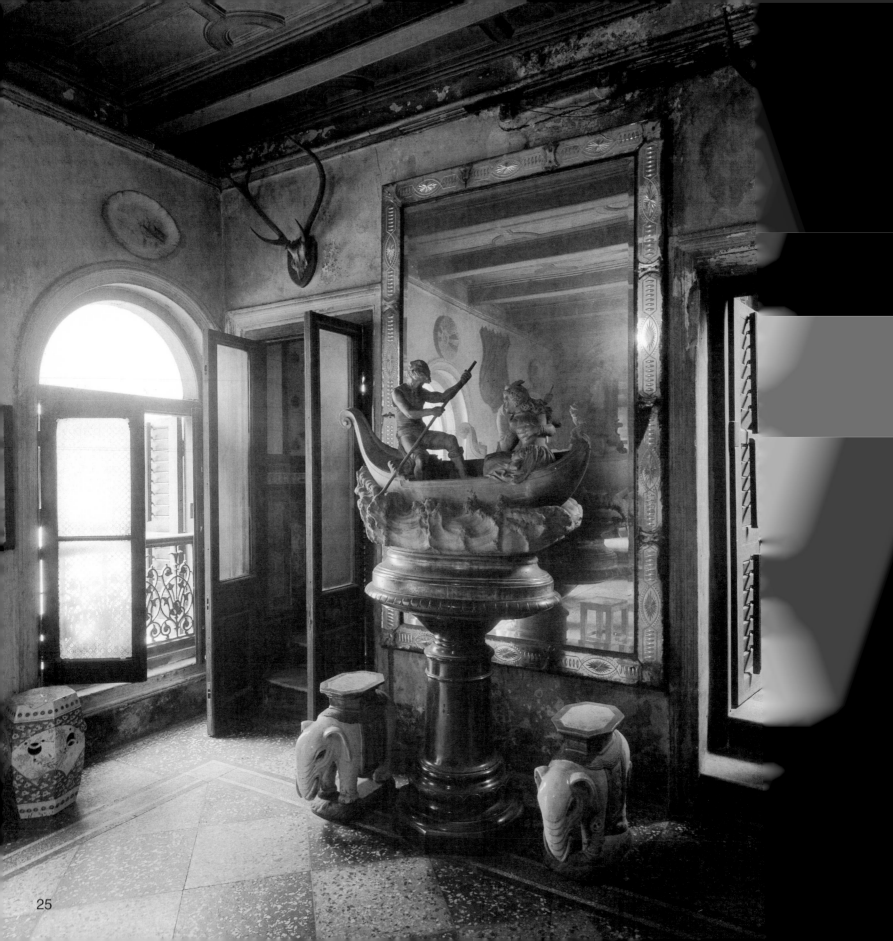

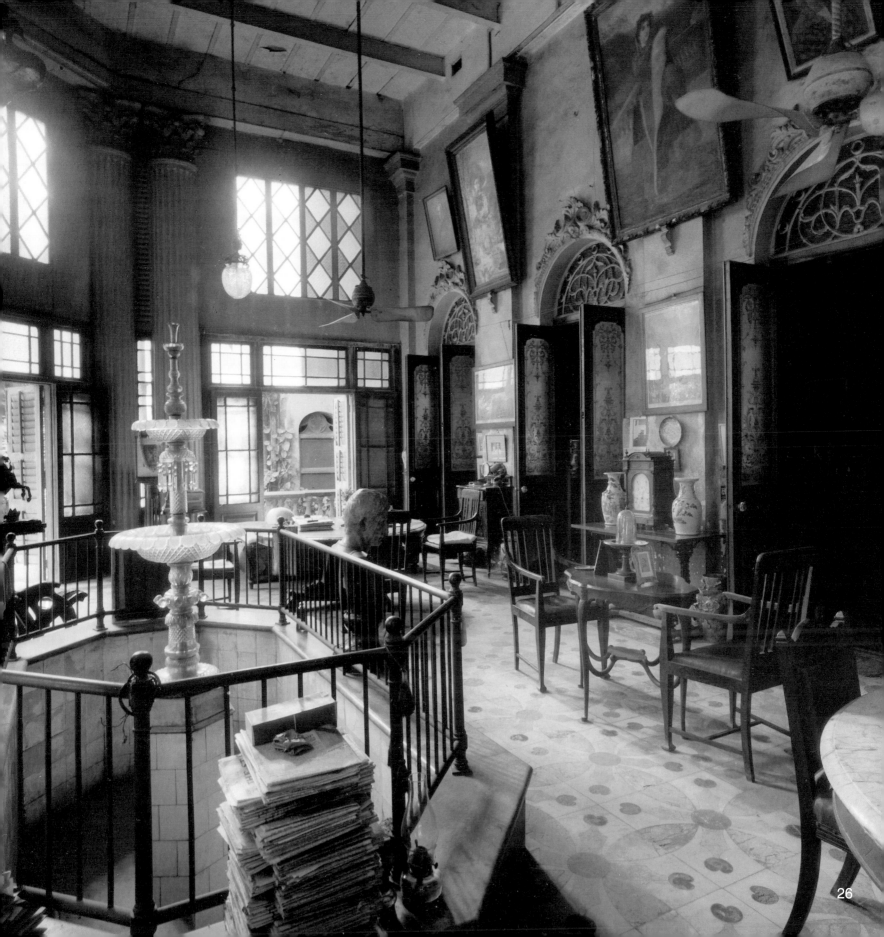

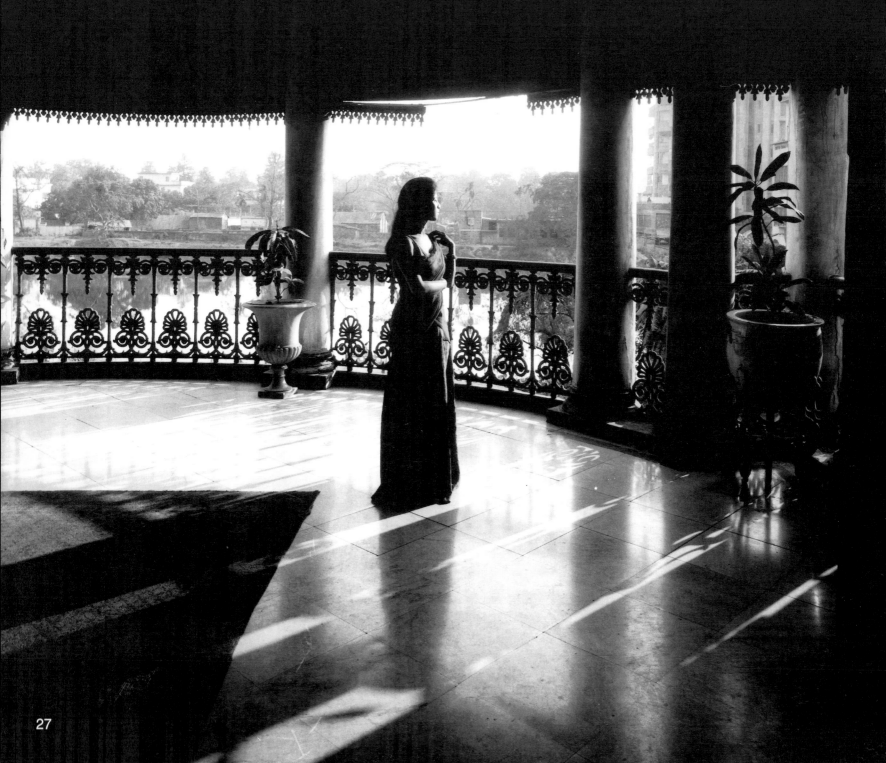

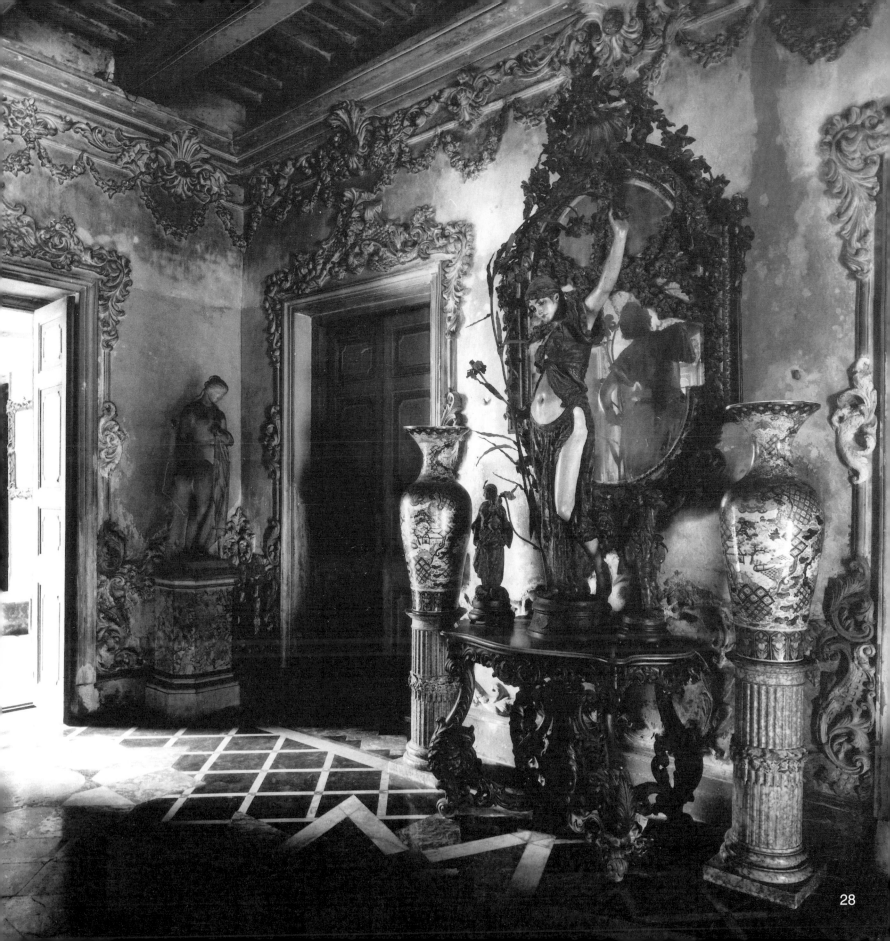

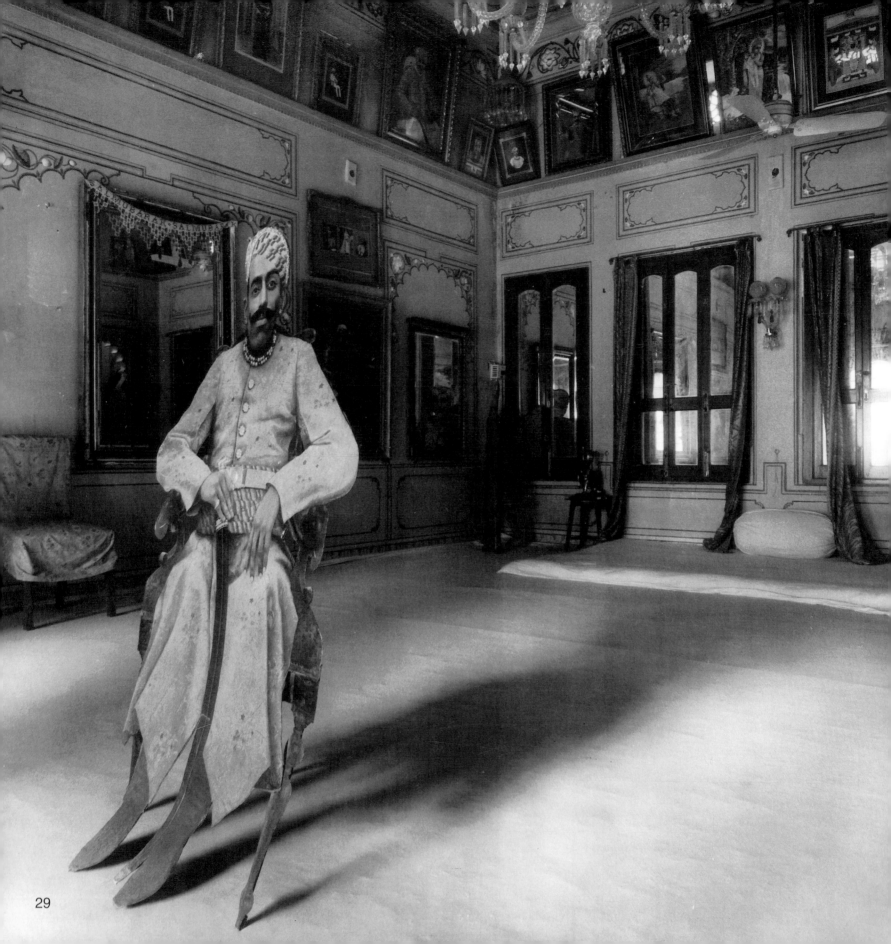

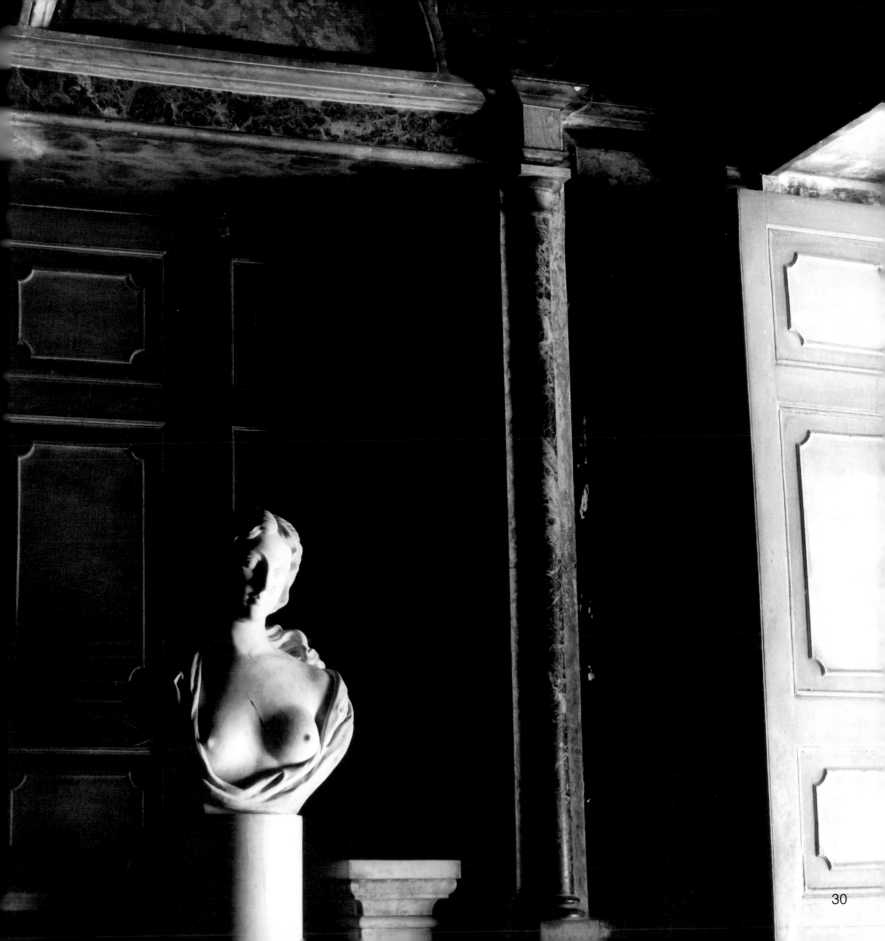

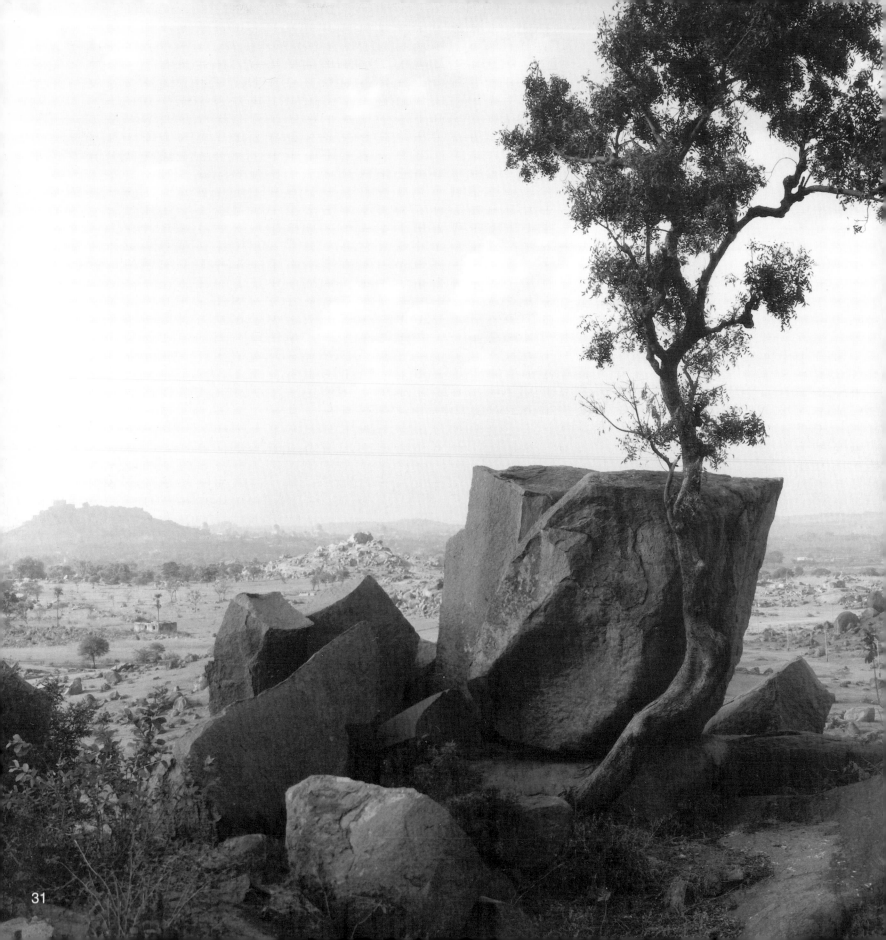

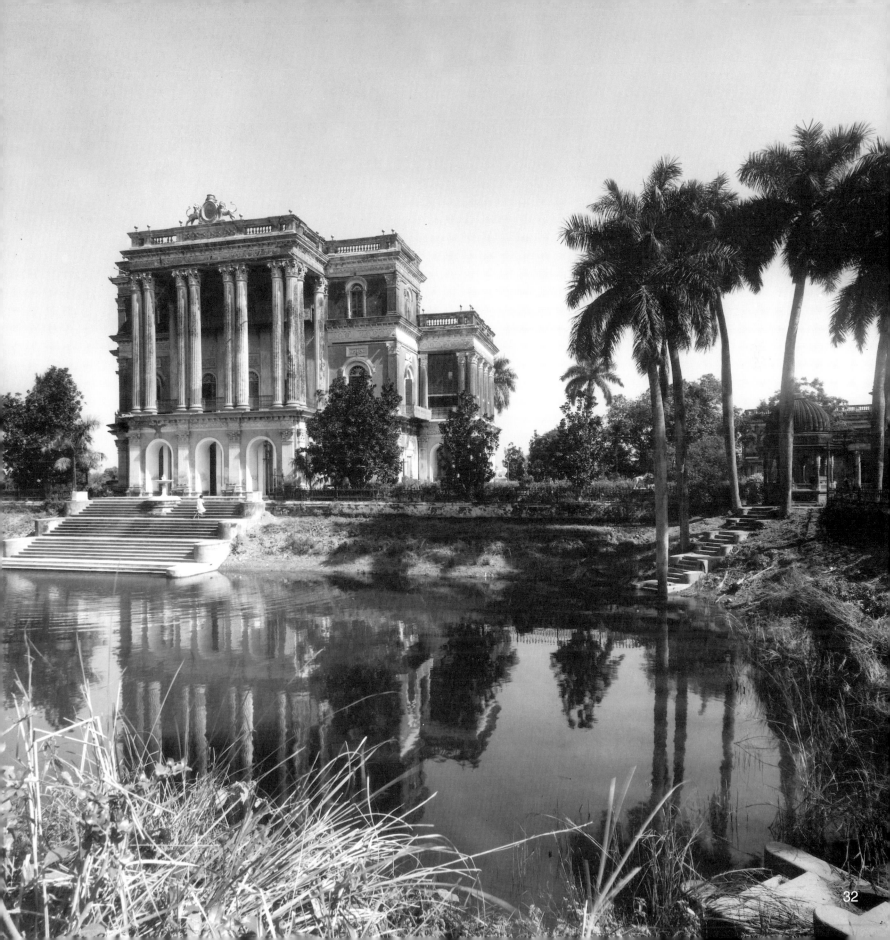

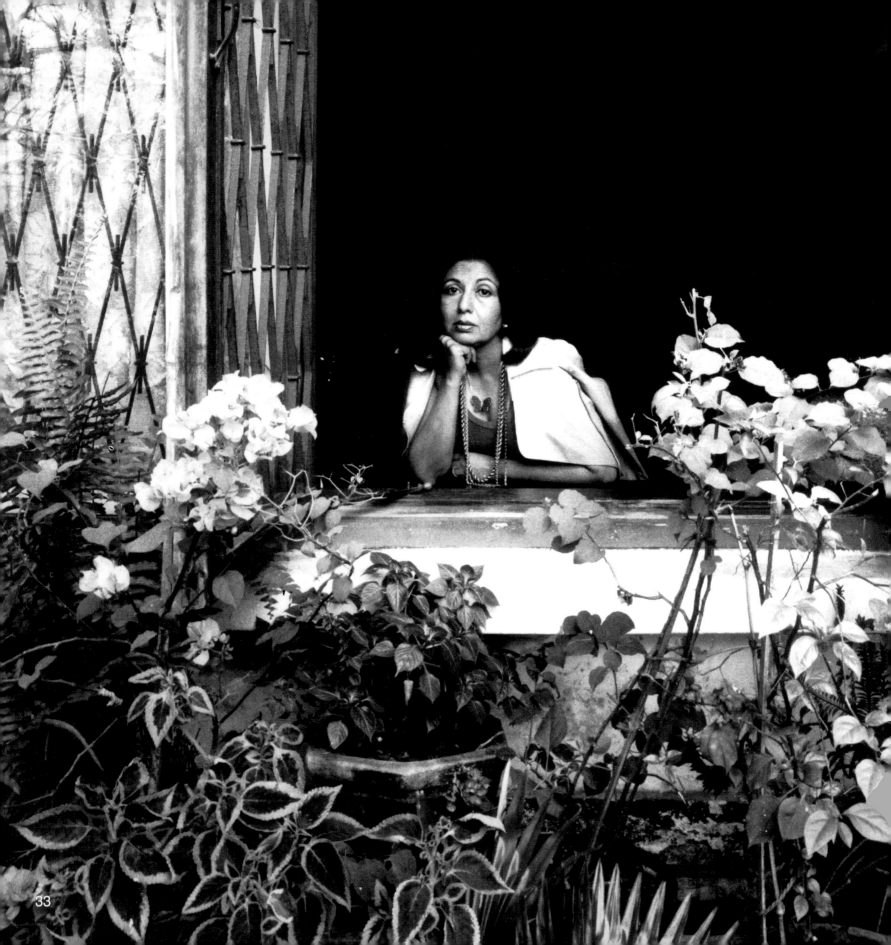

33

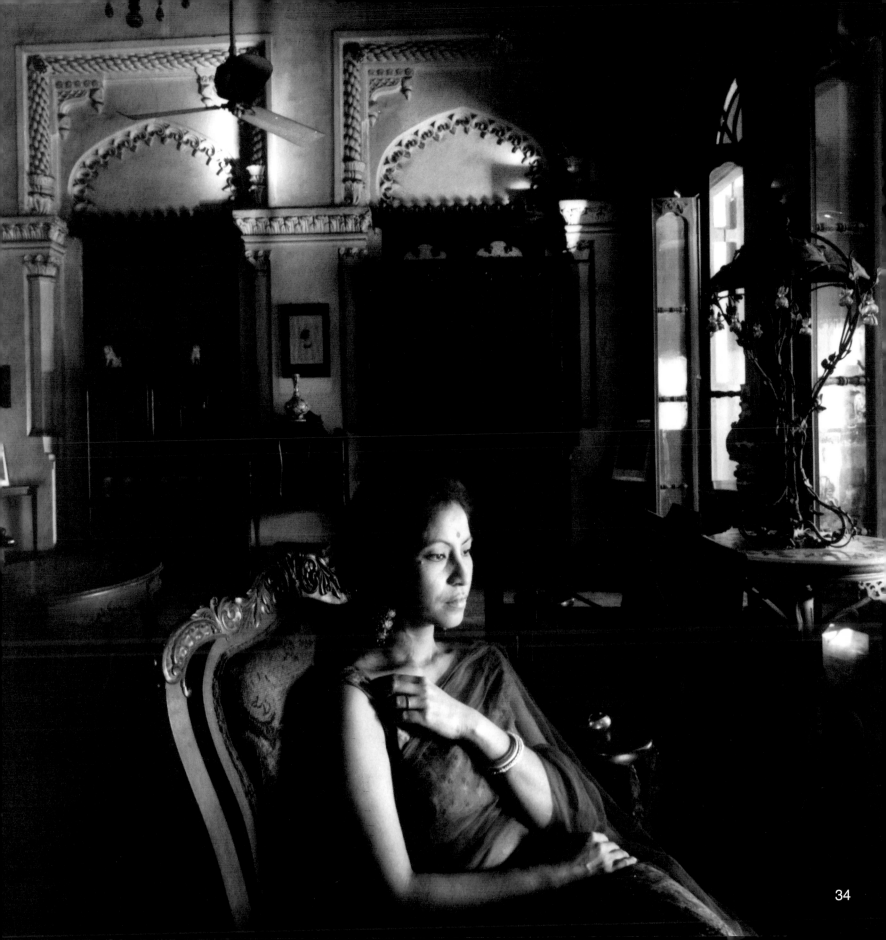

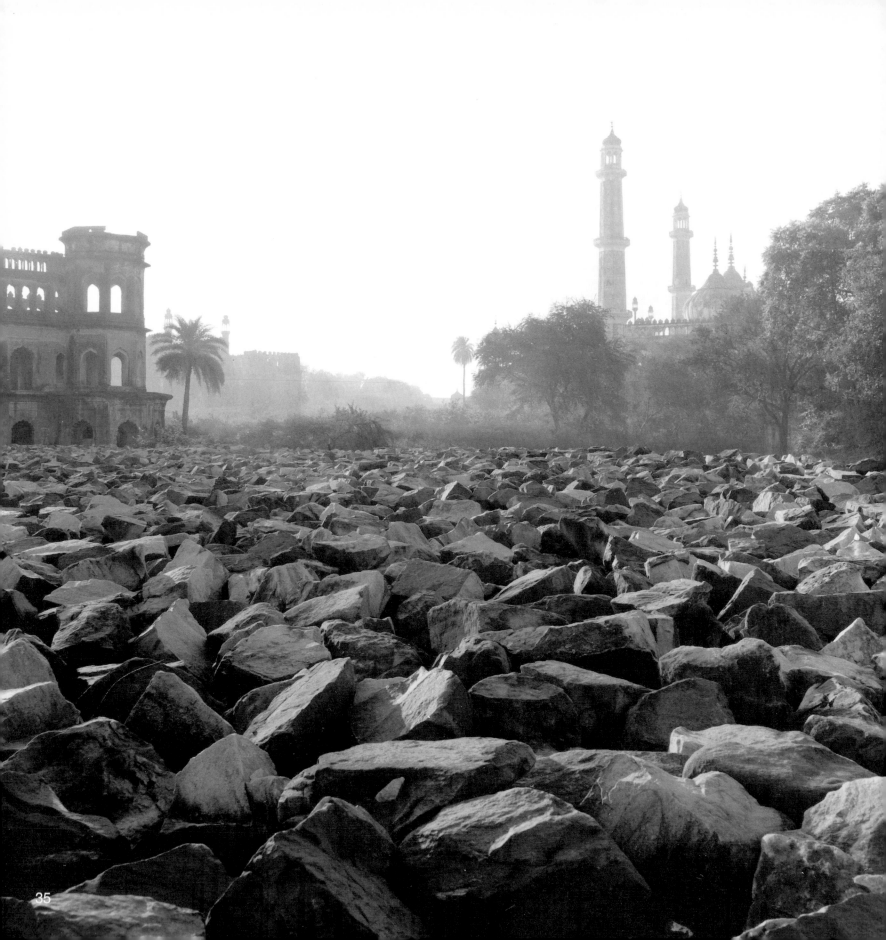

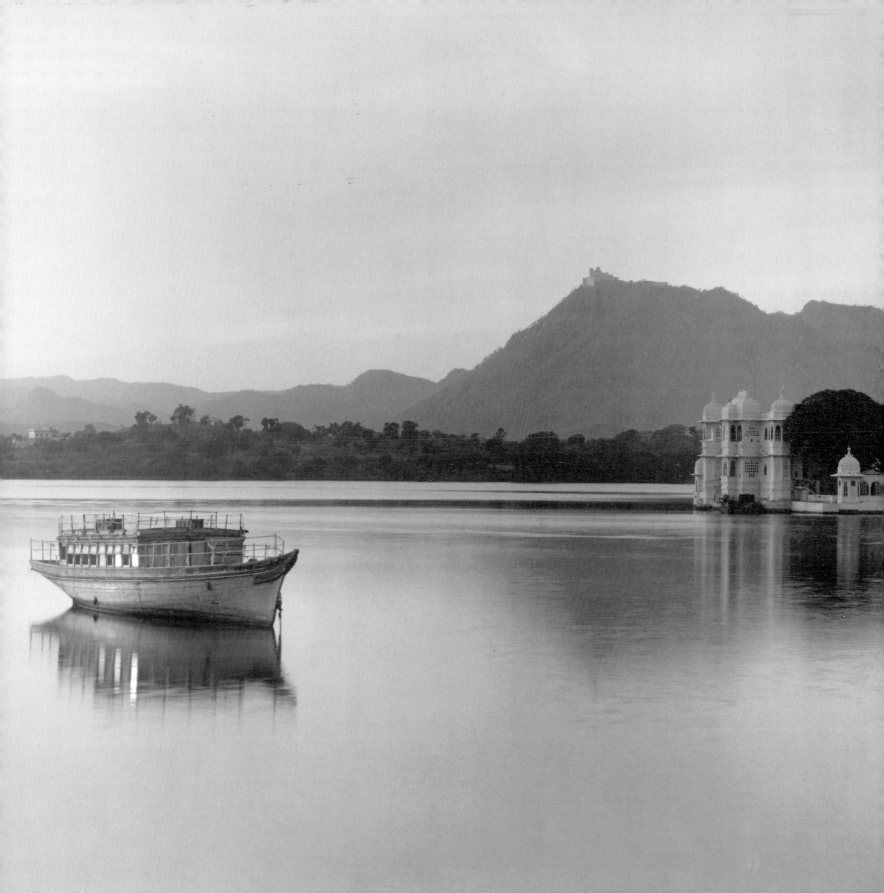

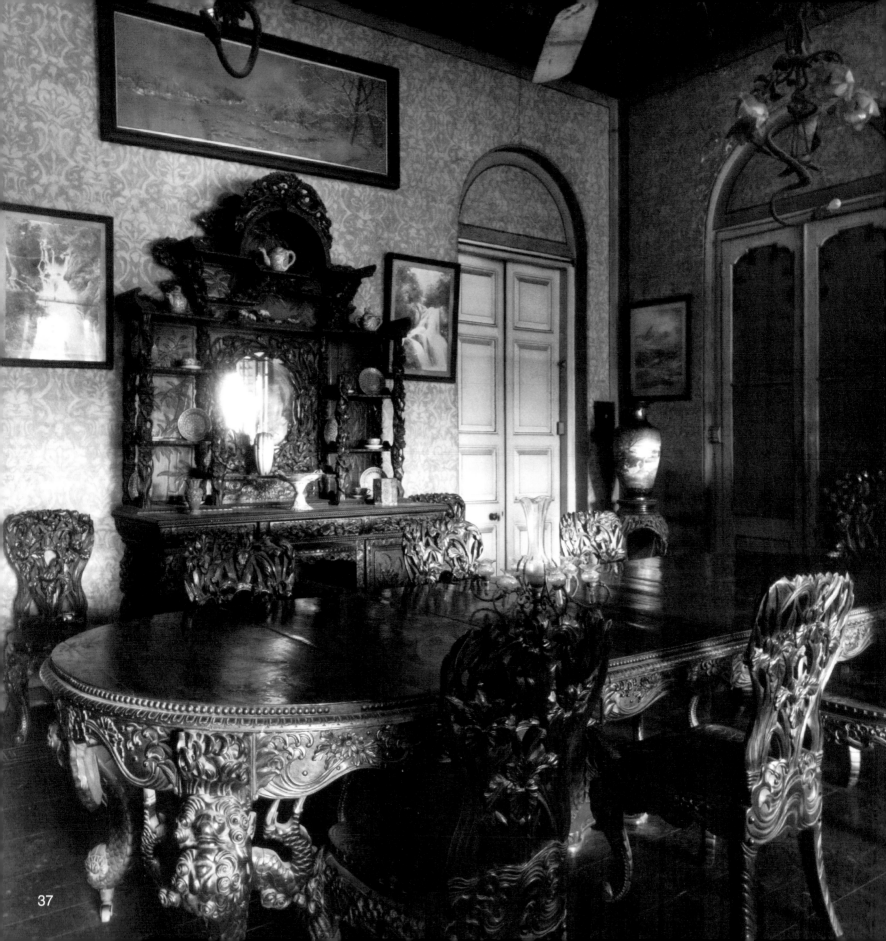

38

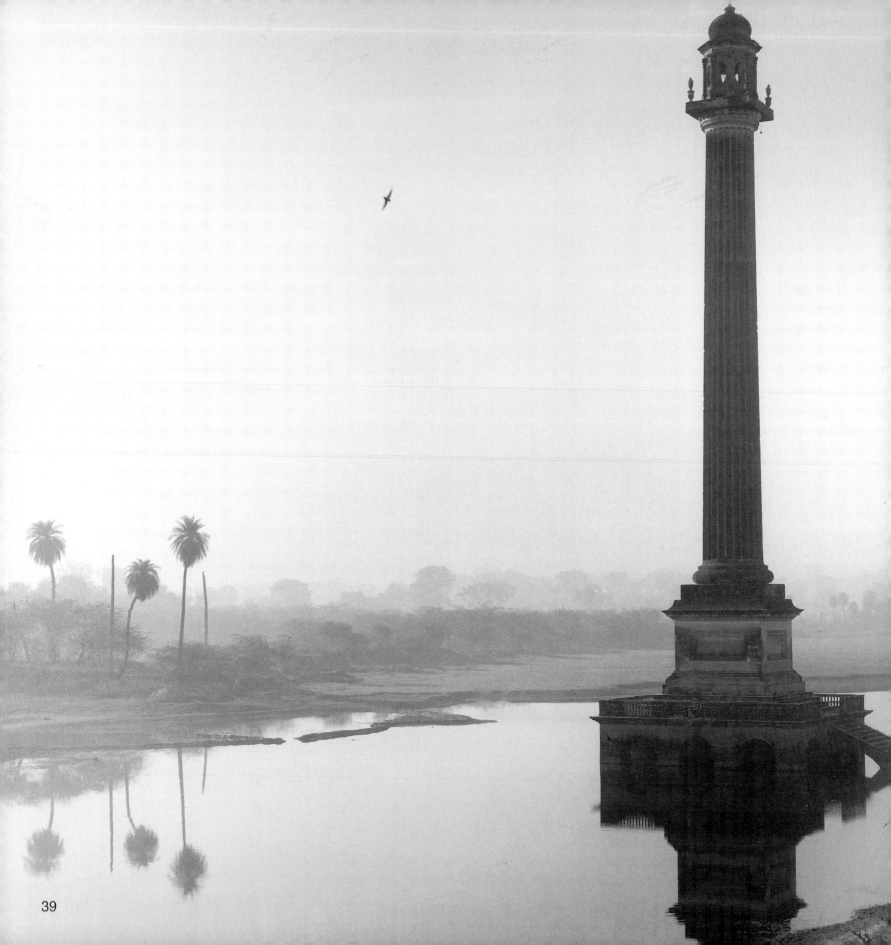

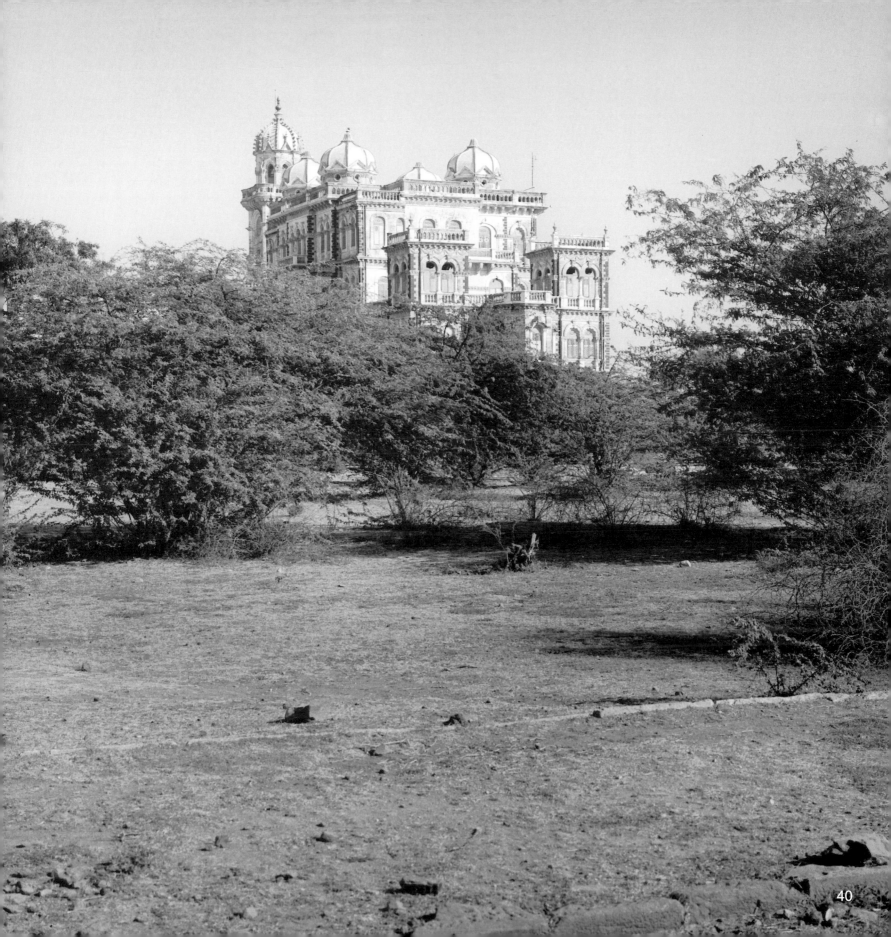

40

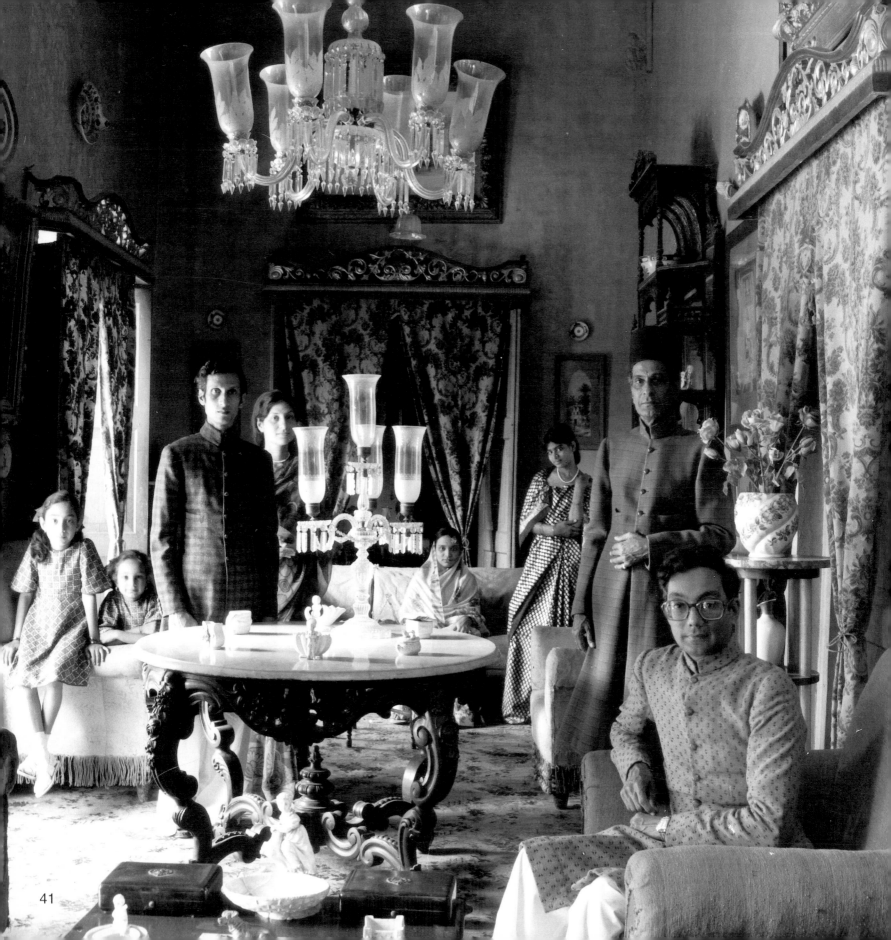

41

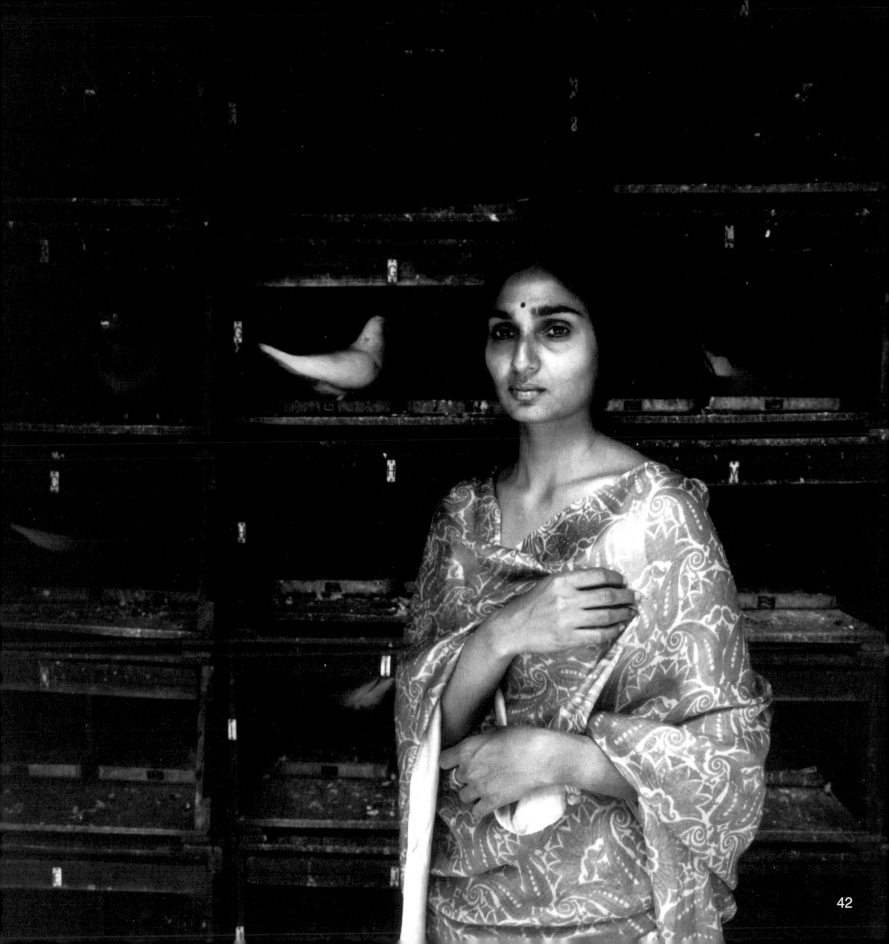

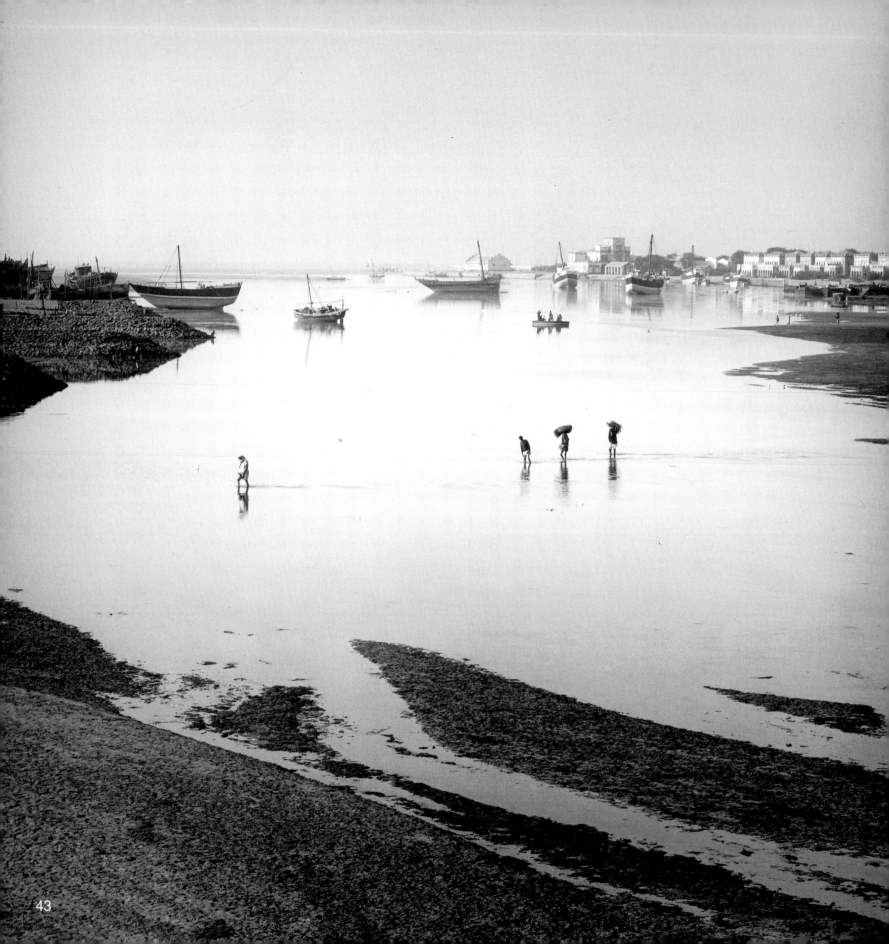

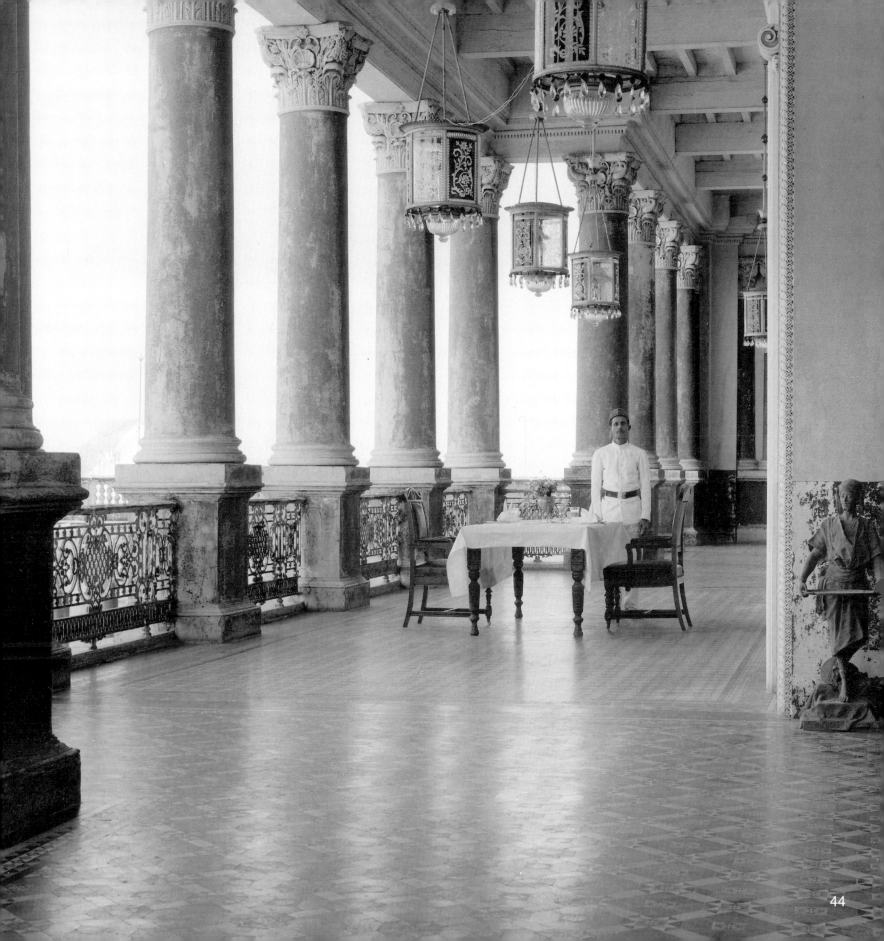

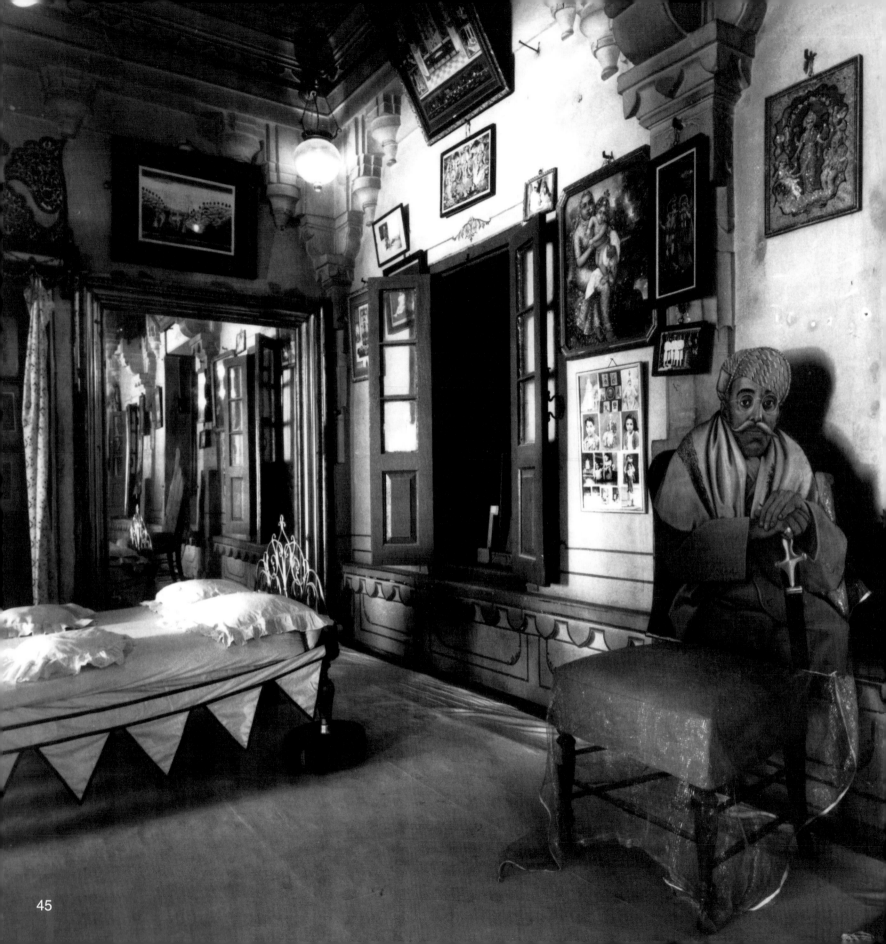

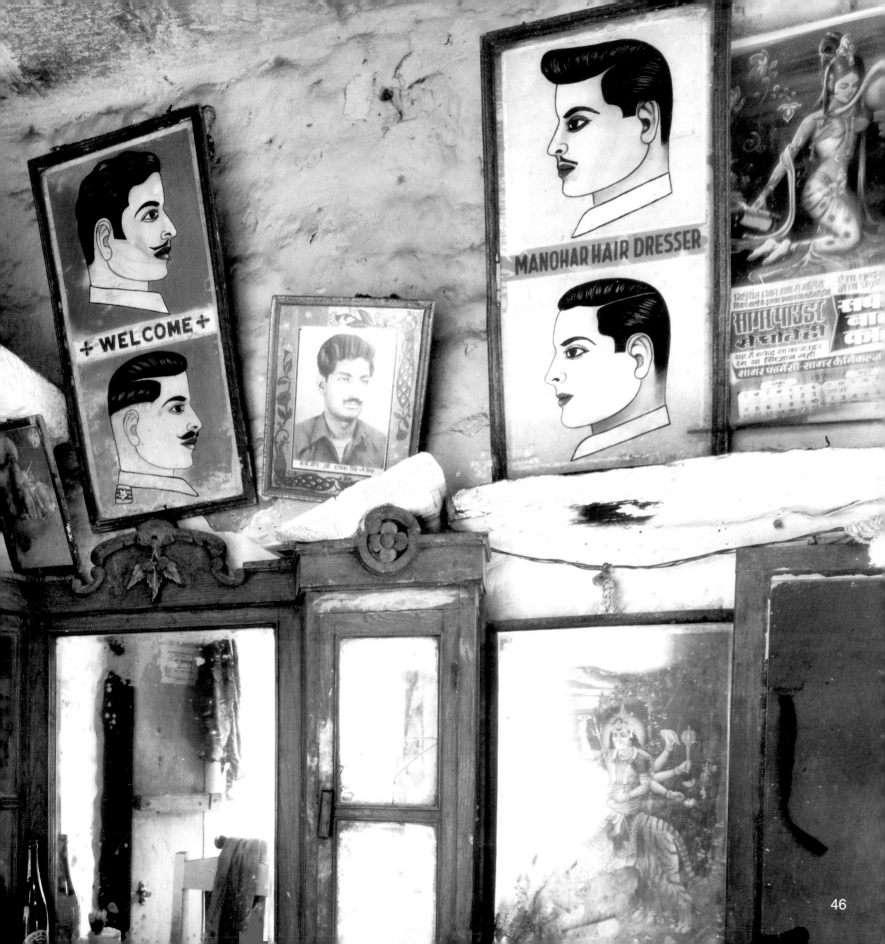

MANOHAR HAIR DRESSER

WELCOME

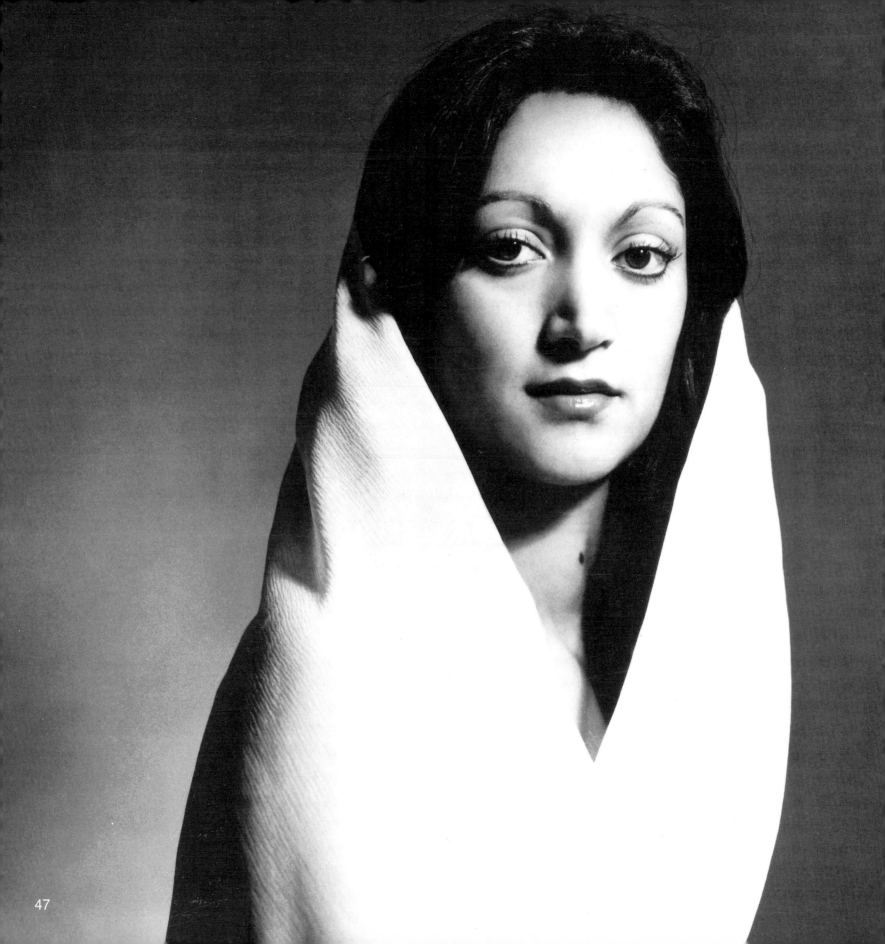

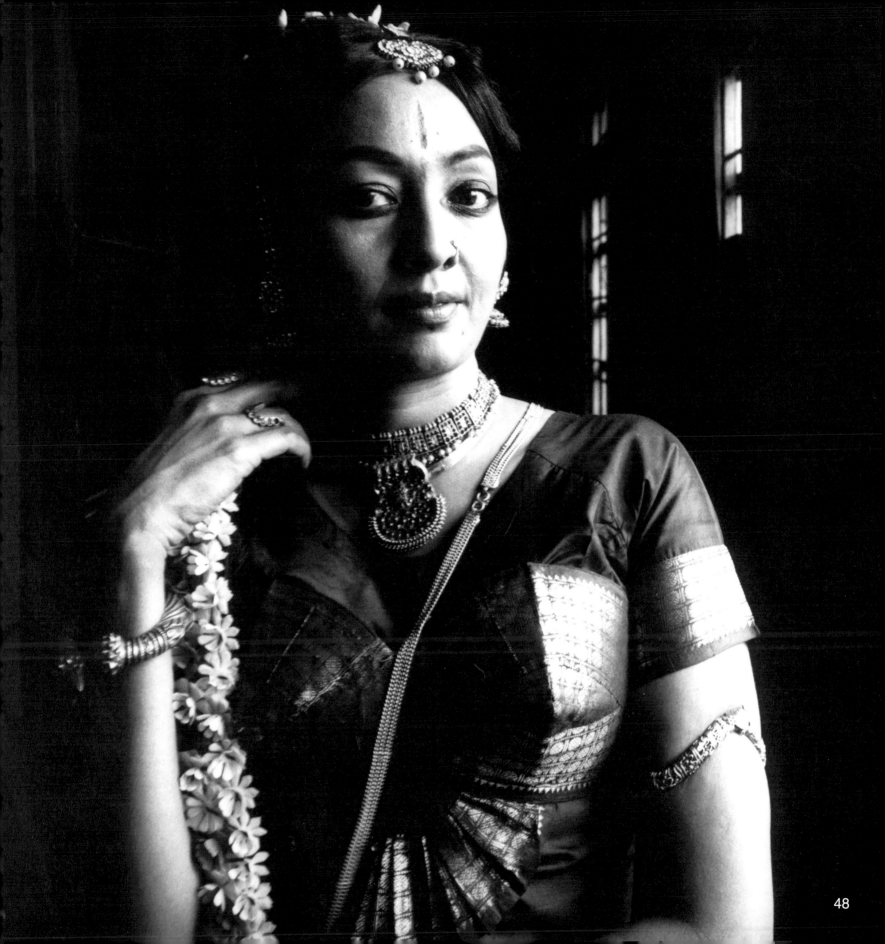

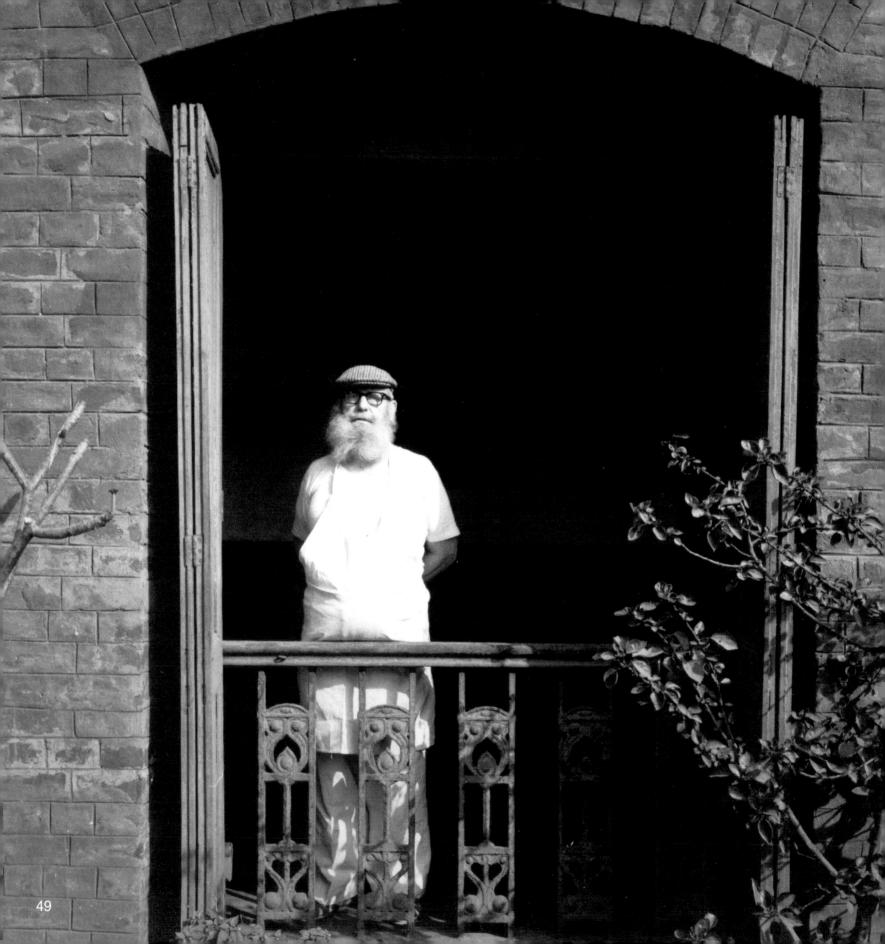

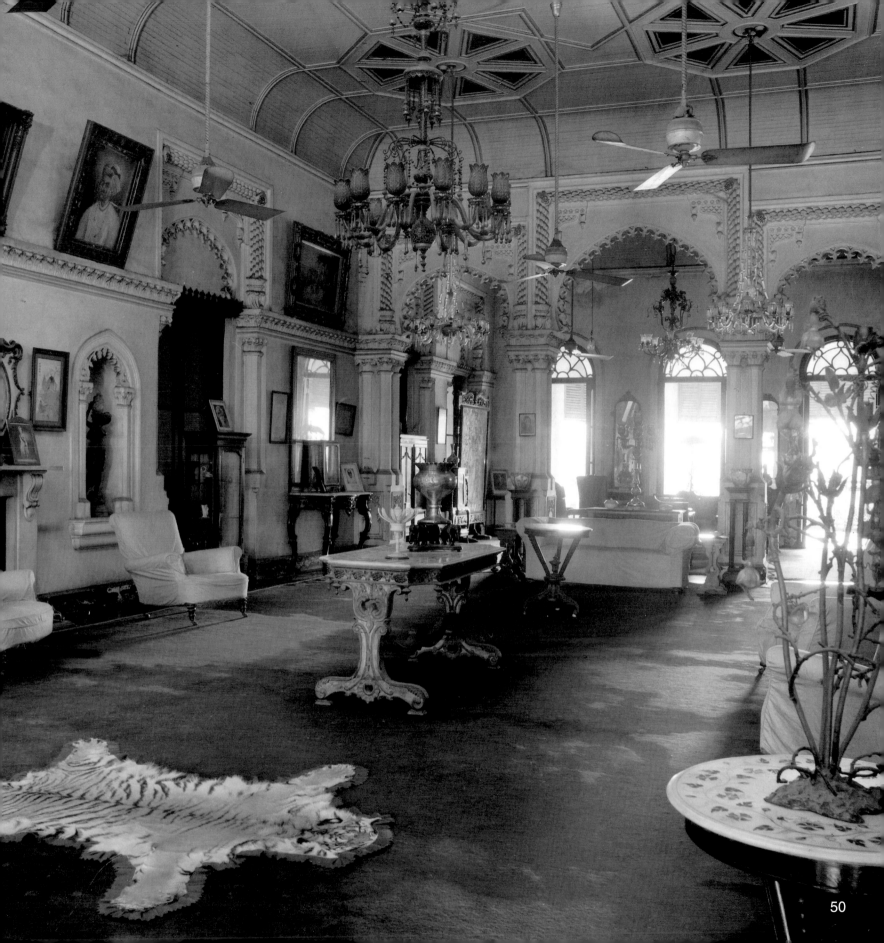

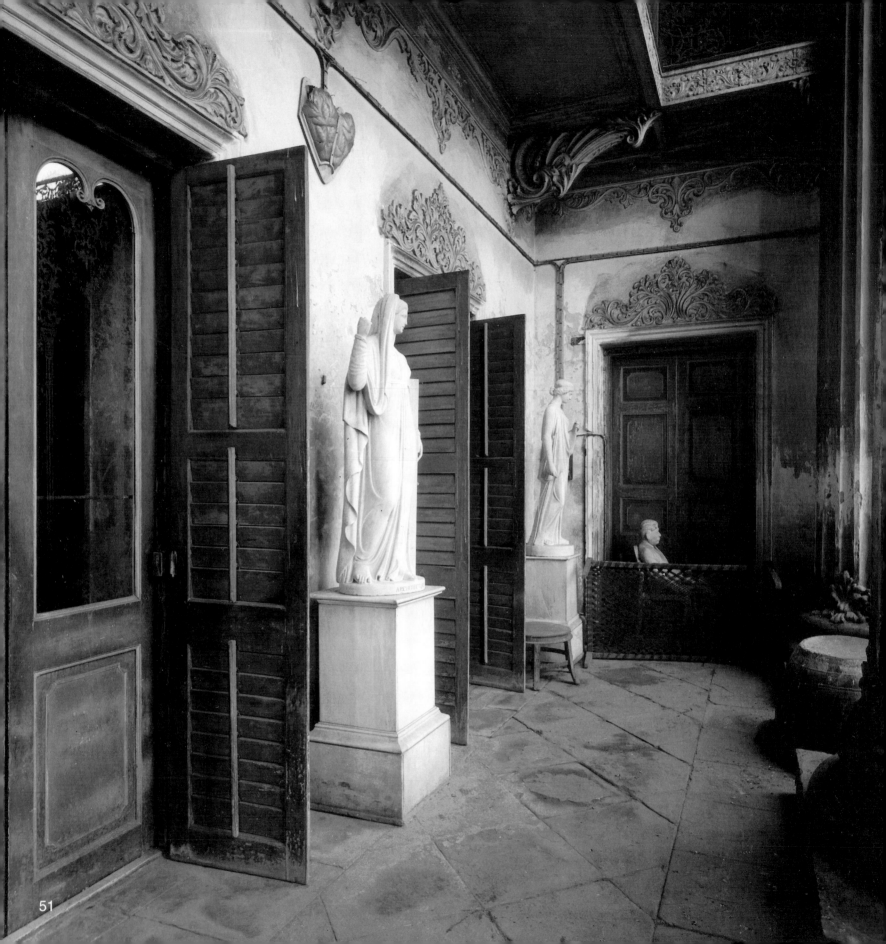

51

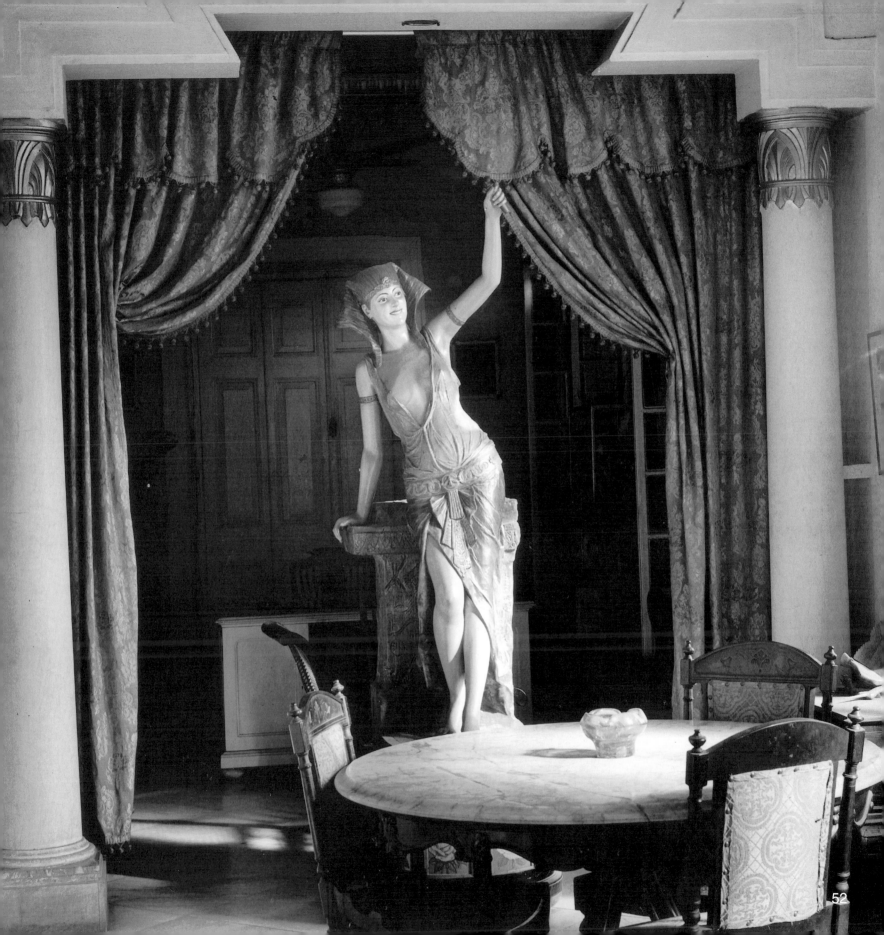

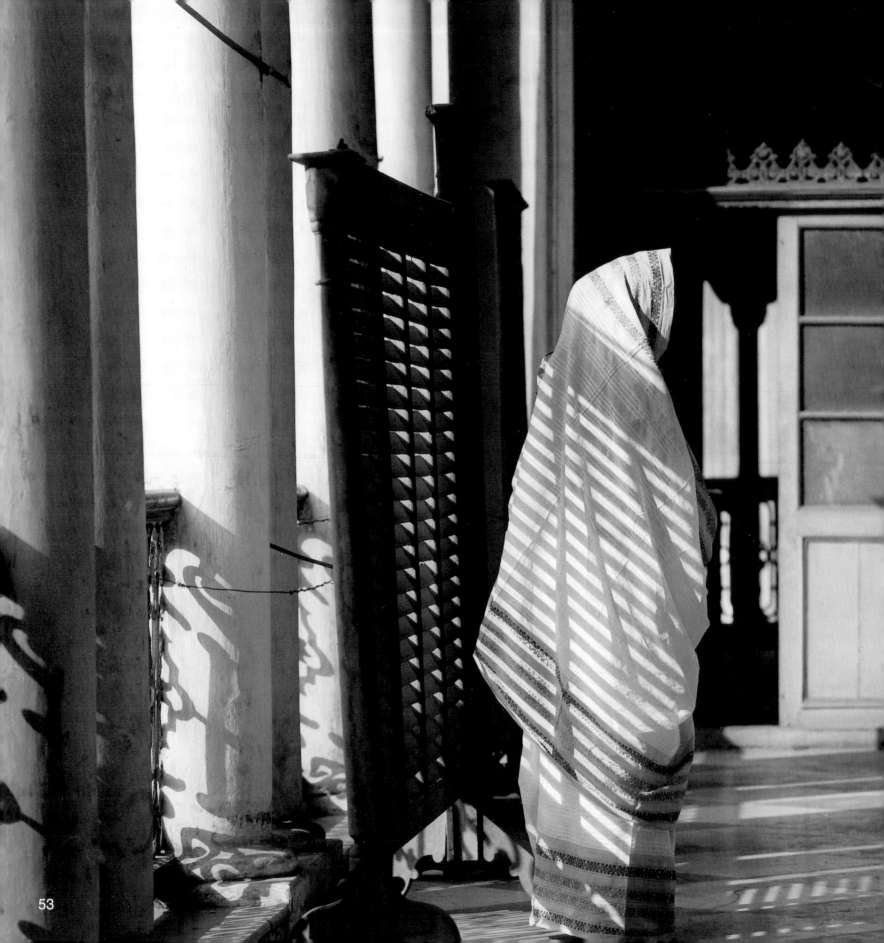

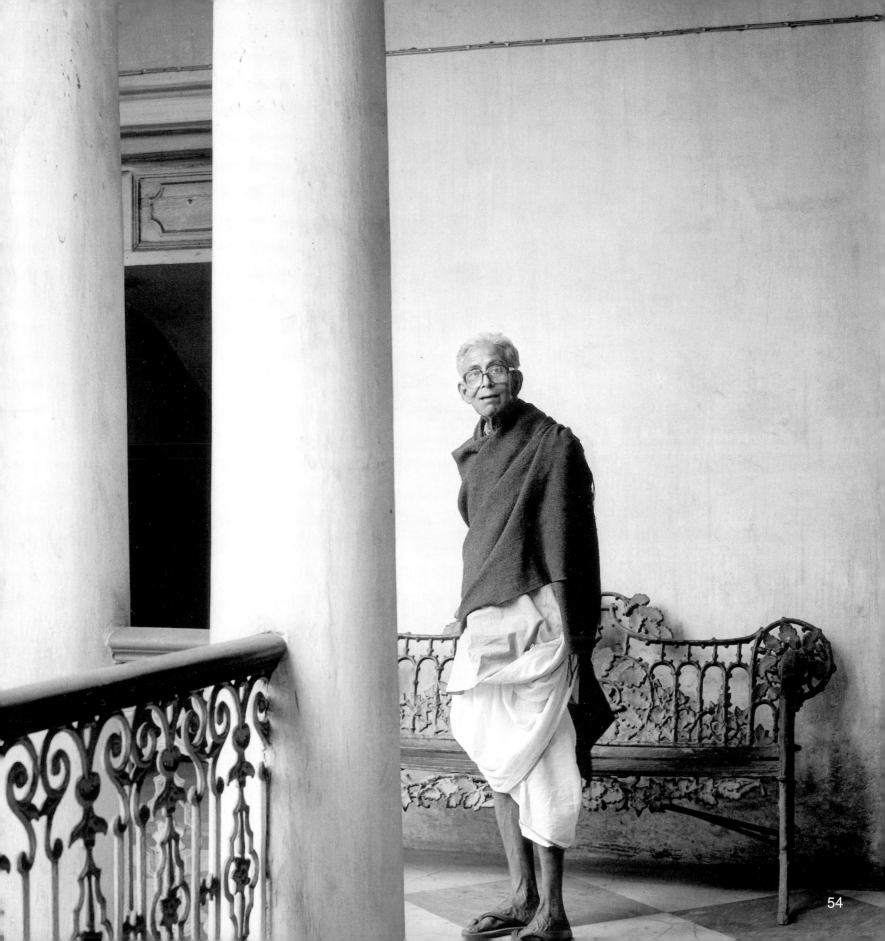

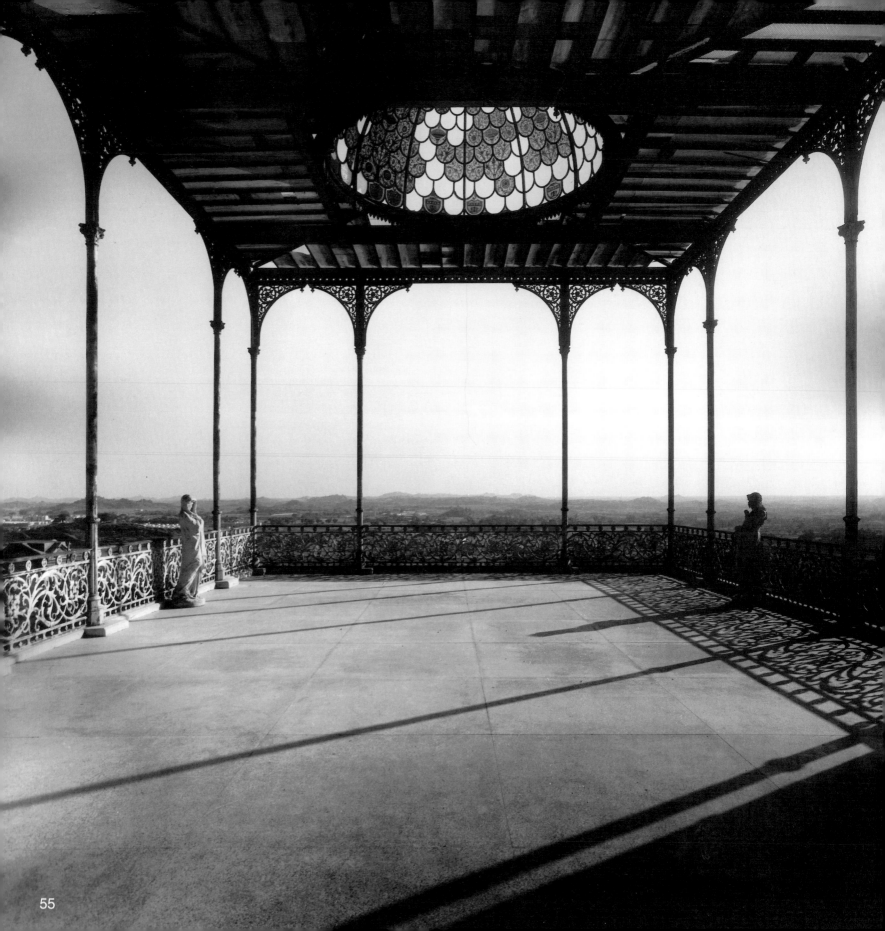

55

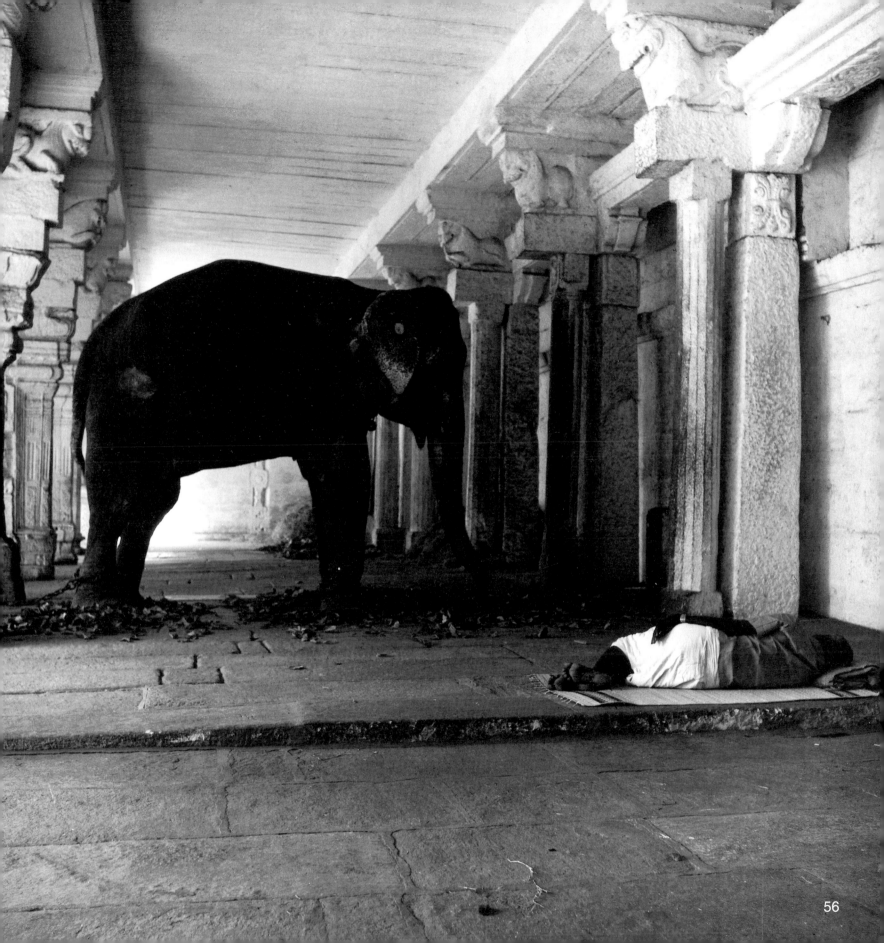

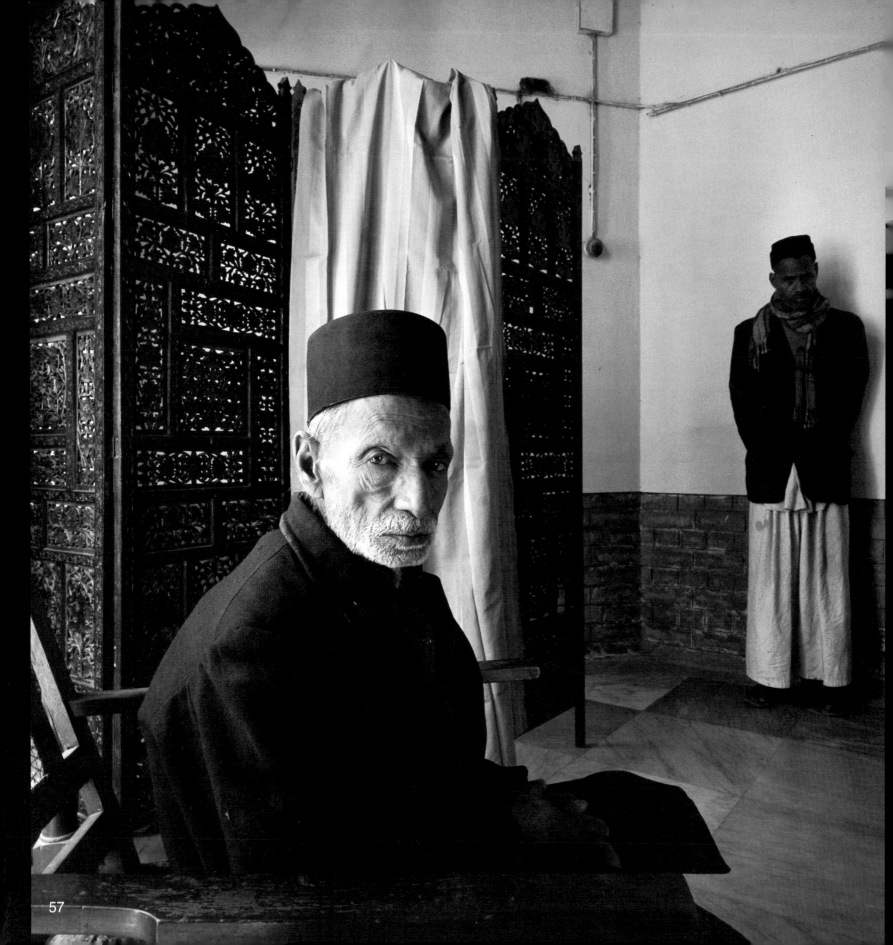

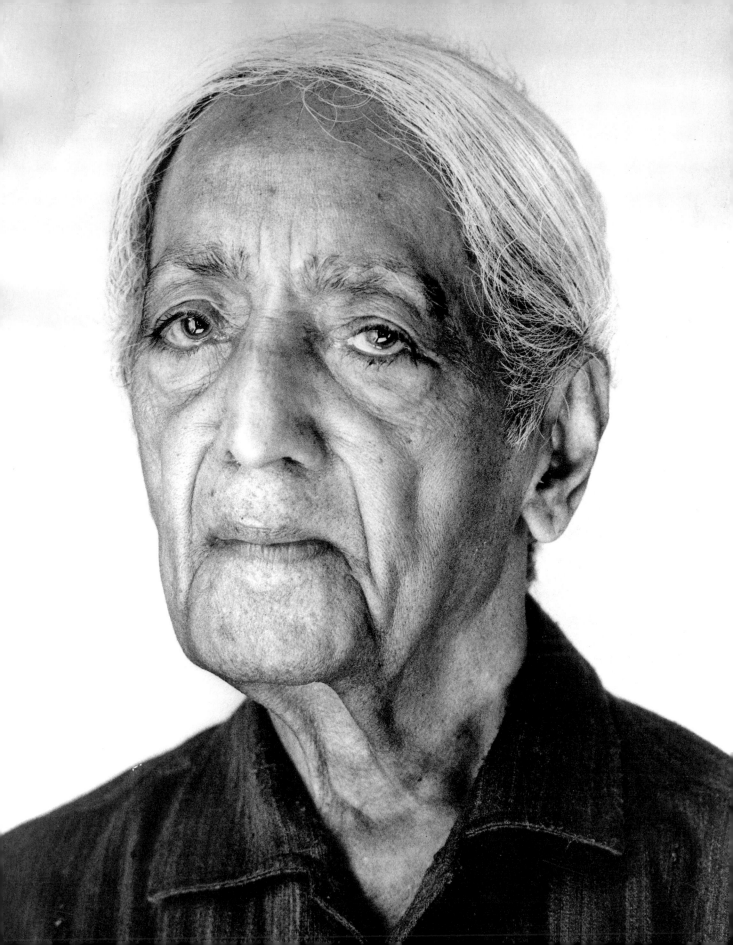

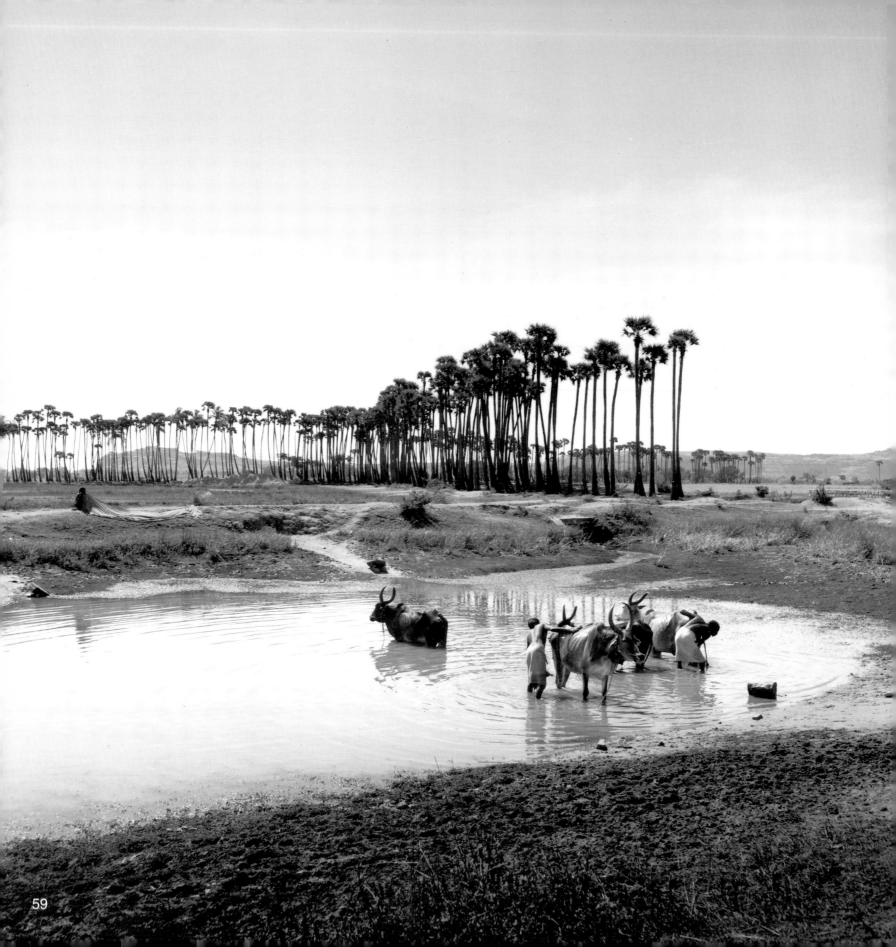

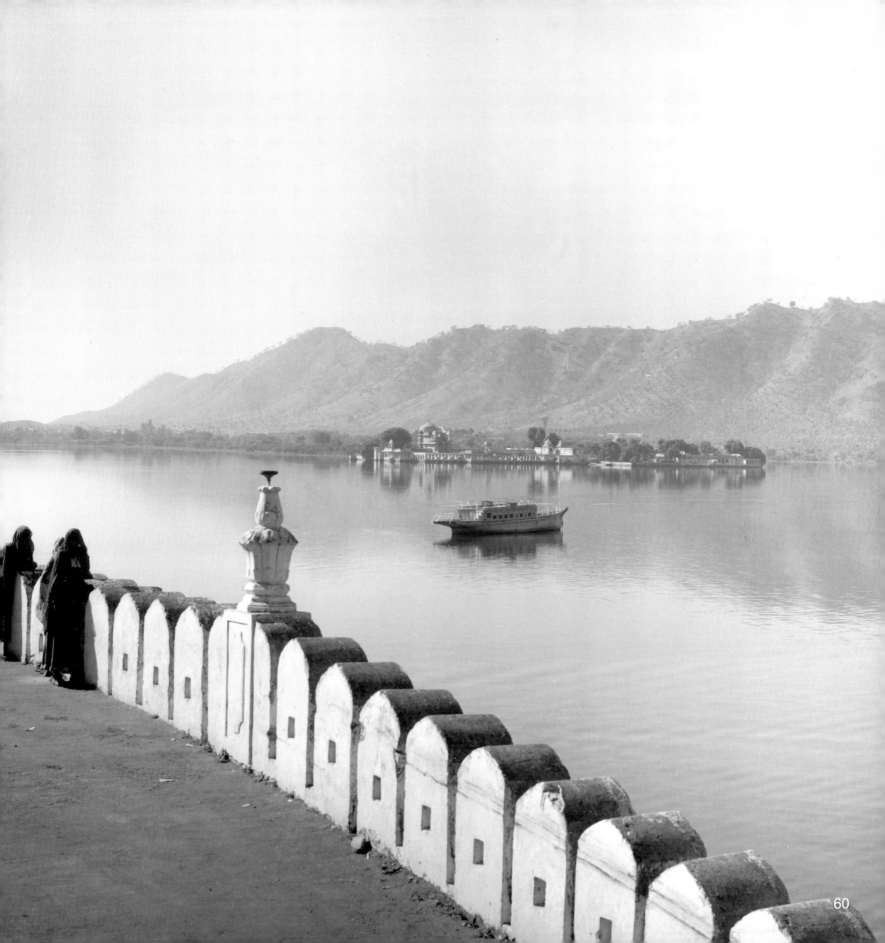

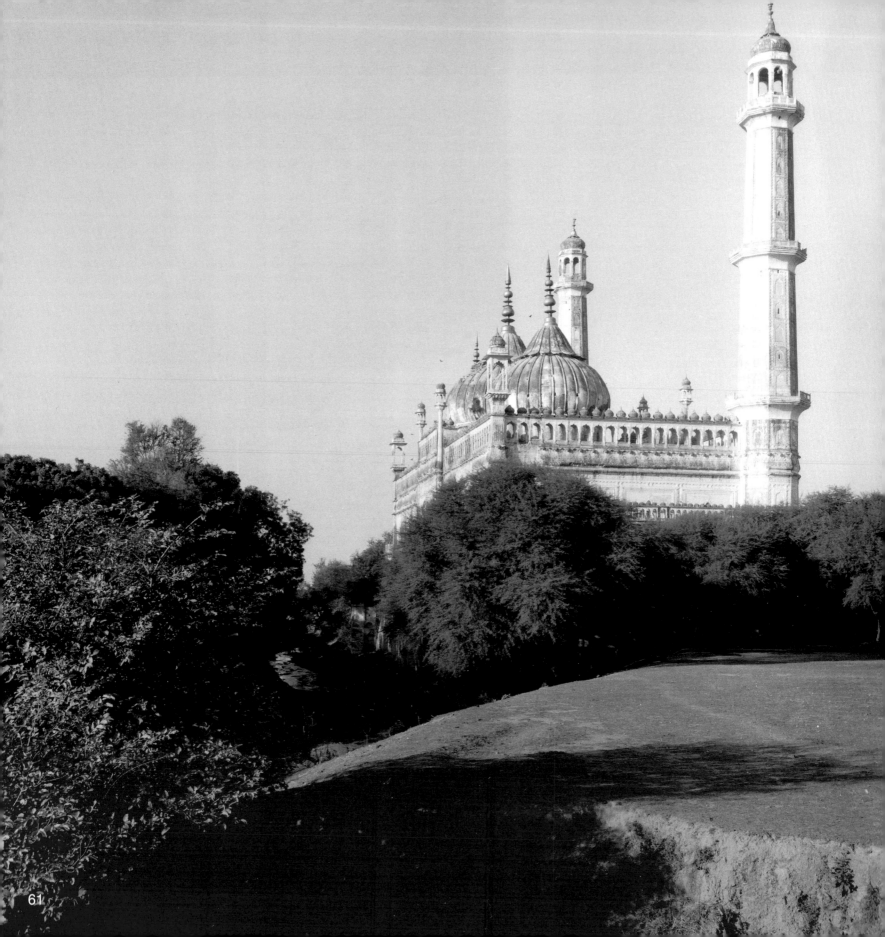

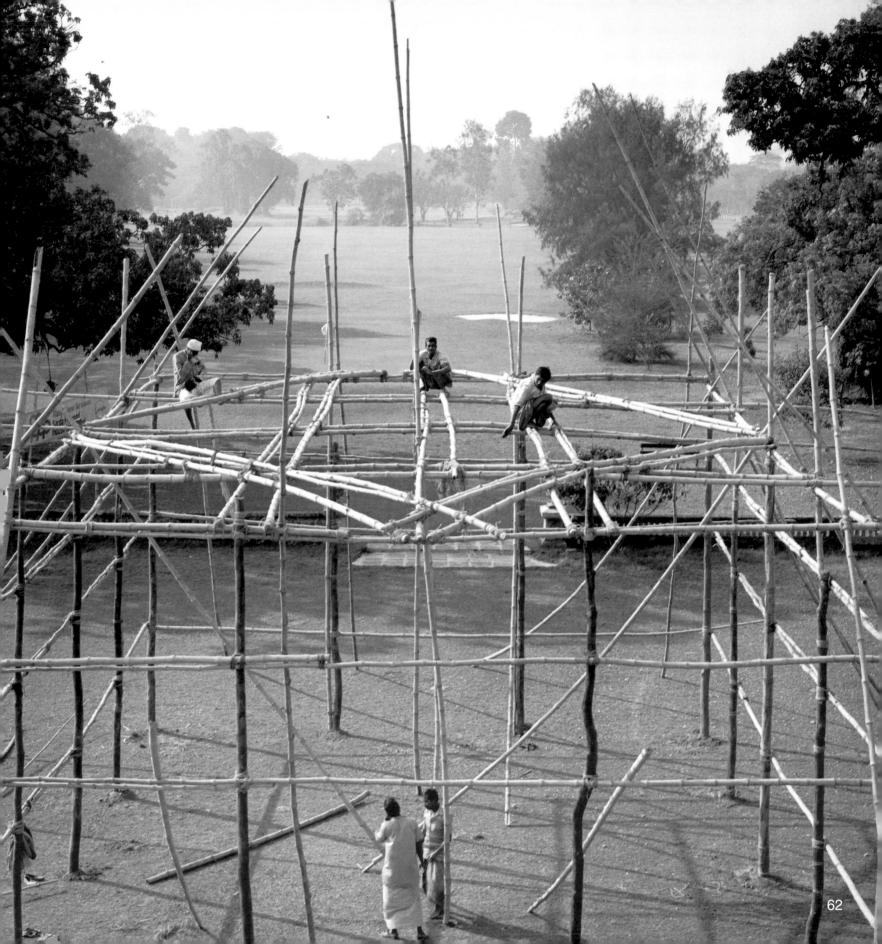

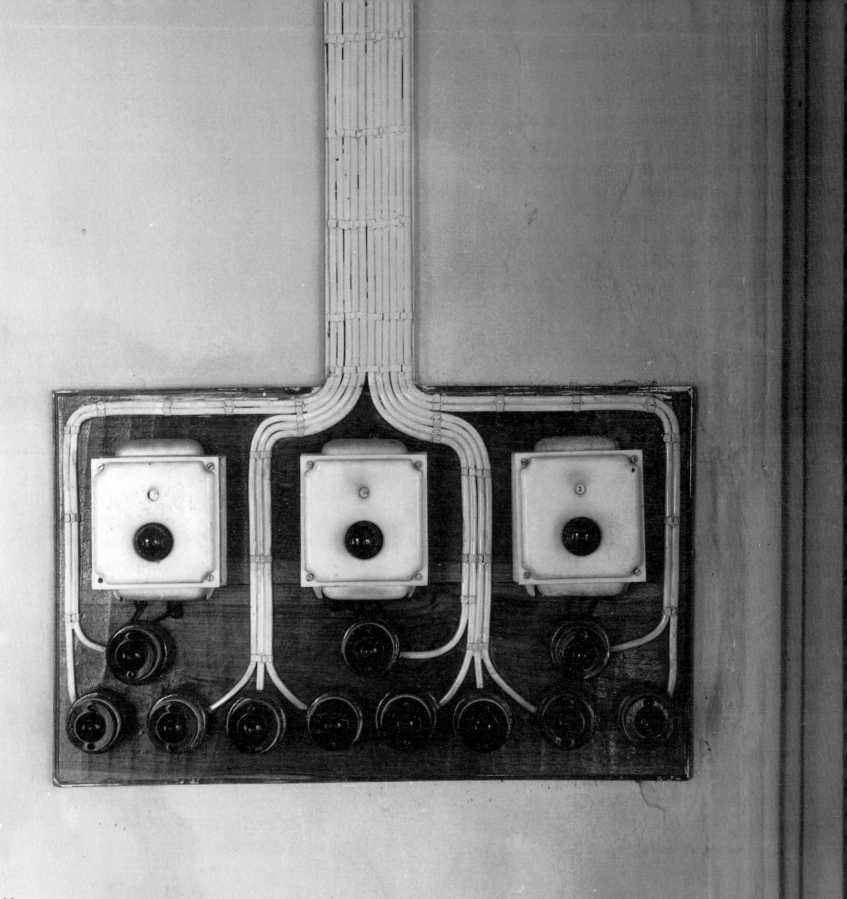

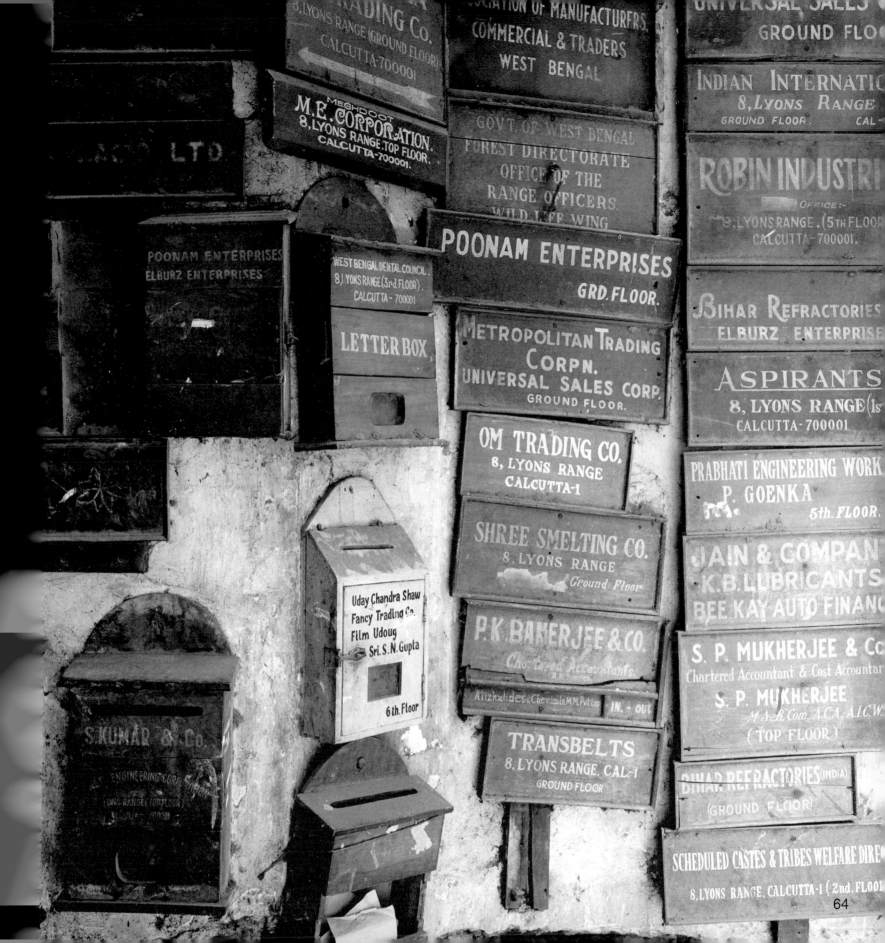

64

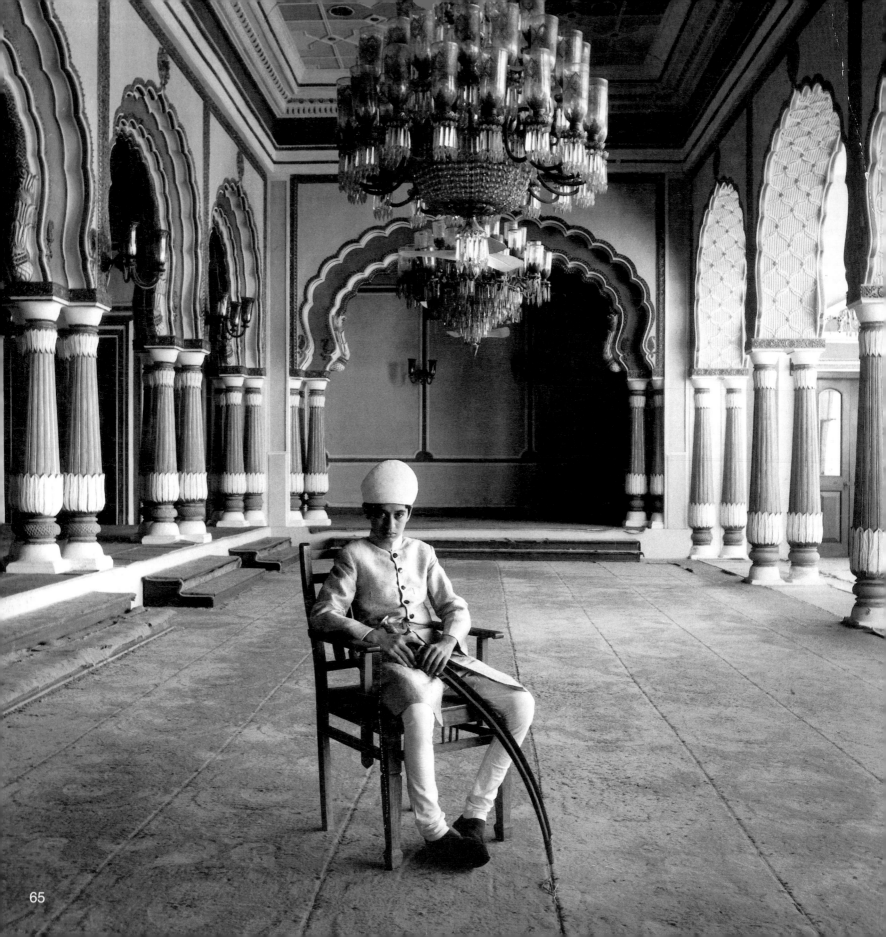

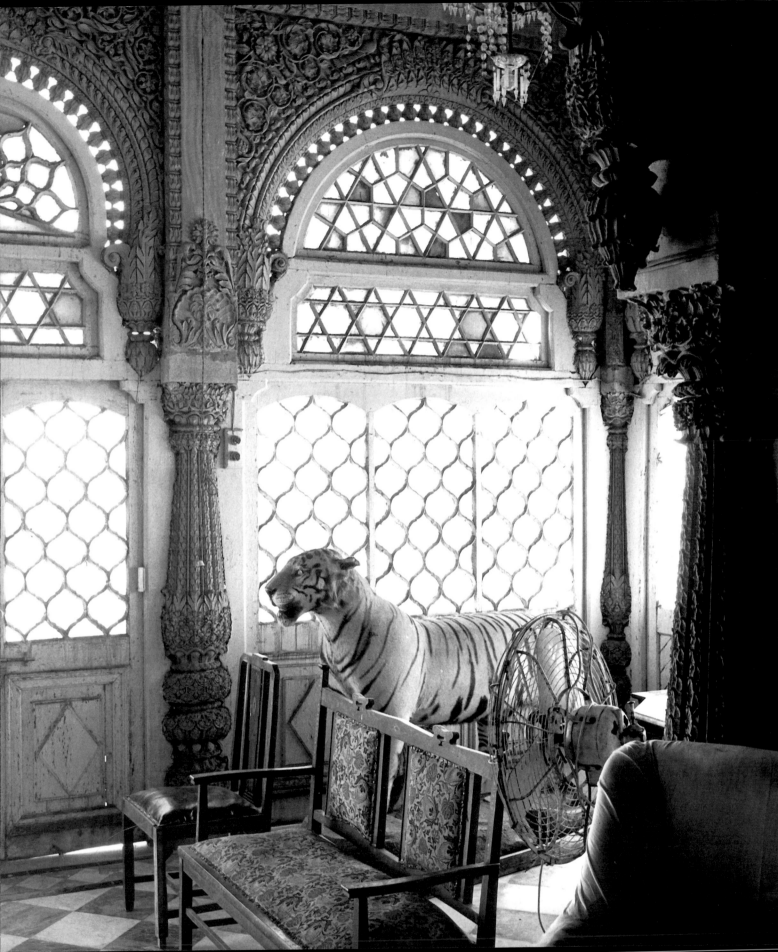

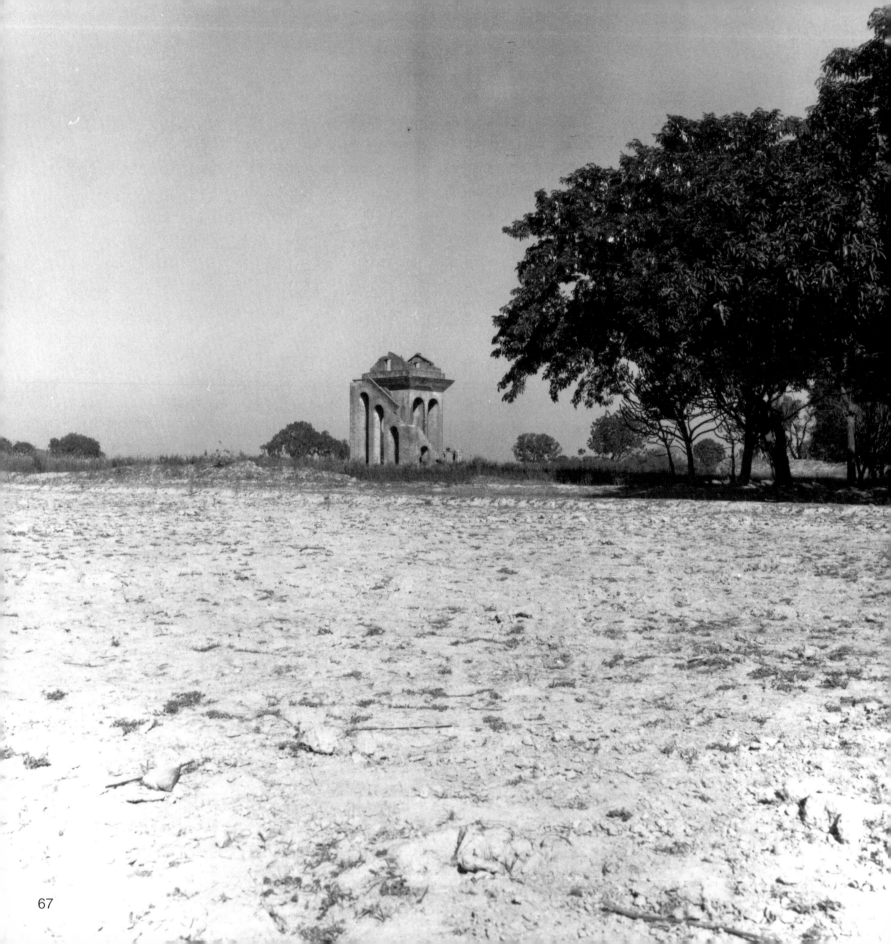

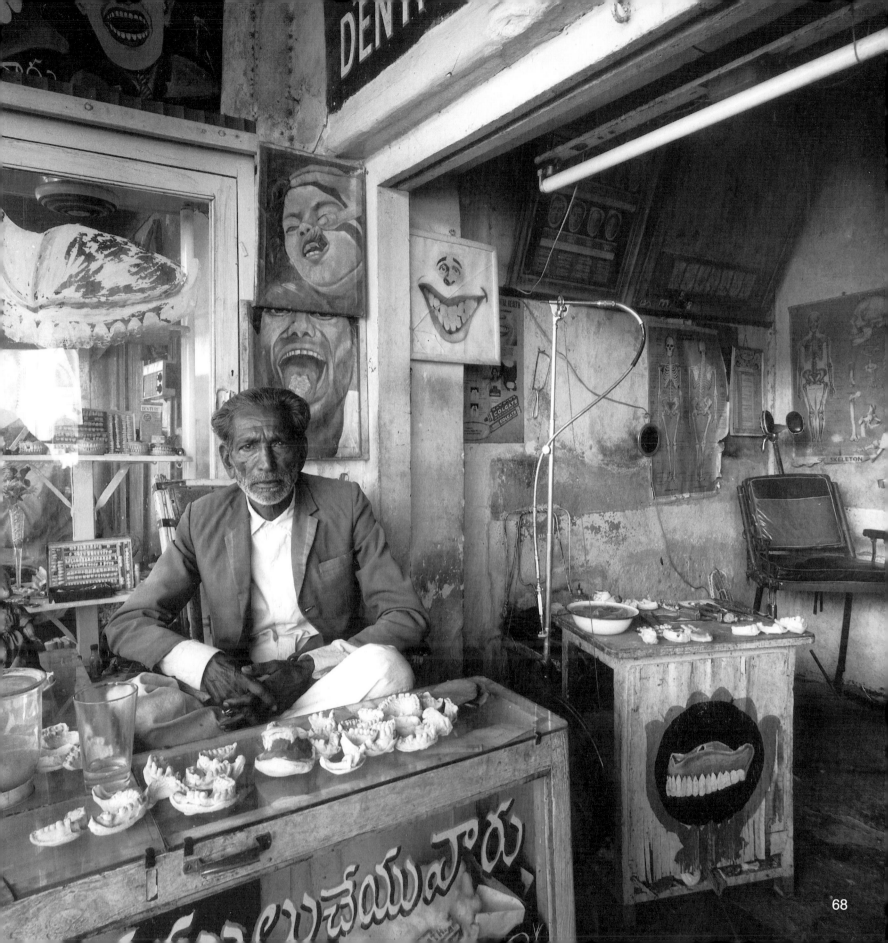

68

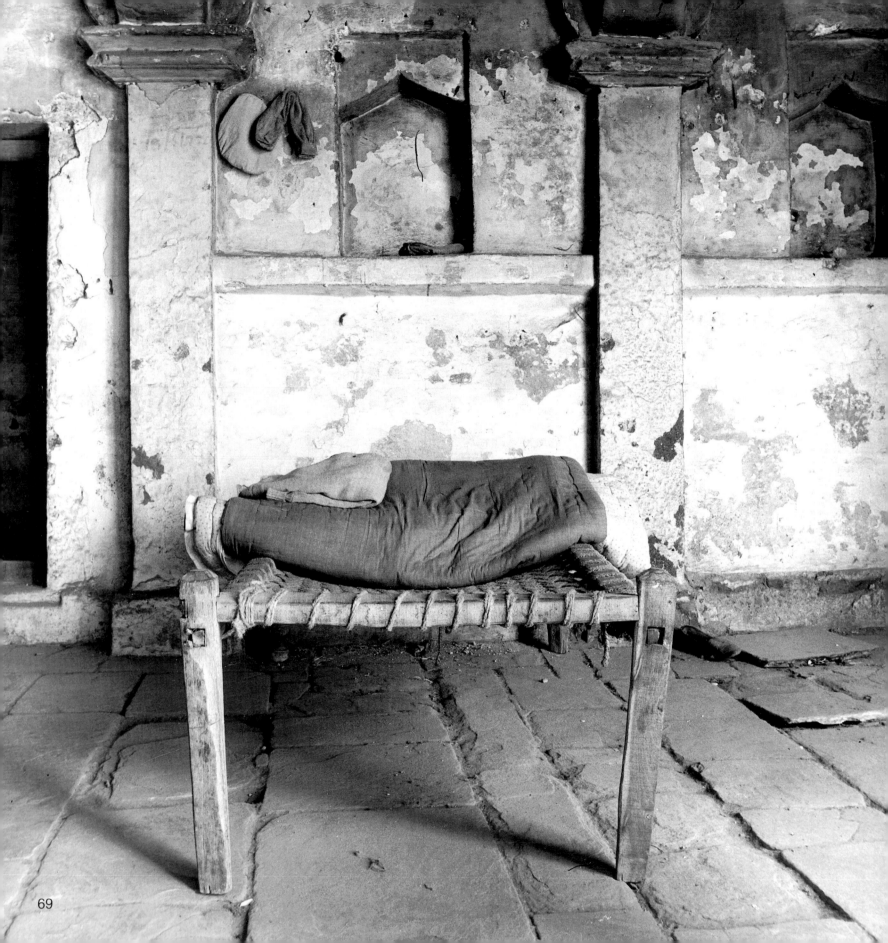

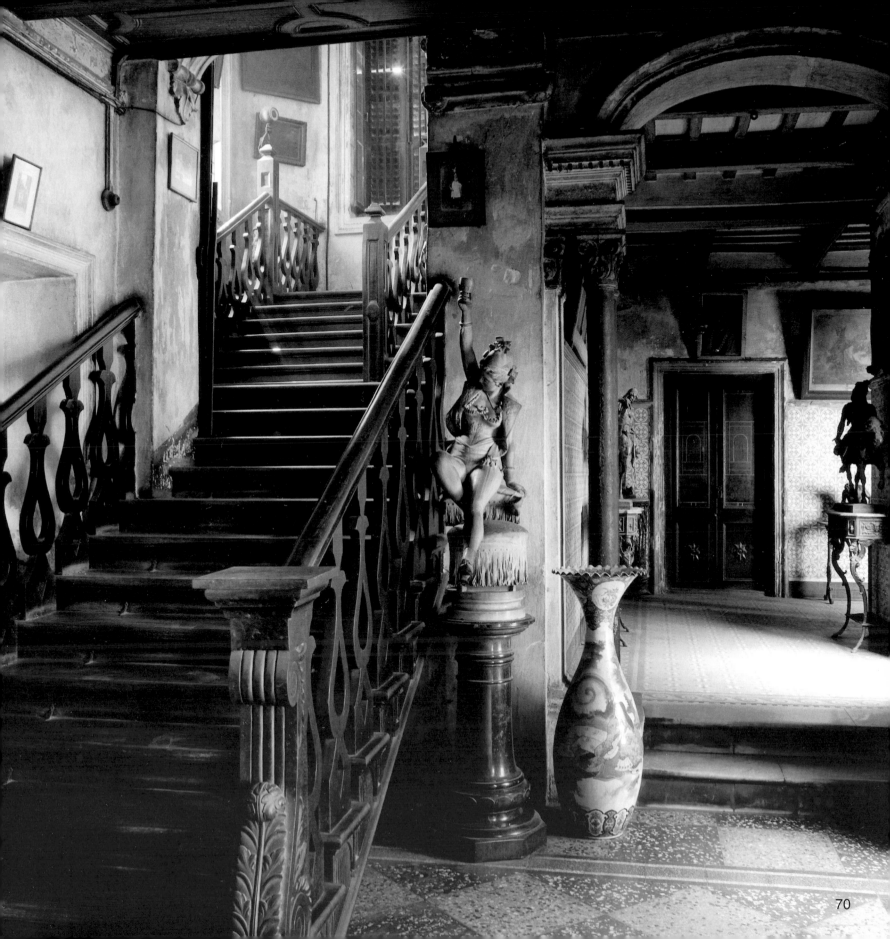

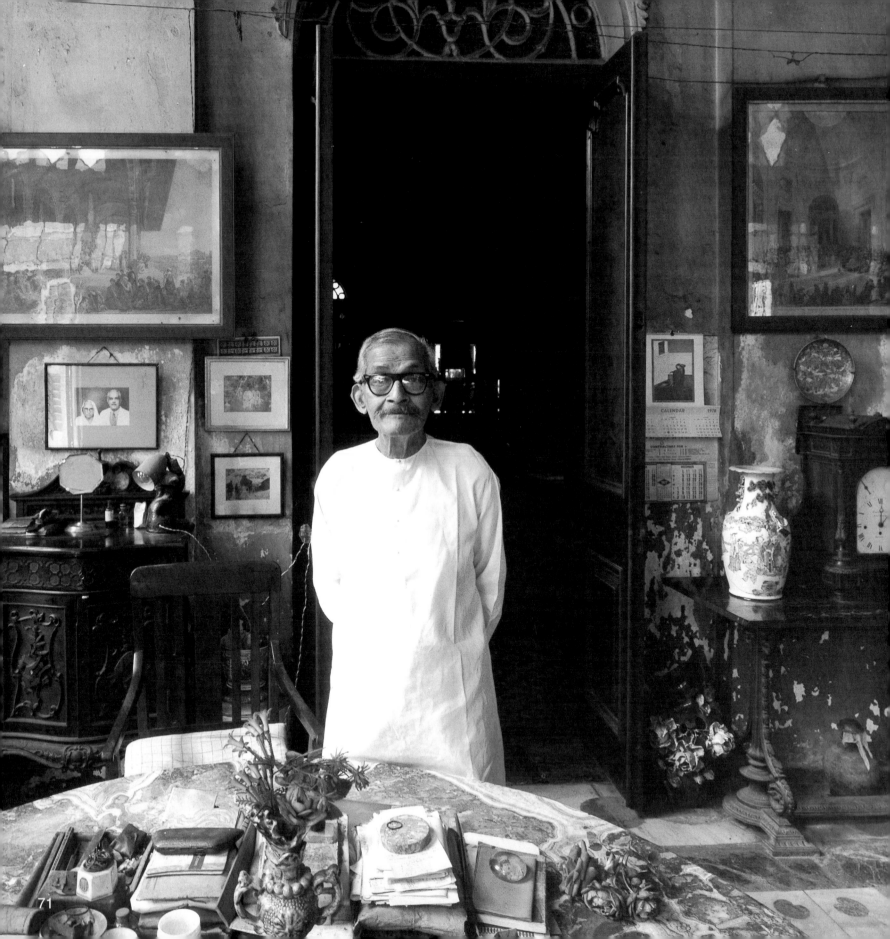

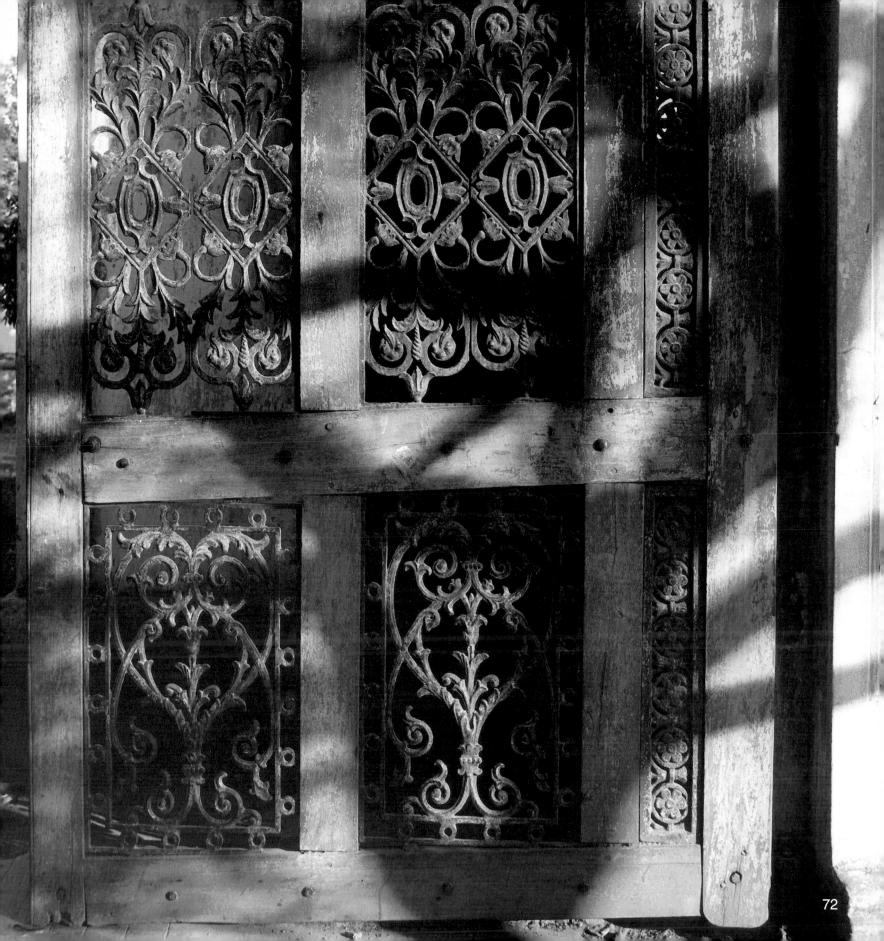

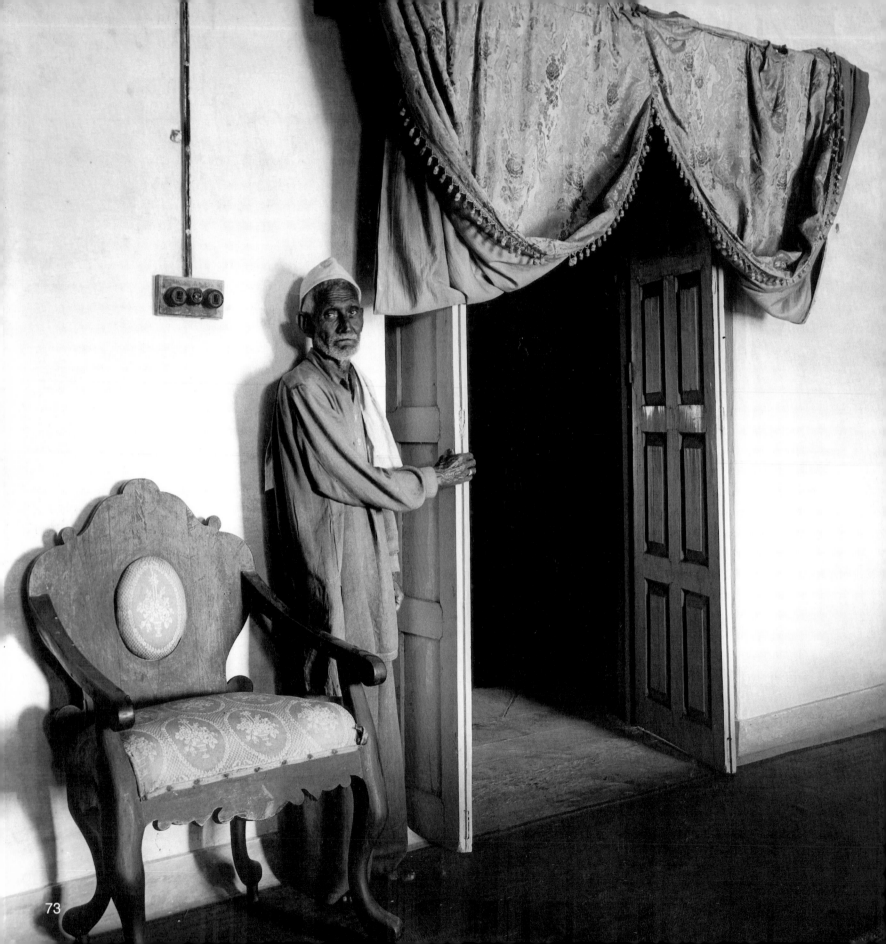

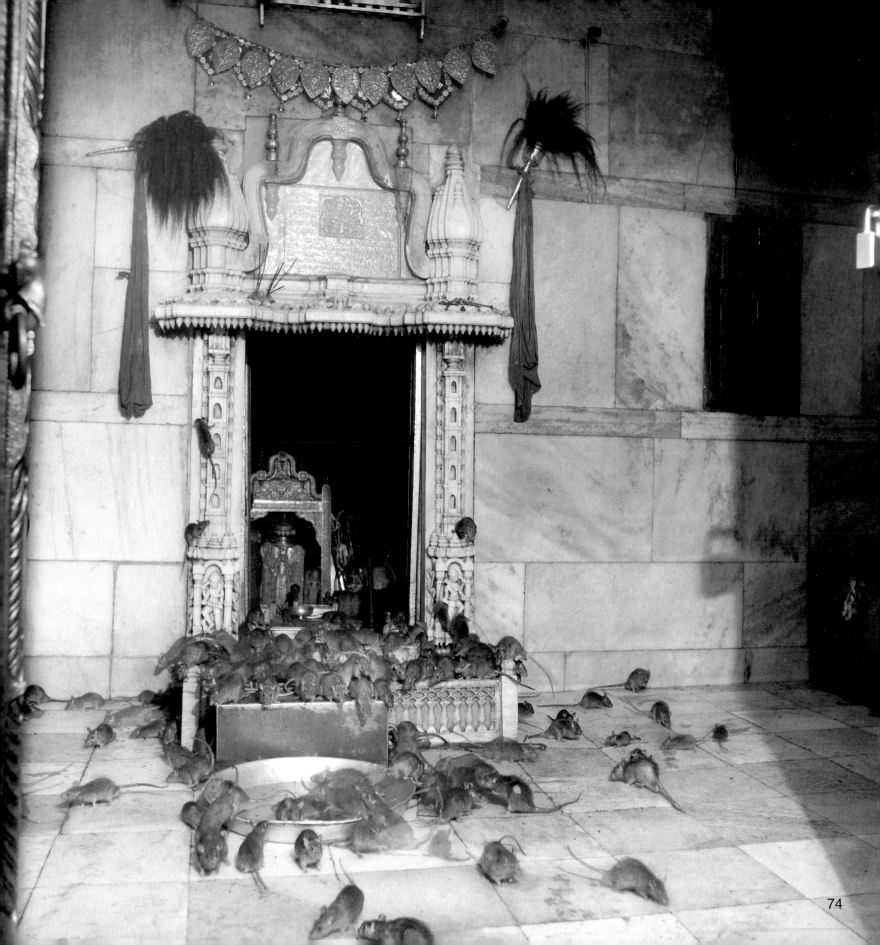

74

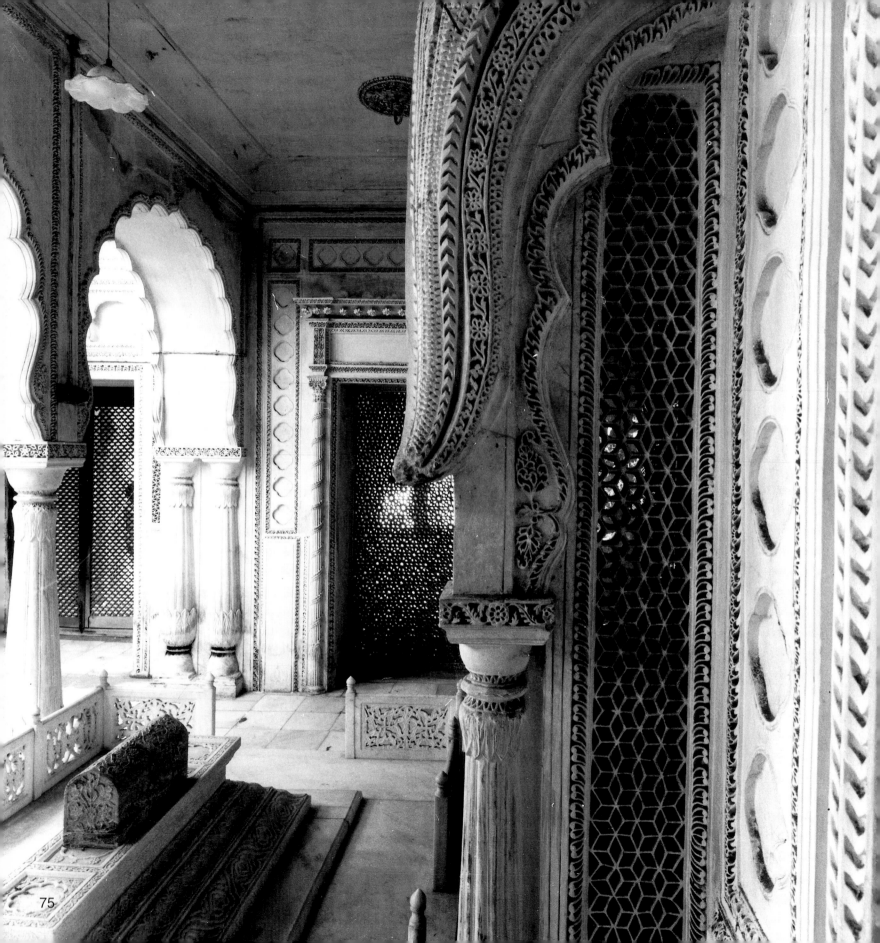

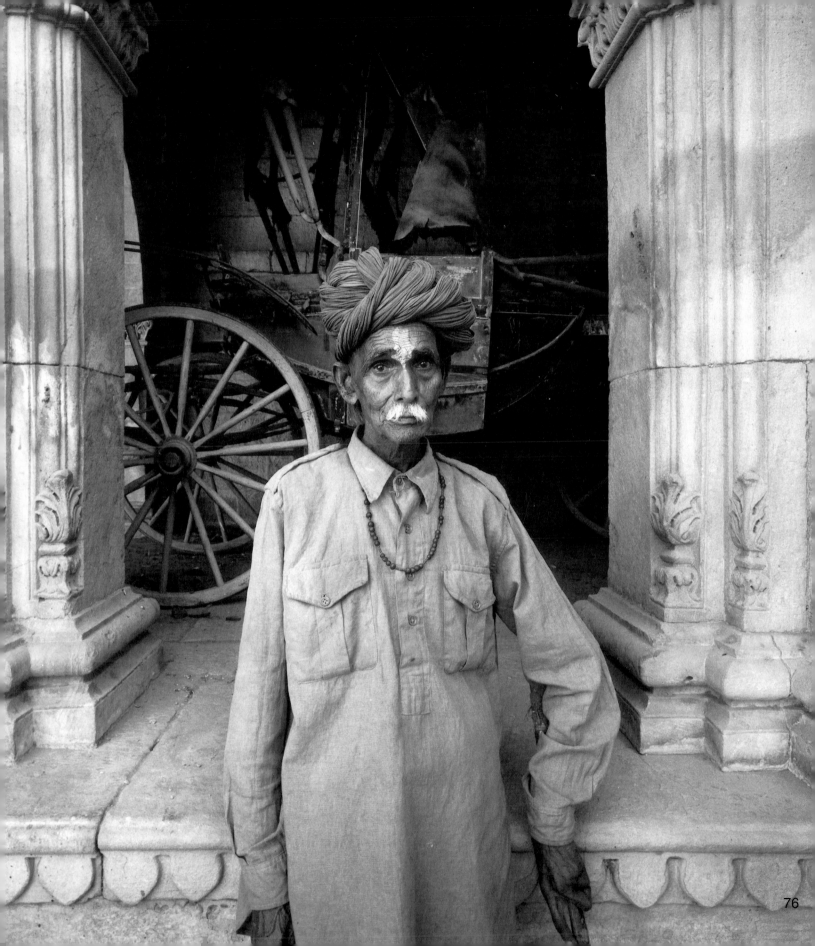

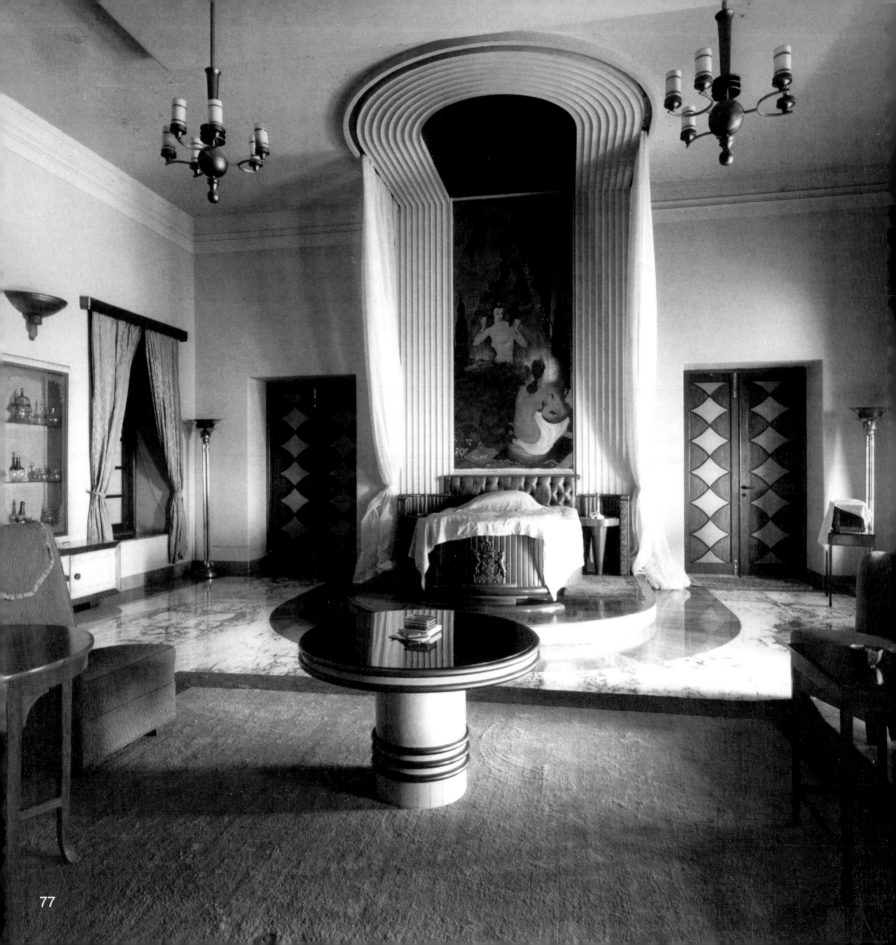

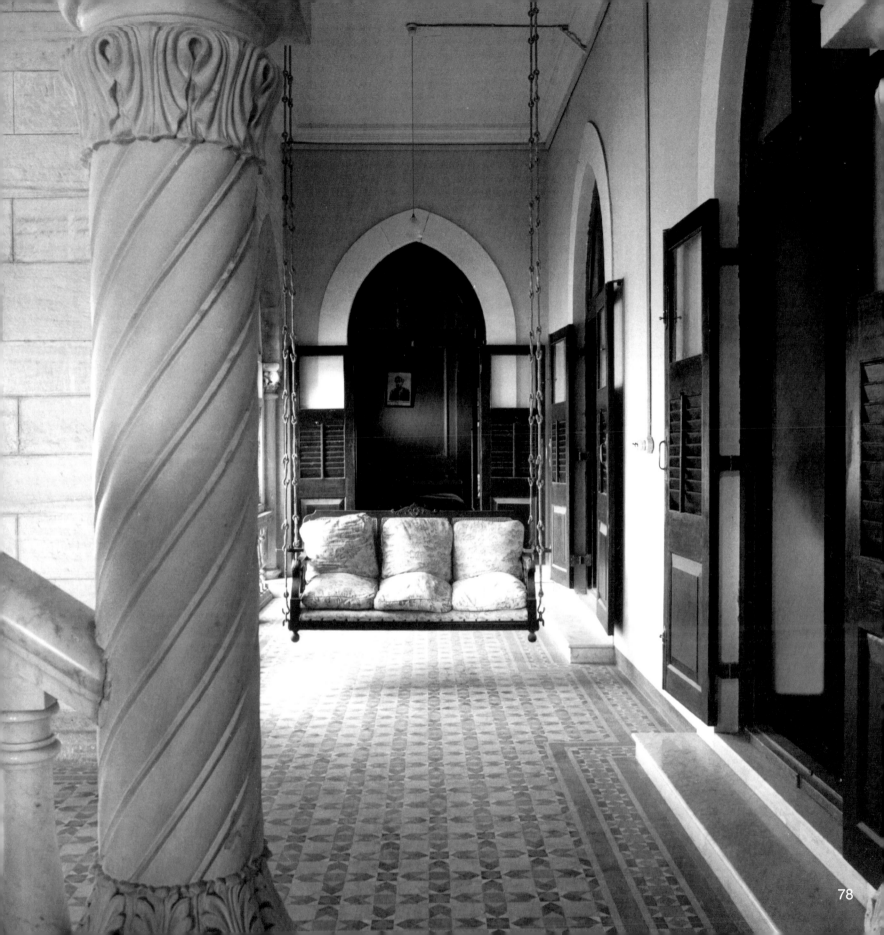

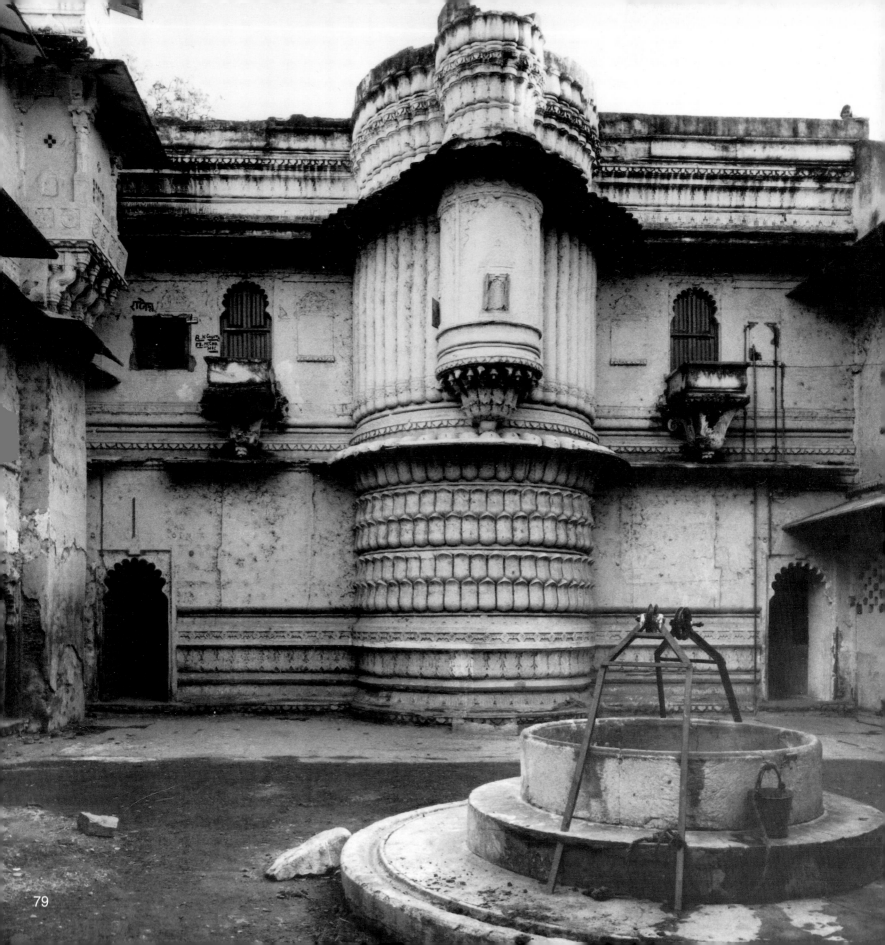

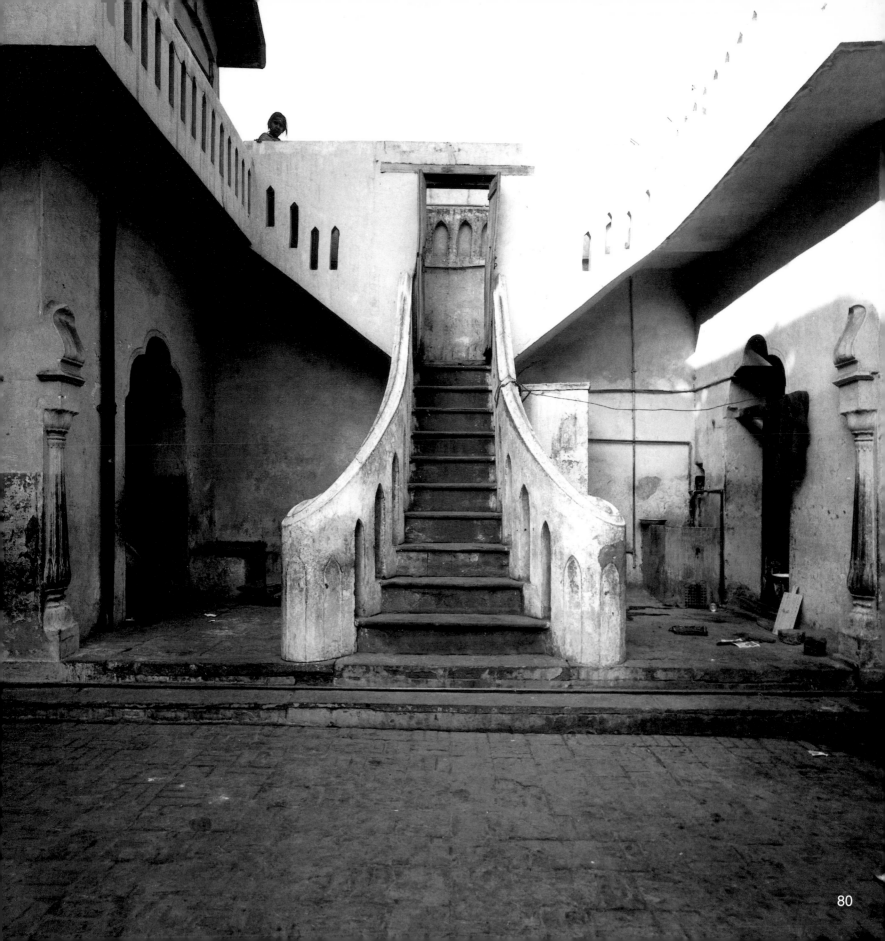

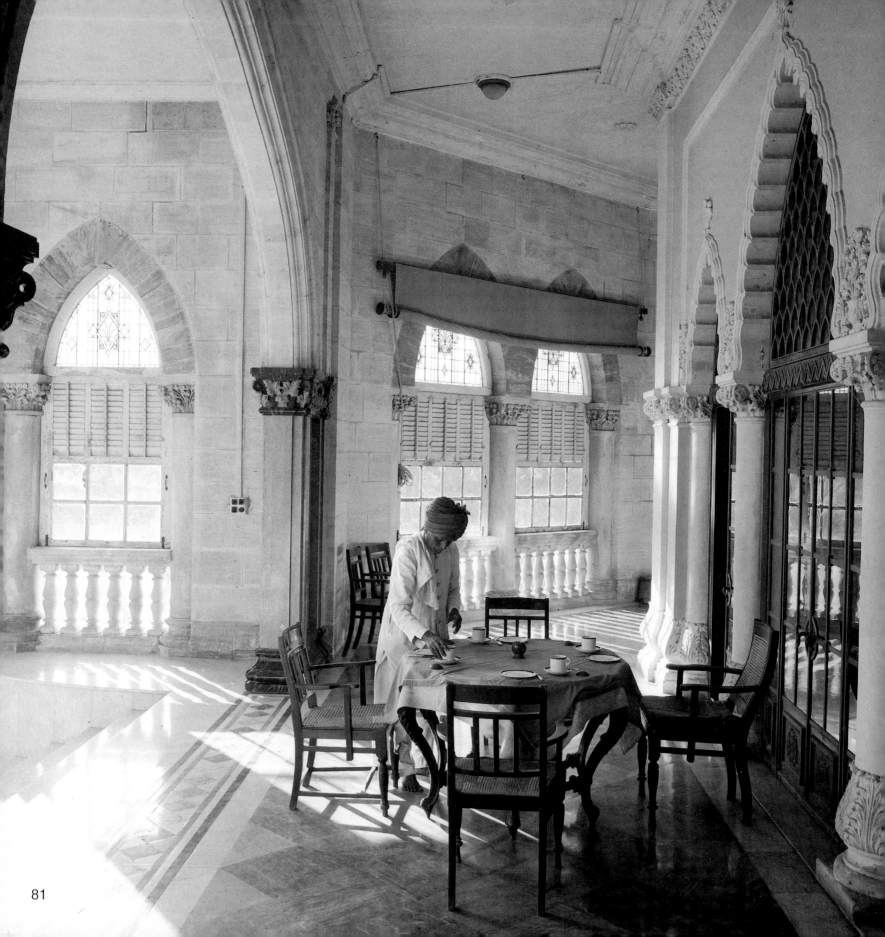

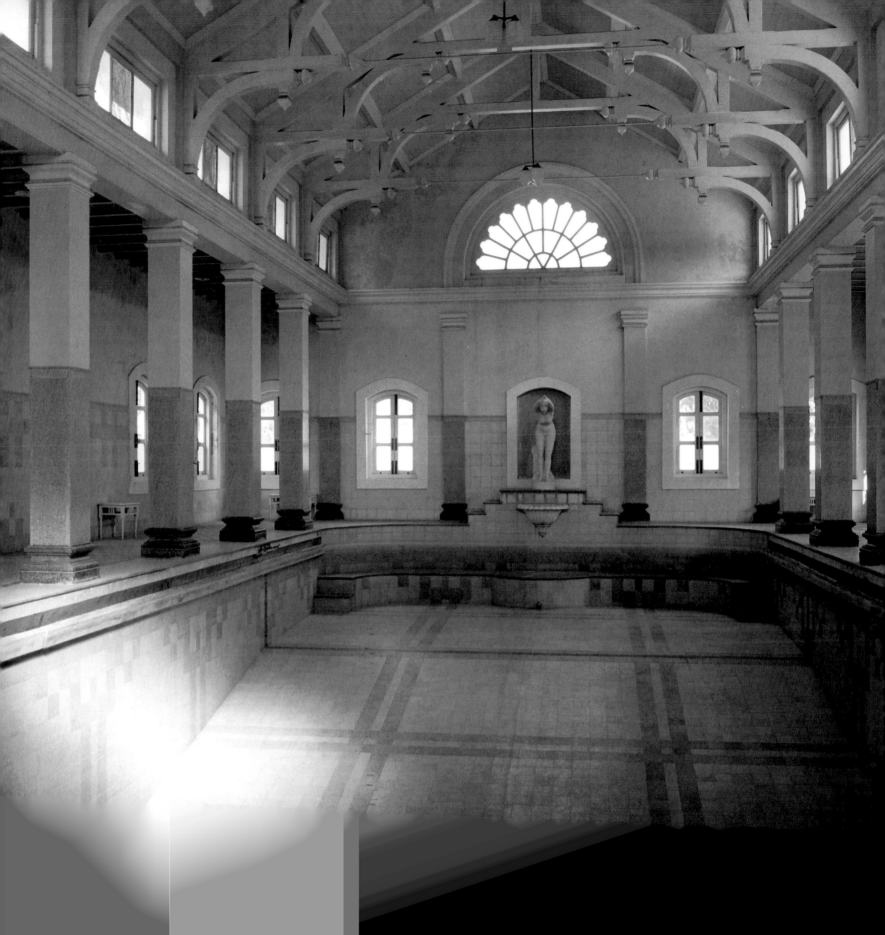

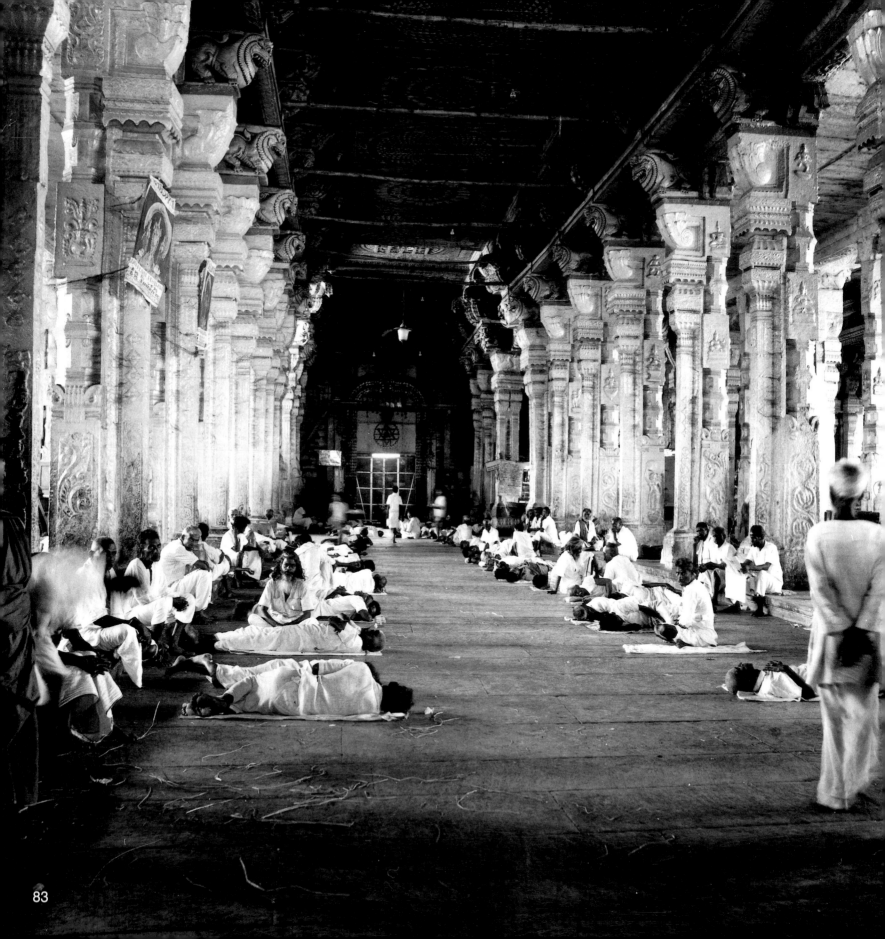

83

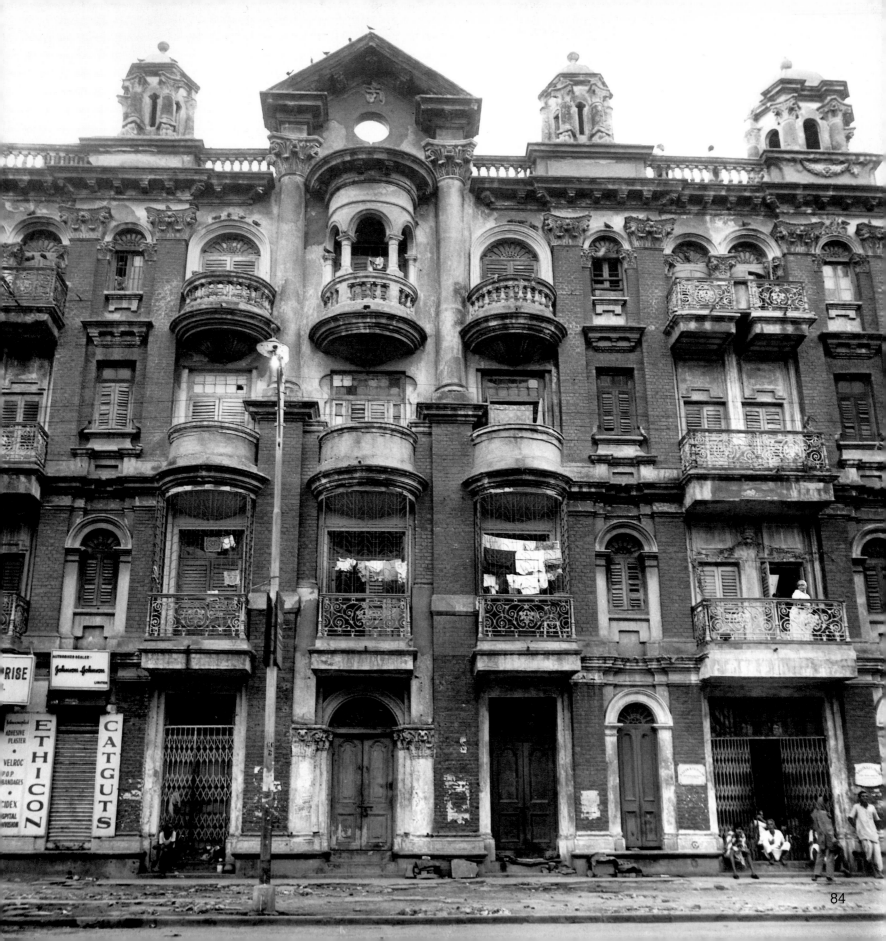

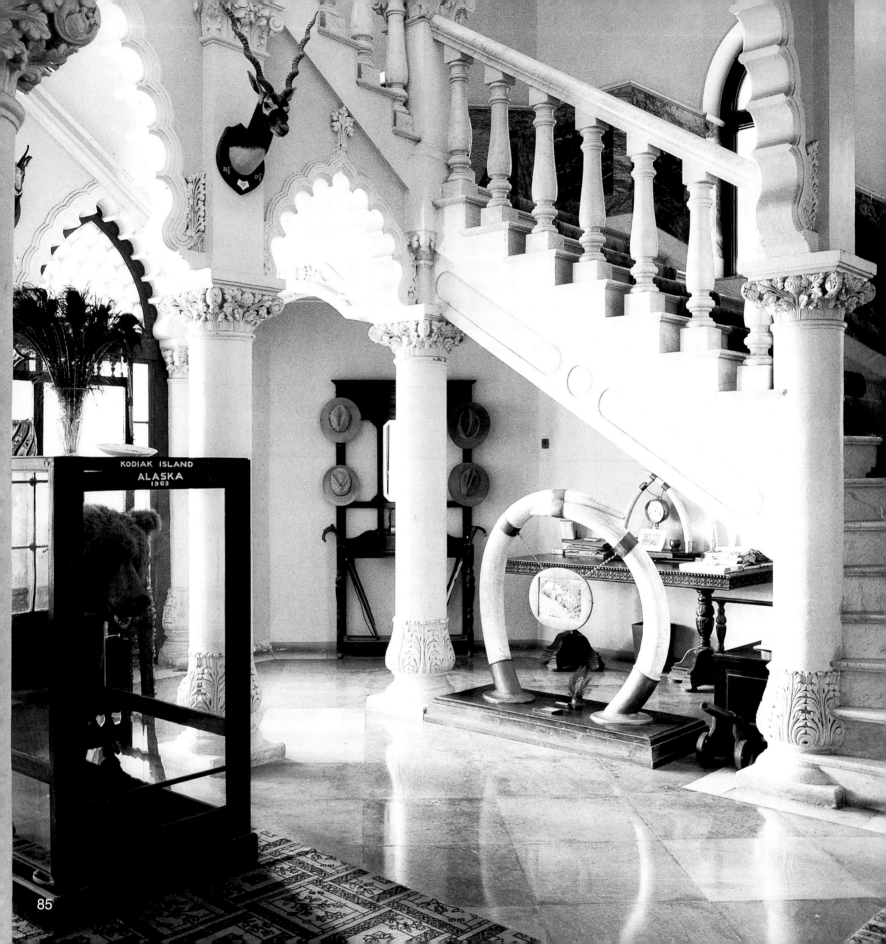

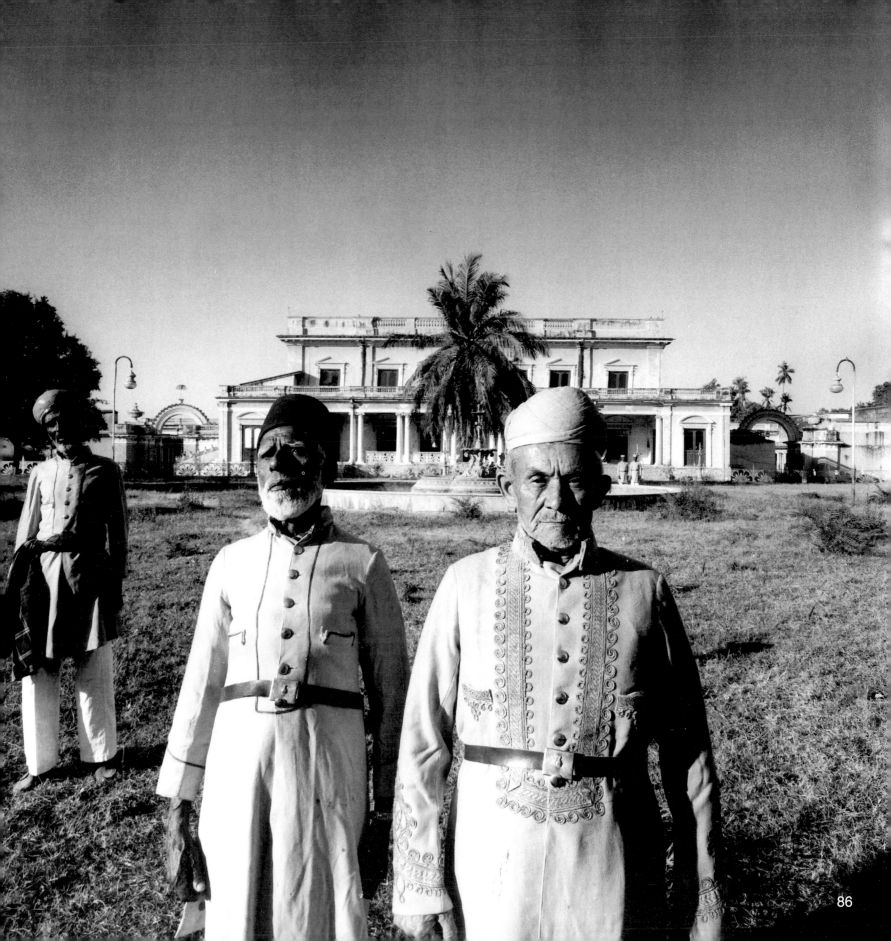

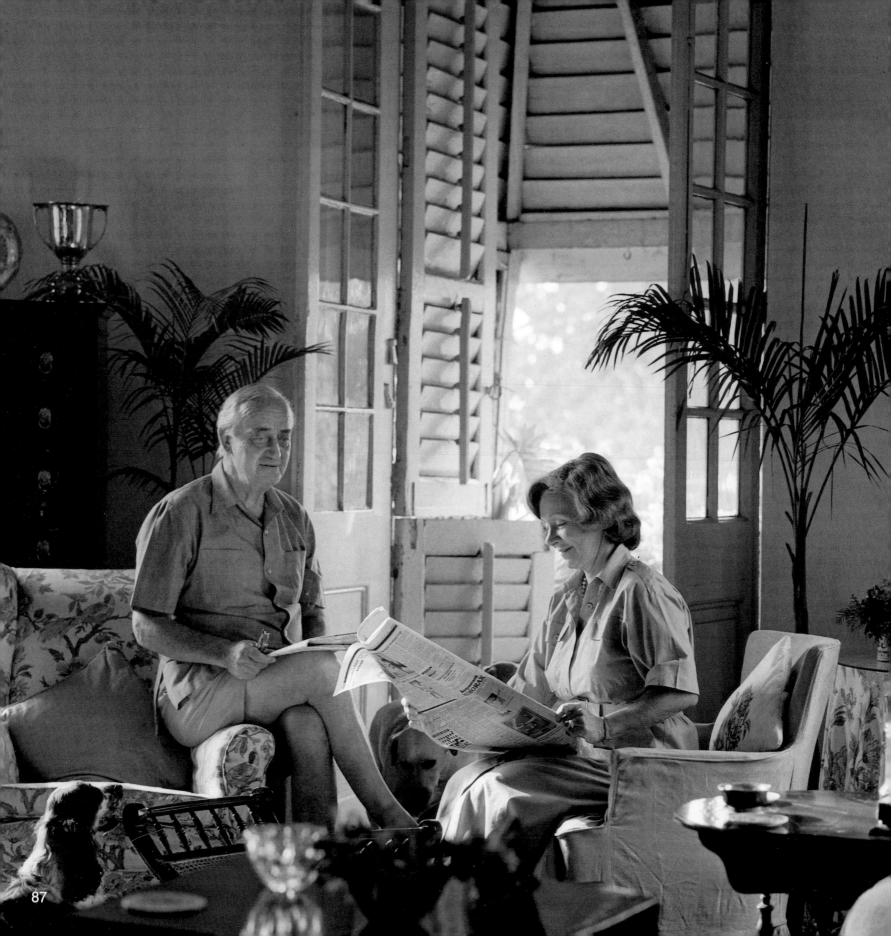

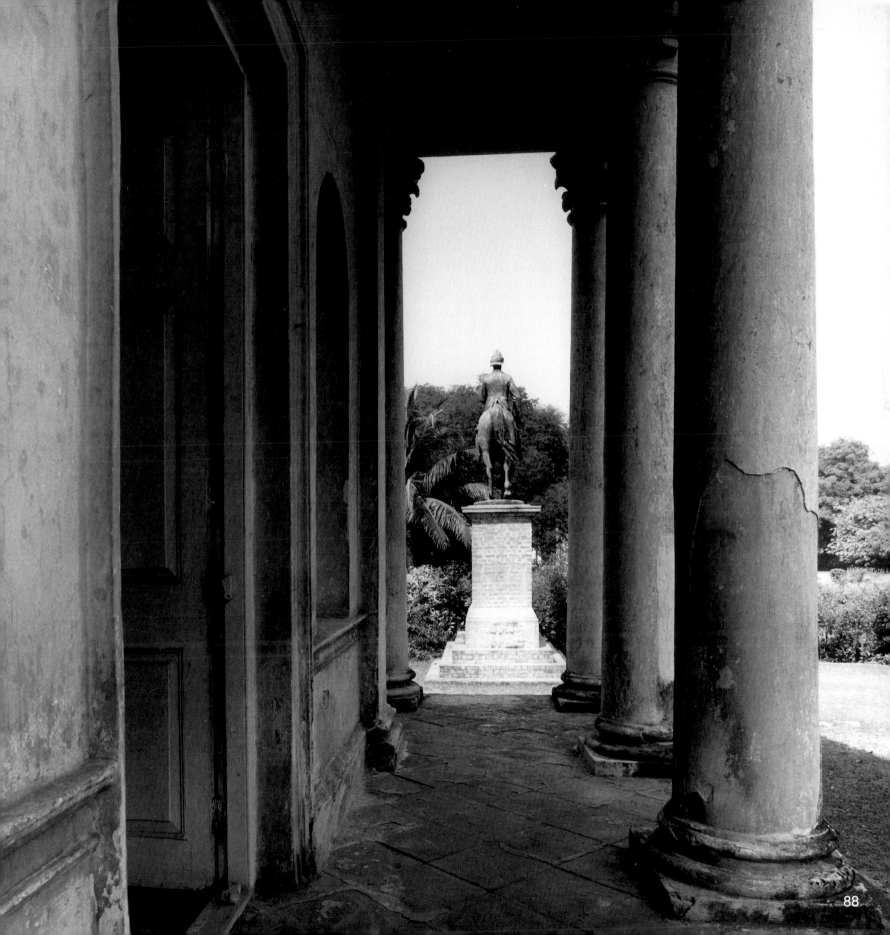

88

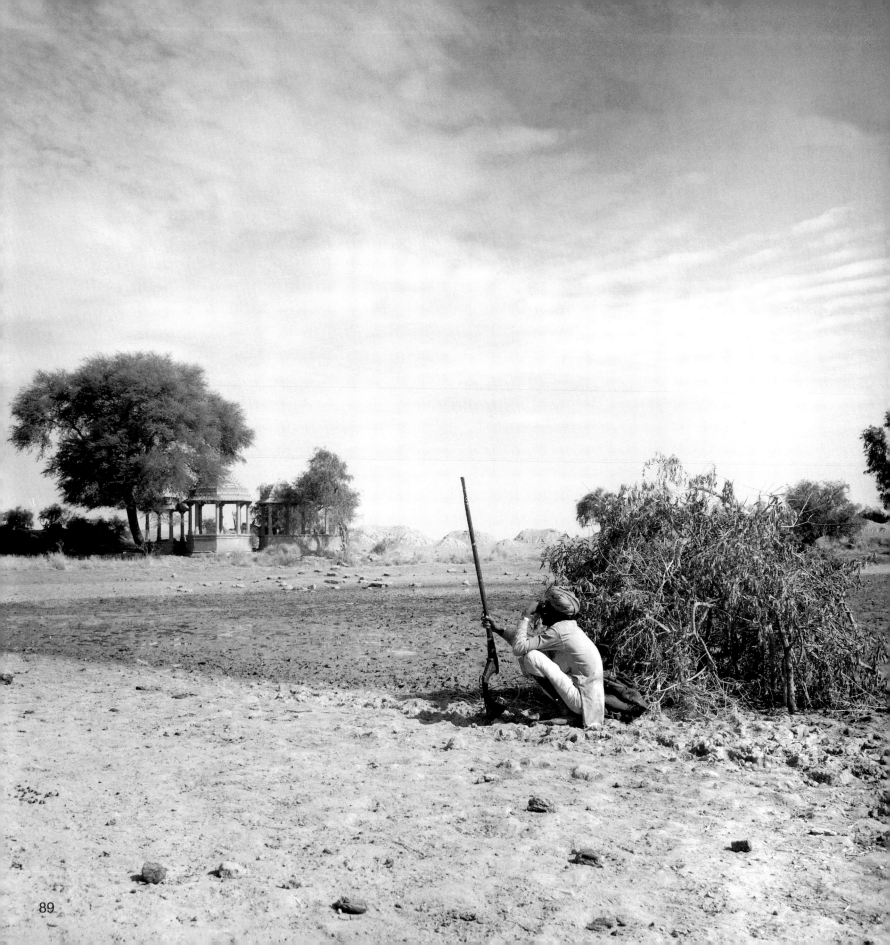

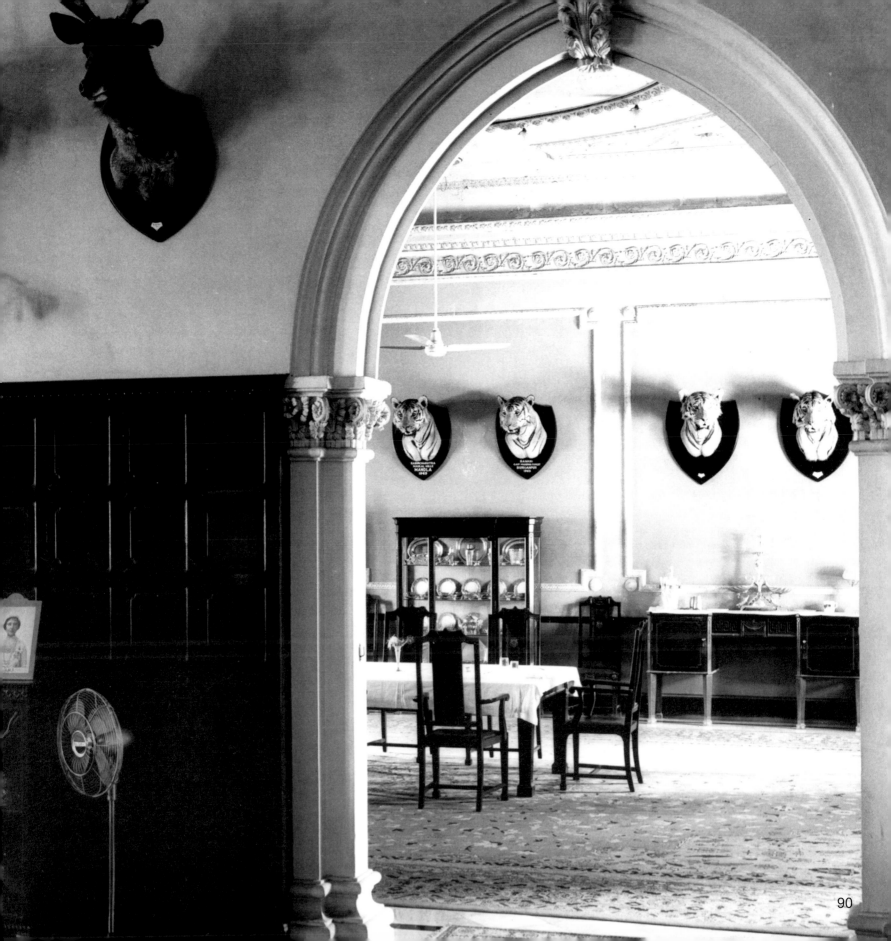

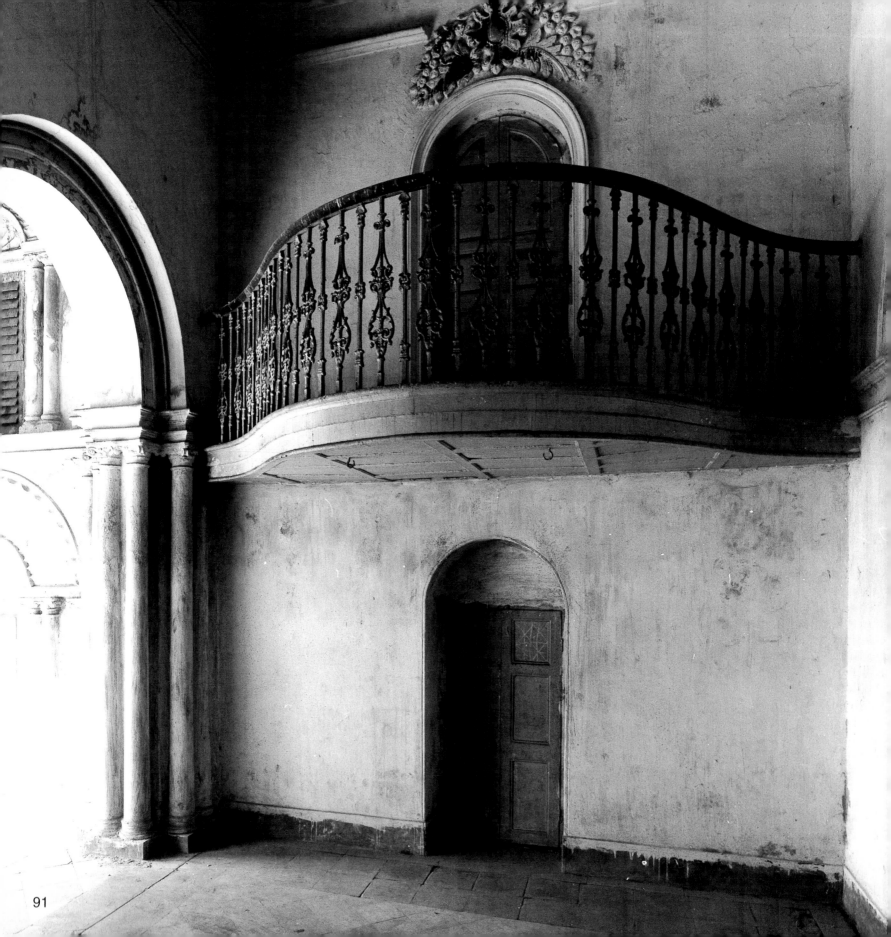

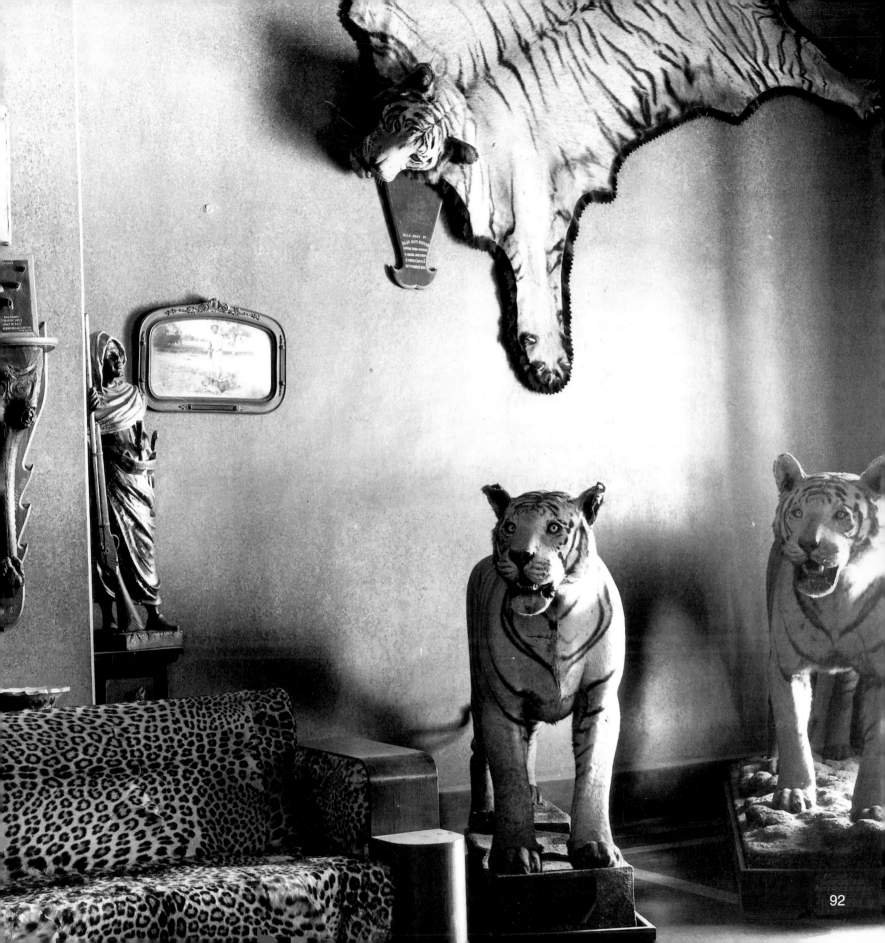

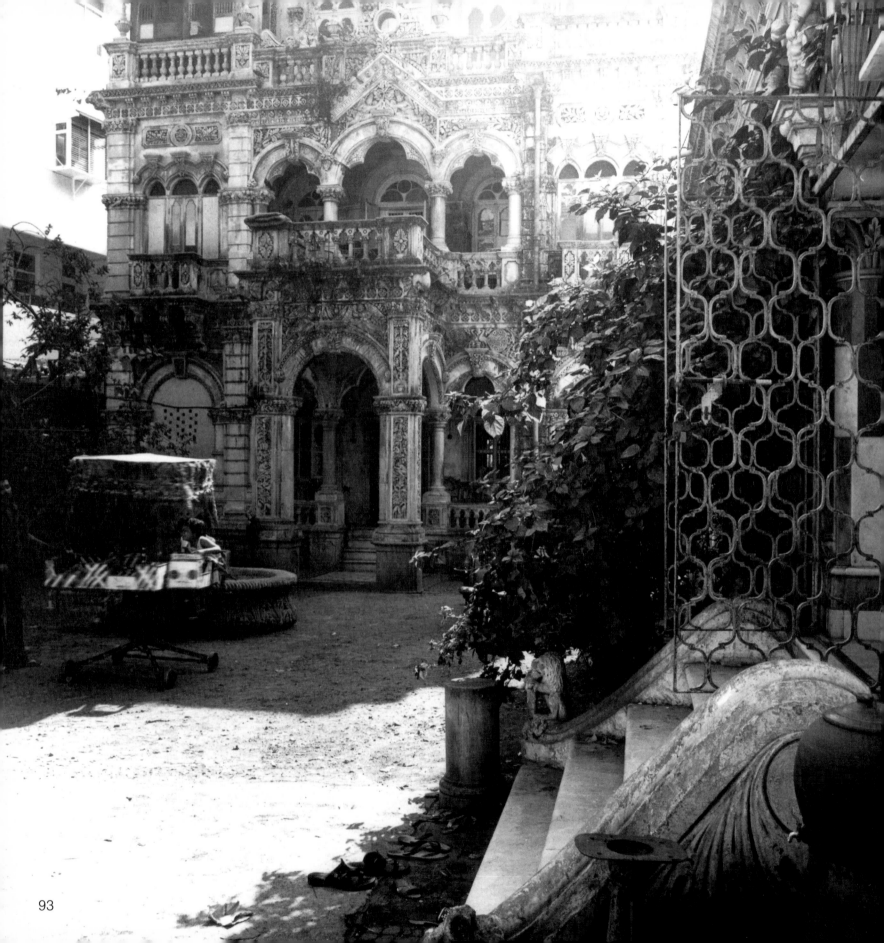

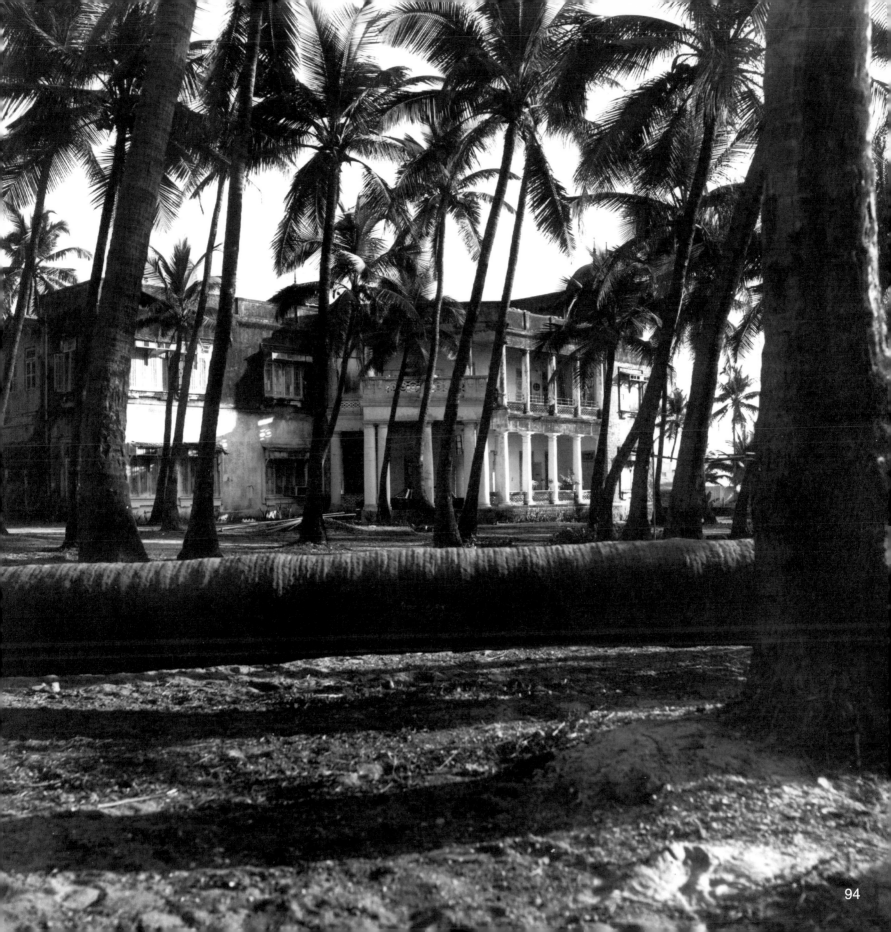

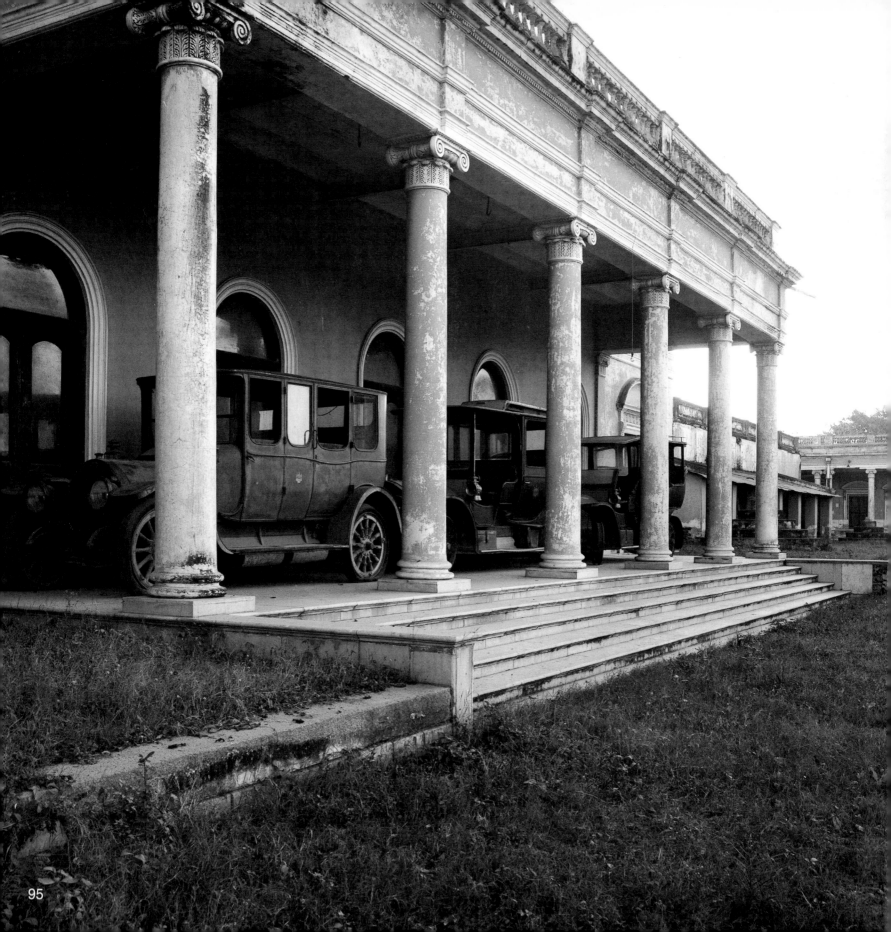

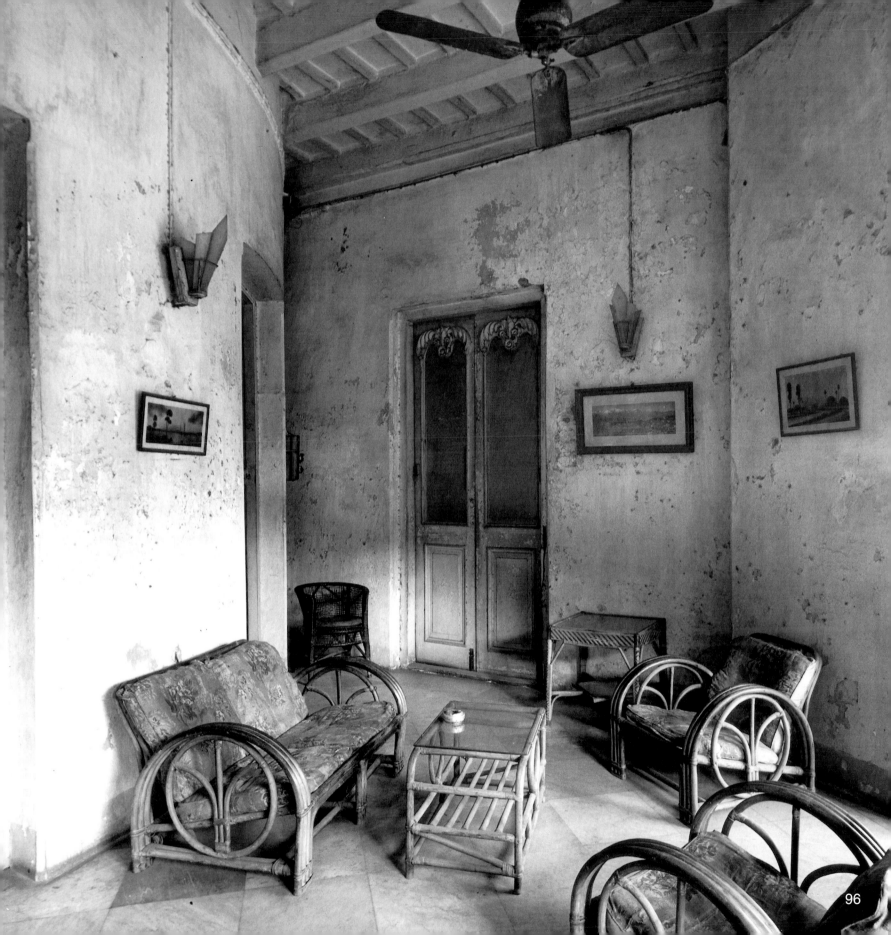

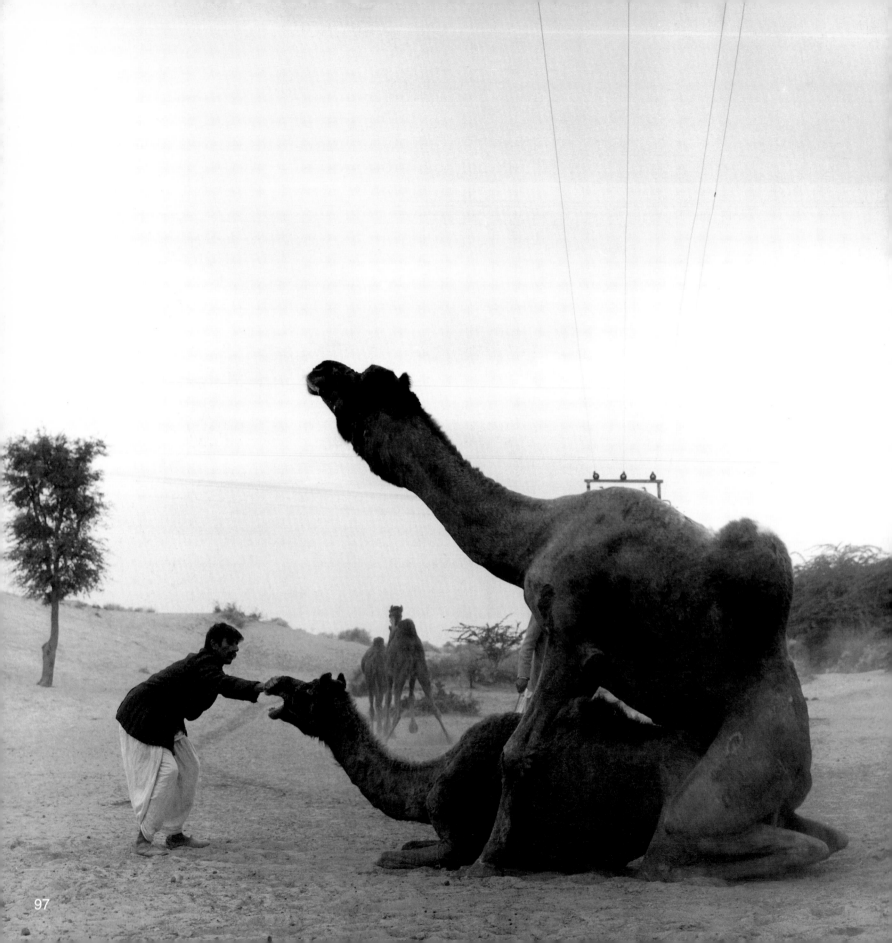

97

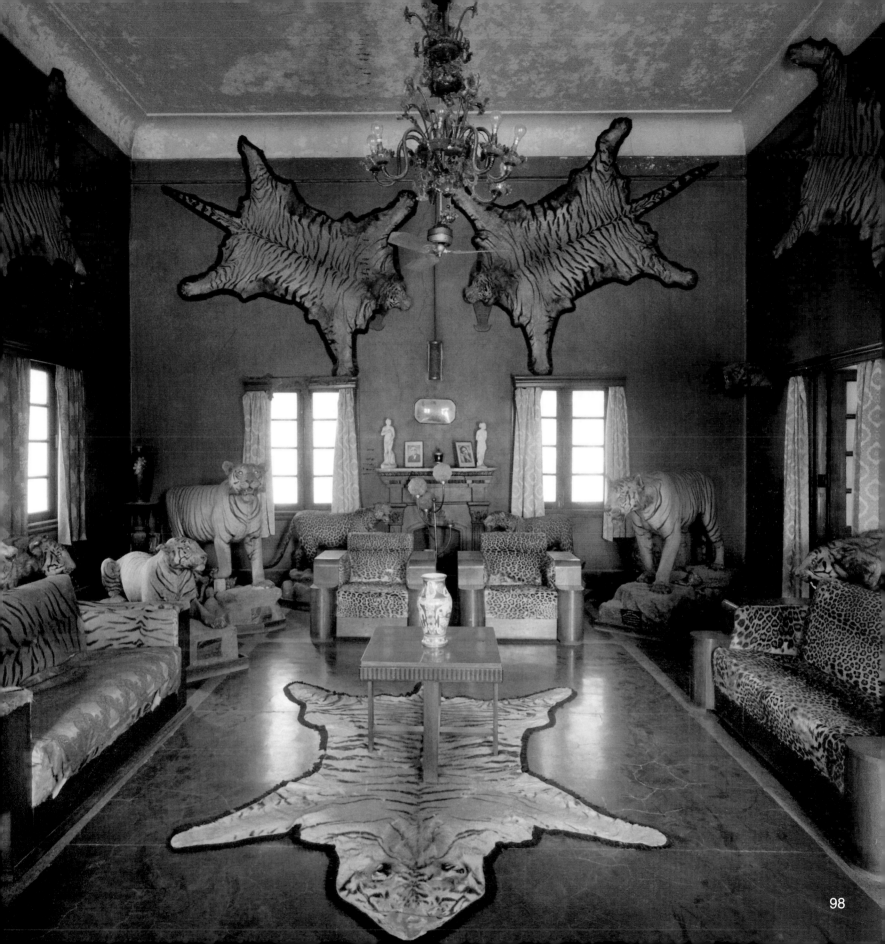

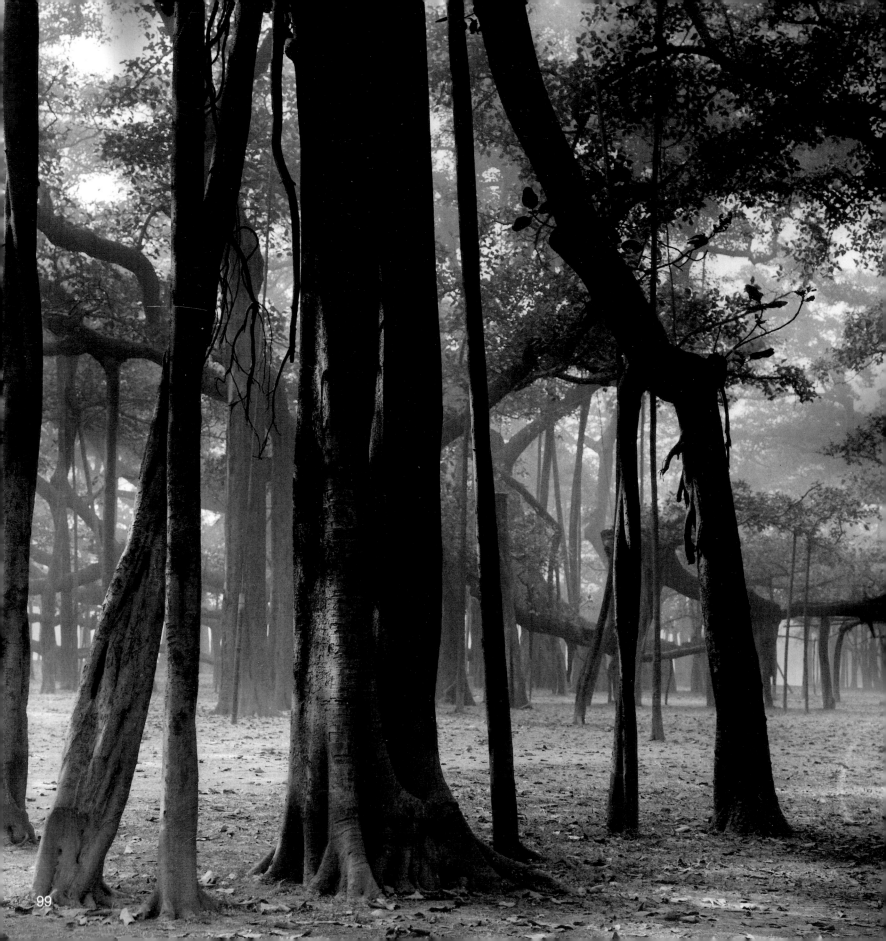

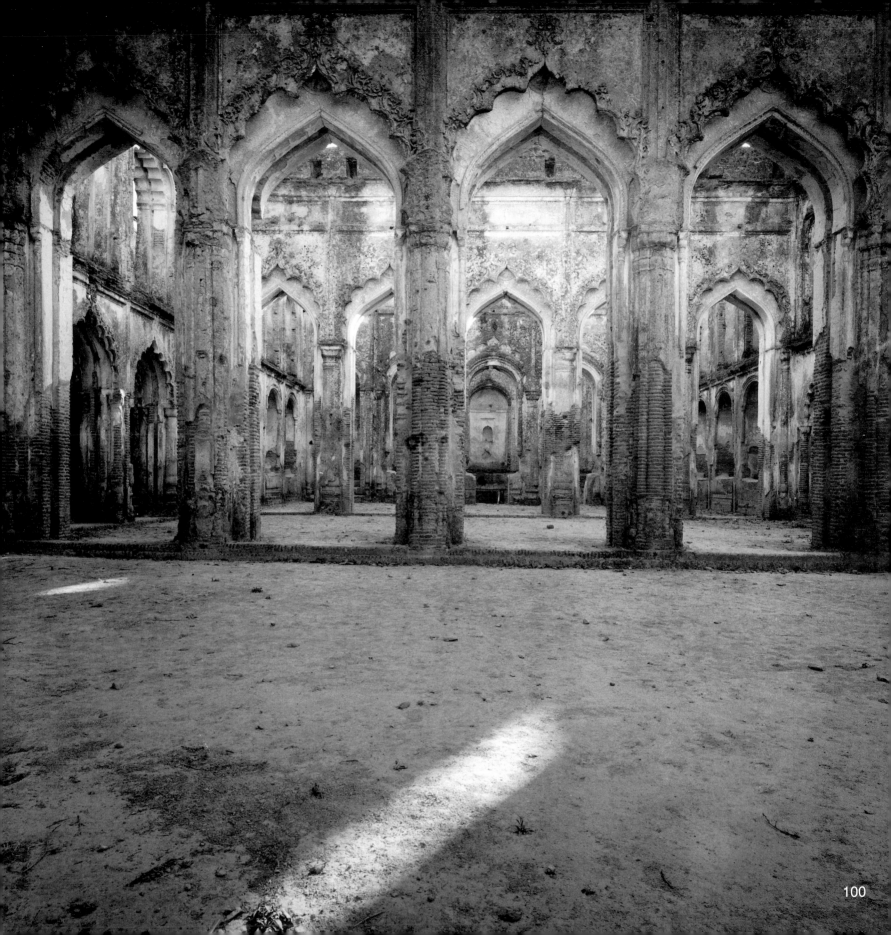

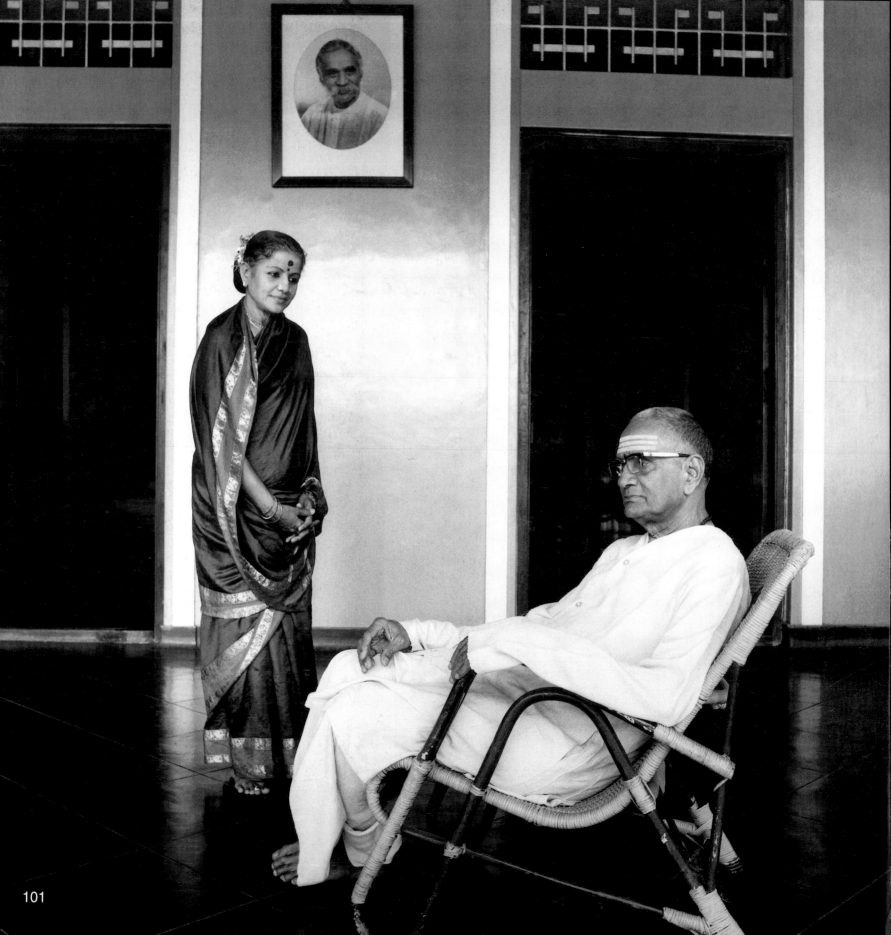

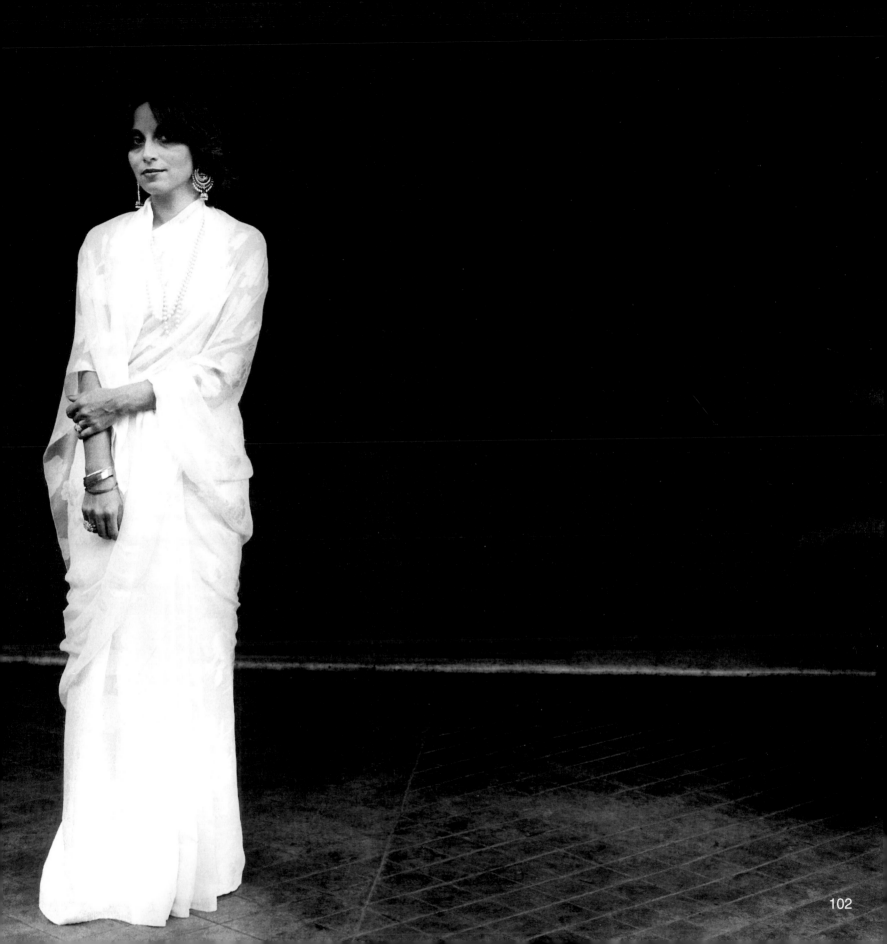

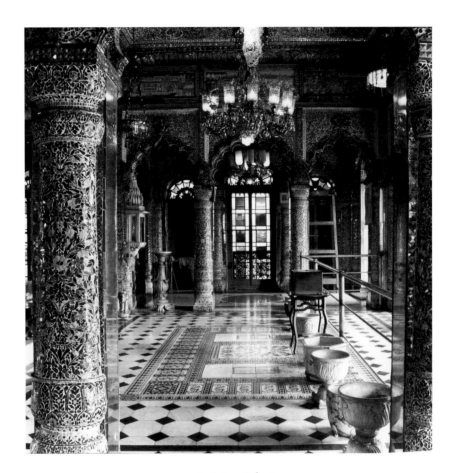

Interior, Calcutta

CAPTIONS

Frontispiece: House with owner, Bengal

1. House, Bombay: detail
2. House, Bombay: detail
3. Interior, Marble Palace, Calcutta
4. Interior, Marble Palace, Calcutta
5. *Ficus* tree, Botanical Garden, Calcutta
6. Marble Palace, Calcutta
7. Interior, palace, Datia
8. Cut-out figure of late His Highness of Mewar, City Palace, Udaipur
9. Guardroom, palace, Rewa
10. Tea-wallah, Writers' Building, Calcutta
11. Rocks, Hyderabad
12. The Johnston tombs, Tollygunge, Calcutta
13. Interior, Calcutta: detail
14. Elizabeth Brunner, New Delhi: a Hungarian painter living in Delhi, she had a great fondness for mice which were welcomed in her house and fed generously
15. Mr Mitter's house, Calcutta
16. Landscape, Golconda, Hyderabad
17. Statues in garden, Calcutta: detail
18. Billiard-room, Faluknuma Palace, Hyderabad
19. Statue, Marble Palace, Calcutta
20. Interior, Calcutta
21. Satyajit Ray, Calcutta
22. Soumitra Chatterjee, actor/director, in his dressing-room in a Calcutta theatre
23. Young man on staircase, Calcutta
24. Saraswati effigies before being dressed for the Saraswati *puja* in Calcutta; at the end of the festival all the figures are transported with ceremony to the Hooghly river and thrown into the water where they dissolve

25. Interior, Calcutta
26. Interior, Mr Mitter's house, Calcutta
27. Veranda, Burdwan House, Calcutta
28. Interior, Marble Palace, Calcutta
29. Cut-out figure of late His Highness of Mewar, City Palace, Udaipur
30. Interior with bust, Calcutta
31. Landscape, Hyderabad
32. Palace, Murshidabad
33. Mrs Sunita Pitamber, Bombay
34. Maharajkumari Nandini Devi of Burdwan, Burdwan House, Calcutta
35. Mosques, Lucknow
36. Lake, Udaipur
37. Dining-room, Burdwan House, Calcutta
38. Victoria Terminus, Bombay, detail
39. Lake, La Martinière, Lucknow
40. Palace, Gujarat
41. Nawab Zainul Abedin Khan and family at home, Hyderabad
42. Girl with homing pigeons, New Delhi
43. River, Gujarat
44. Veranda, Faluknuma Palace, Hyderabad
45. Cut-out figure of late His Highness of Mewar, City Palace, Udaipur
46. Barber's shop, Jaisalmer
47. Miss Bina Shivdasani
48. Yamani Krishnamurti, the dancer, in her house, New Delhi
49. Major Gardiner, who ran a Salvation Army-type hostel in Calcutta
50. Interior, Burdwan House, Calcutta
51. Porch, Calcutta
52. Statue in dining-room, Calcutta
53. Woman in shadows
54. One of the owners of this house, Calcutta
55. Veranda, Faluknuma Palace, Hyderabad

56. Temple elephant, the Great Temple, Madurai
57. *Chokidar* (watchman), Lucknow; this man was a direct descendant of the last king of Oudh
58. Krishnamurti
59. Buffaloes being washed near Tanjore
60. Lake, Udaipur
61. Mosque, Lucknow
62. Wedding tent being erected, Tollygunge Club, Calcutta
63. Light and fan switches
64. Letter boxes and company signs, office building, Calcutta
65. The son of Nawab Habeeb Jung, wearing court uniform, Chaumahalla Palace, Hyderabad
66. Interior with tiger, palace, Datia
67. Landscape, Gujarat
68. Dentist, Hyderabad
69. Charpoy in guardroom, Rewa
70. Interior, Calcutta
71. Mr Mitter, Calcutta
72. Gate of the Mushidabad house, Calcutta
73. Servant, Datia
74. Rats in the temple where they are considered sacred, Bikaner
75. Paigar tombs, Hyderabad
76. Palace guard, Jaisalmer
77. Bedroom, palace, Morvi; this art-deco palace was built in the 1940s
78. Swinging sofa, palace, Wankaner, Gujarat
79. House and courtyard, Udaipur
80. Staircase of house, Delhi
81. Veranda with servant setting tea, palace, Wankaner
82. Swimming-pool, palace, Wankaner

83. Pilgrims at the Great Temple, Madurai
84. Apartment building, Calcutta
85. Interior, palace, Bikaner
86. Palace guards, Chaumahalla Palace, Hyderabad
87. Mr and Mrs Bob Wright, Tollygunge Club, Calcutta
88. Colonnade with statue of British general, Barrackpur, Bengal. The statues of British India formerly in Calcutta were moved to Barrackpur after 1947
89. Country near Bikaner with hopeful hunter
90. Dining-room in palace, Wankaner, Gujarat
91. Interior, La Martinière, Lucknow
92. Interior with tigers, and tiger and leopard skins, Lucknow
93. House, Bombay
94. House on the outskirts of Bombay
95. Cars, Chaumahalla Palace, Hyderabad
96. Veranda of Murshadabad House, Calcutta
97. Mating camels, Bikaner
98. Interior, Jodhpur
99. The Great Banyan Tree, Botanical Garden, Calcutta. Everything that can be seen is part of the same tree. In 1938 it was over 1,000 feet in circumference; the central column was removed in 1925
100. The ruins of the Residency, Lucknow
101. T.S. Sadasivam and his wife, the great singer Subulaksmi, Madras
102. Mrs Naresh Kumar, Calcutta

ACKNOWLEDGEMENTS

I owe thanks to many people in India whose names escape my memory: I hope these omissions will be forgiven.

I would particularly like to thank Princess Esra Jah who first invited me to Hyderabad and extended such generous hospitality to me there; Mrs Sunita Pitamber to whom I owe my first visit to Bombay in 1976; Mr and Mrs Bob Wright who put me up – and put up with me – at the Tollygunge Club in Calcutta on many occasions; likewise Mr and Mrs Naresh Kumar for all their kindness in Calcutta; the late Maharajkumar Swaroop Bhanjdeo of Mayurbhanj; Ajit Singh; the Earl and Countess of Harewood who furnished me with some invaluable introductions on my first visit, in particular to Mr and Mrs T.S. Sadasivam to whom I owe especial thanks; Jamshed Bhabha; Nawab Habeeb Jung; Nawab Zainul Abedin Khan; Her Highness Annabel Singh of Mewar; Miss Camelia Panjabi; the late J.R.D. Tata; Farid Faridi; Mrs J.C. Ghosh; Mani Sankar Mukherji; the late Satyajit Ray; Maharajkumari Nandini Devi; and finally John Murray whose idea it was to publish this book in its present form, who edited the photographs brilliantly and ruthlessly, and whose energy and enthusiasm made the book a reality.

128